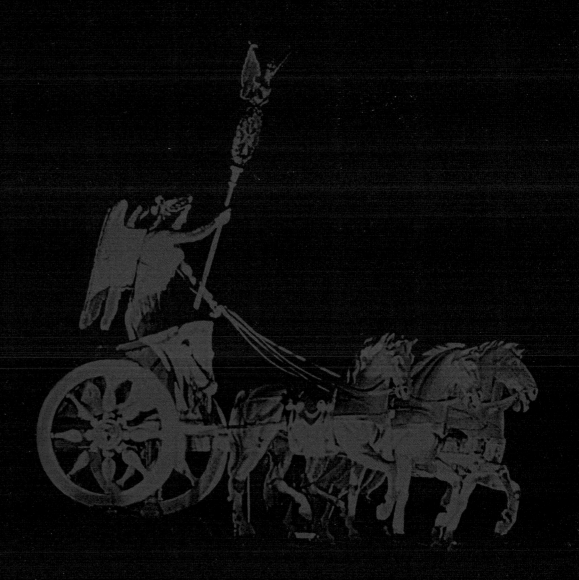

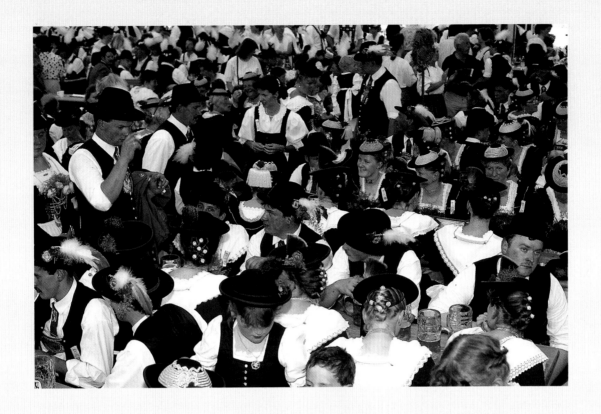

Journey through

GERMANY

Photos by
Horst and Daniel Zielske,
Martin Siepmann
and Karl-Heinz Raach

Text by
Ernst-Otto Luthardt

Stürtz

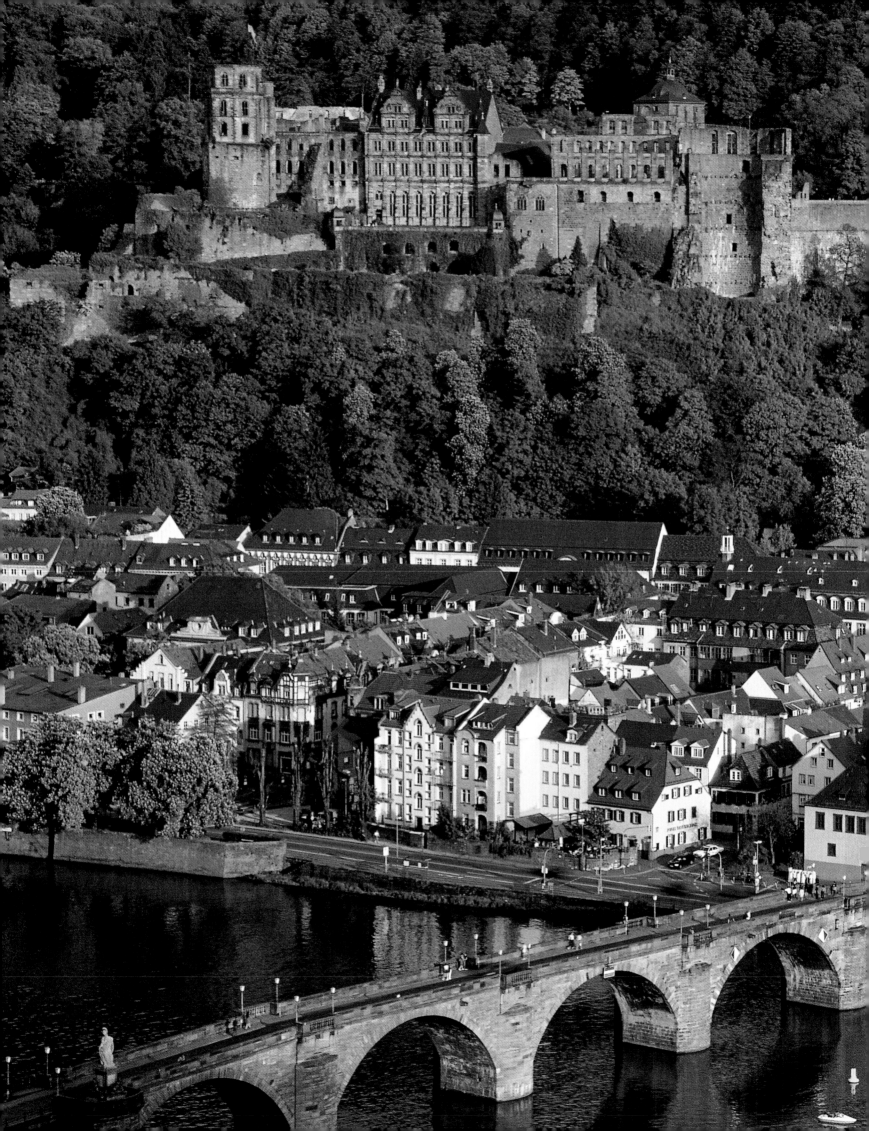

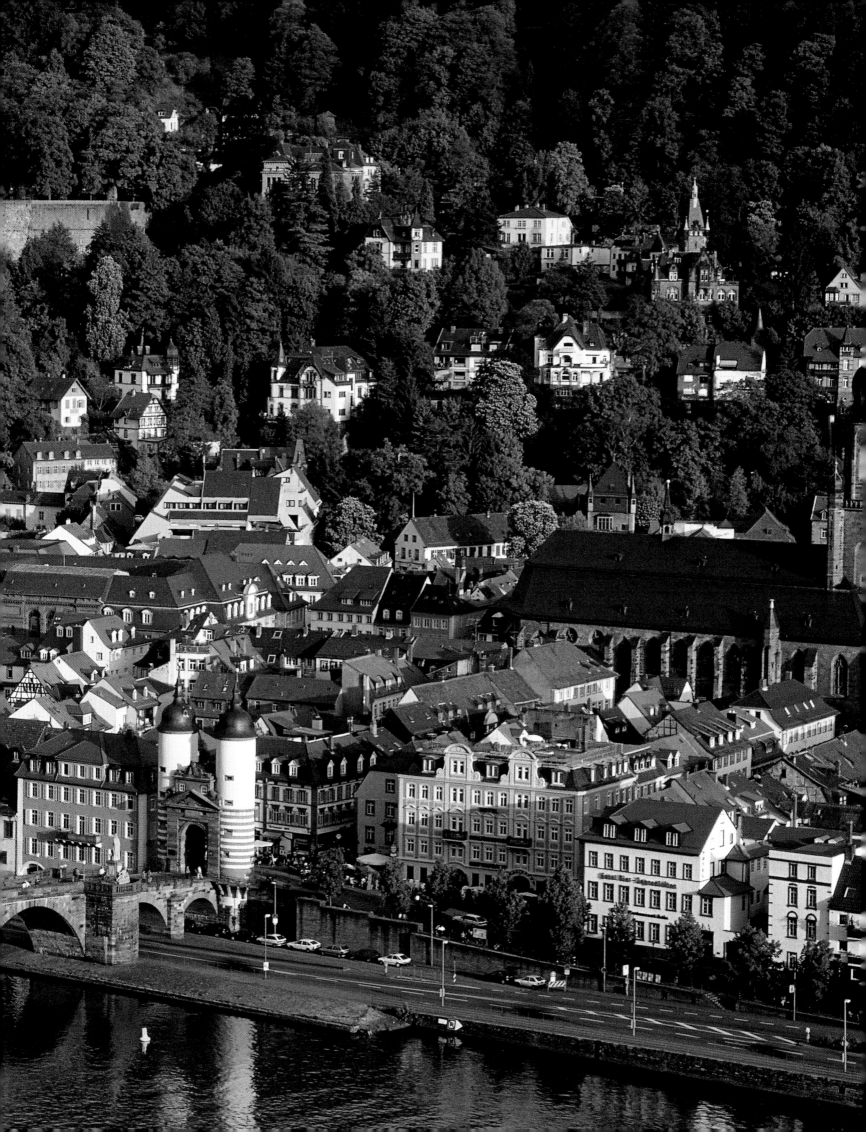

Previous page:
*Heidelberg, with its
magnificent ruined castle
towering above the River*

*Neckar, is for many the
embodiment of German
Romanticism.*

Below:
*"Europe's biggest
presbytery" was the
name Napoleon gave to*

*Würzburg's residential
palace. The vaulted
ceiling over Balthasar
Neumann's splendid*

*staircase has the largest
complete fresco in the
world, painted by Giovanni
Battista Tiepolo.*

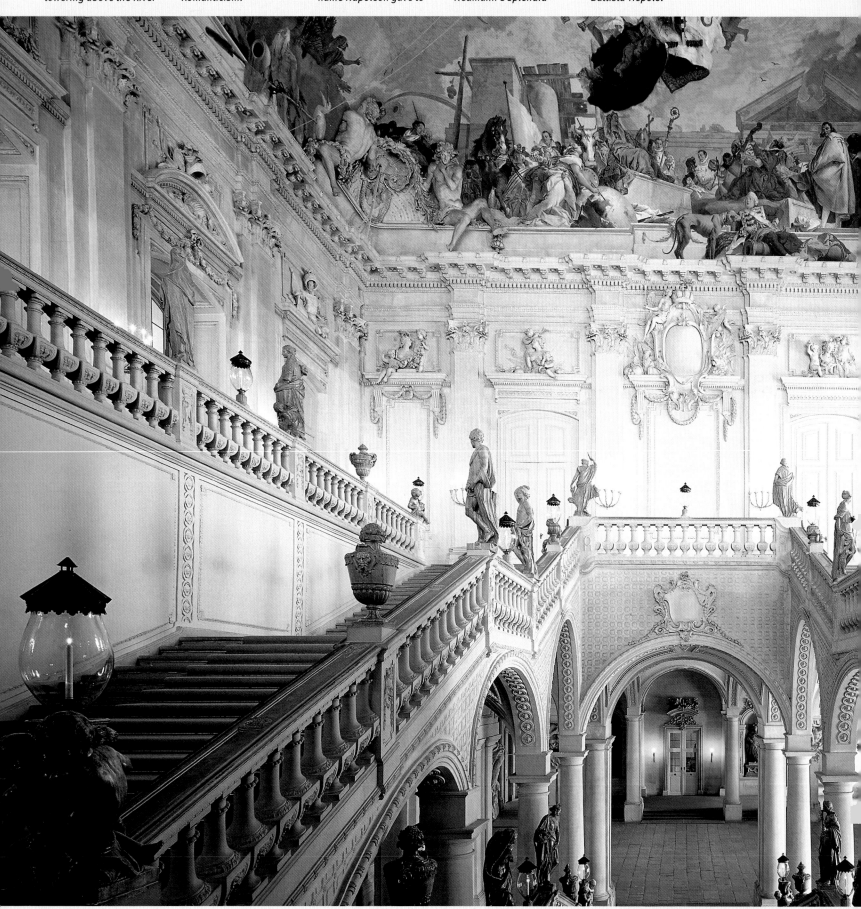

Page 10/11:
The history of St Trudpert's in the southern Black Forest goes back to the year 800. The convent is now run by the nuns of St Joseph.

Contents

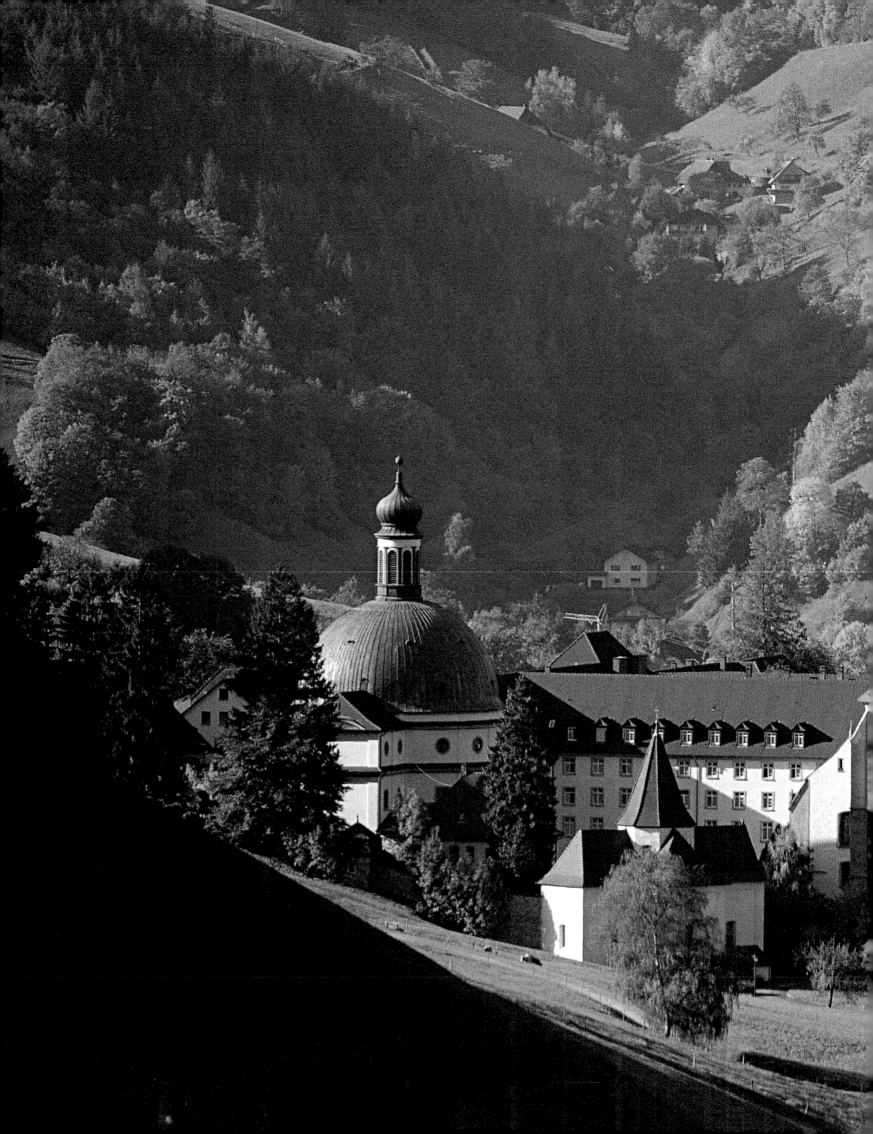

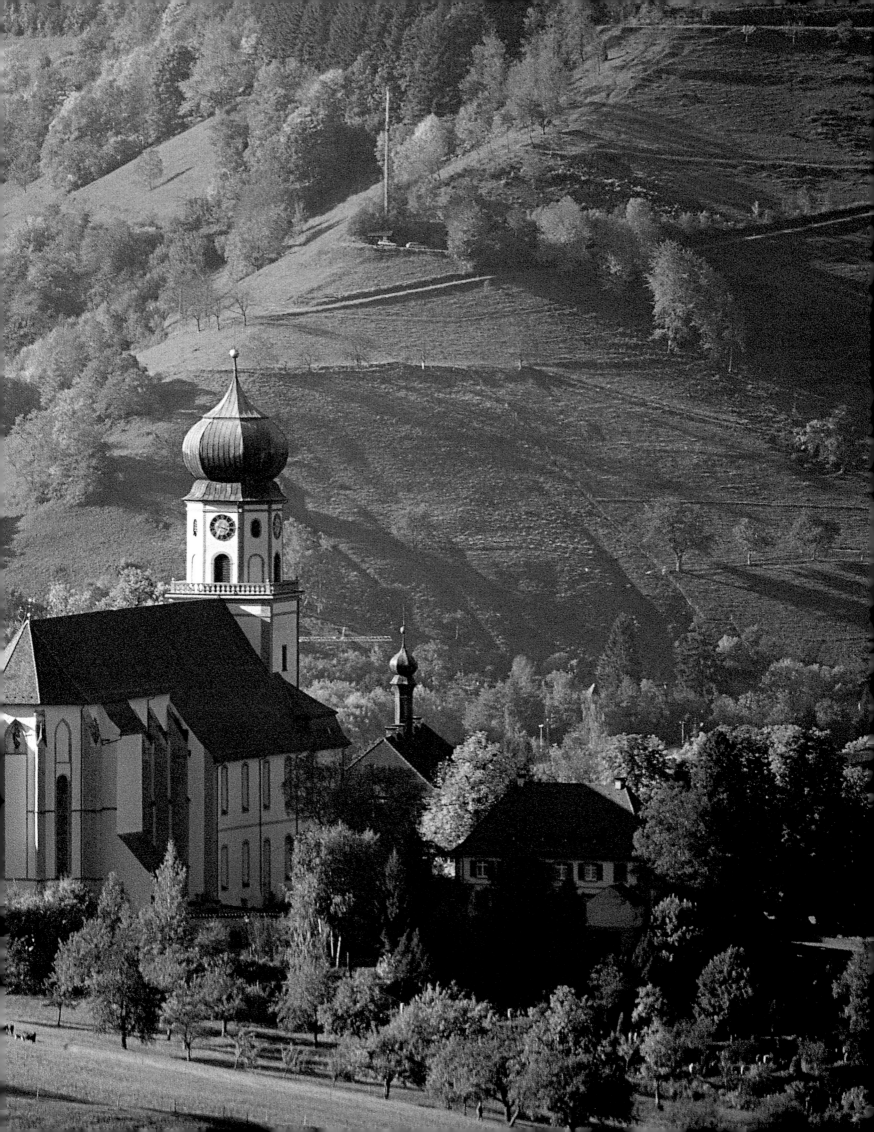

The Men Who Would Be King

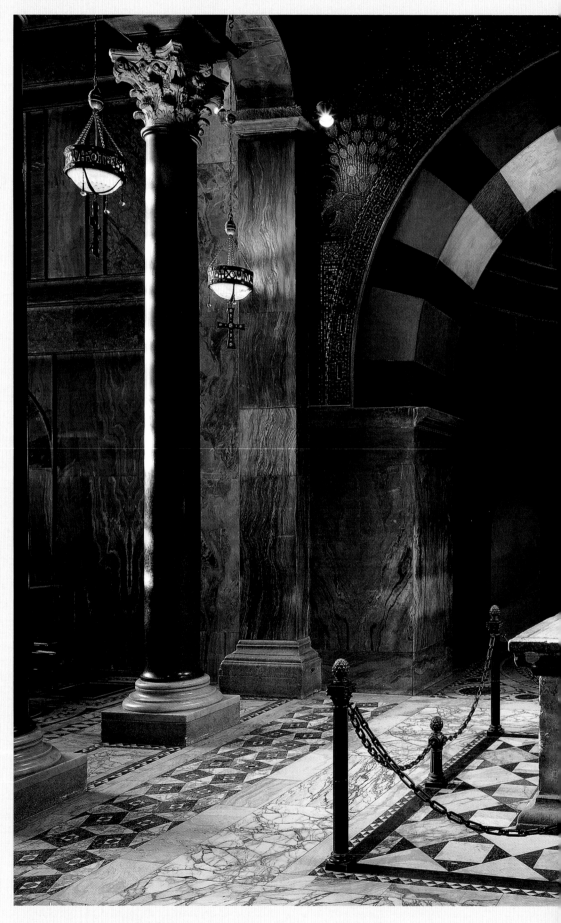

The Palatine chapel at the heart of Aachen's minster was built by Charlemagne between 786 and 805. This is where 30 German kings and emperors were crowned between the 10th and 16th centuries. The emperor's marble throne has six steps going up to it, like that of King Solomon.

Of all the crowned heads in medieval Europe it was the kings of Germany whose thirst for travel was the most insatiable. They forged east, hungry for new domains and rich booty, and down into Italy. From 962 onwards they successfully swelled the territories of the Kingdom of Germany in the Holy Roman Empire – and increasingly neglected their duties at home. The fall of the Staufer dynasty in 1254 signalled the end of a centralised regal power, making way for the ascension of the more prosperous towns and of territorial sovereigns both sacred and secular. Each made politics as they thought fit, seeing themselves as big-time potentates with the power to rule. The many royal capitals blossomed and built theatres with orchestras to play in them. Local magnates collected valuable works of art and beautiful female artistes; they constructed one splendid edifice after another until the coffers were empty. The wealthy free cities were every bit as ambitious as their princely cousins. As paradox as it may seem, it's this period of political fiasco which has left Germany with the rich architectural and cultural legacy tourists today find so compelling.

Where the land meets the sea

In the Middle Ages, when the sea was thought to be the beginning of the end of the world, the marine merchants who formed the Hanseatic League made it their objective to venture out to new shores and sources of profit. The largest of Germany's confederation of cities which flourished in the 14th century successfully seized control of trade on the northern seas and prospered. Lübeck, Hamburg, Bremen and the

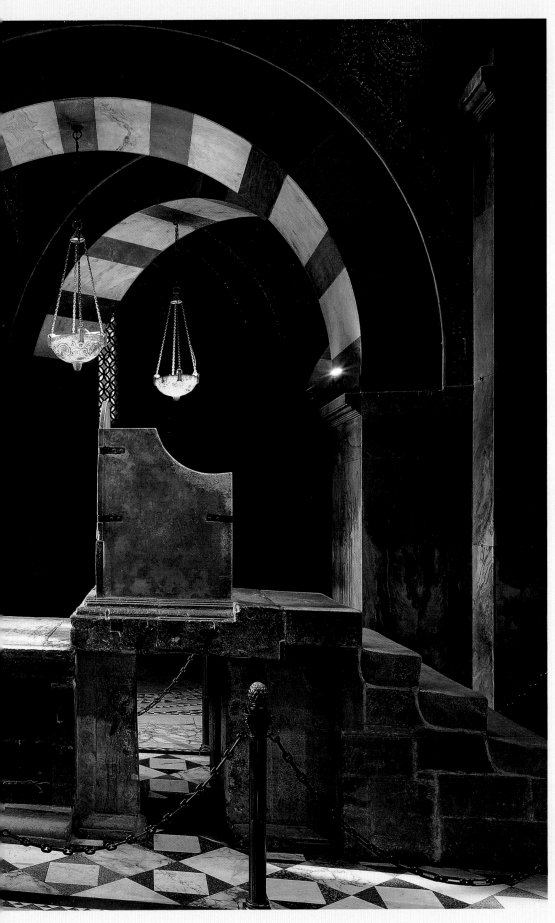

remaining members of the League proudly exhibited their new-found wealth, having ornate houses, hospitals, town halls and churches erected in legendary Gothic brick.

Schleswig-Holstein was initially a province of seafarers and farmers. This changed when the discovery was made that the sea is a marketable commodity. The tourist industry boomed. It now attaches greater value to holidays with class as opposed to those en masse; modern-day strand-lovers have enough opportunities to escape the obligatory seaside attractions of the more sizeable beaches. There are desert islands for would-be Robinson Crusoes for hire – at least for the duration of a holiday – in both North and East Frisia.

The East Frisian holiday isles of Norderney, Borkum and Spiekeroog belong to not to Schleswig-Holstein but to Lower Saxony. The second-largest German province stretches from the low mountains of the Harz to the beautiful briny North Sea. The land in between is flat but far from boring. Take the superb heathlands around Lüneburg, for example, whose carpet of heather swathes the nature reserve in brilliant cerise in the autumn. Or the castles and town houses of the Weser Renaissance, whose richly ornamented stone and half-timbered façades have many a mysterious tale to tell.

The states that are cities

Before the River Weser runs into the North Sea, it weaves its way through an ancient city whose foundation goes back to 787 and a bishopric established by Emperor Charlemagne. In the 11th century Bremen was thus known as the Rome of the North, until three centuries later the city's development fell to the minds and monies of the Hansas. This period of prosperity is preserved in stone on the market place, for example, with the cathedral, Schüttinghaus and town hall – not forgetting the stone giant called Roland, who has guarded the city's privileges with his sword and shield since 1404.

Like Berlin and Hamburg, Bremen is both city and federal state. With Bremerhaven as its coastal port, Bremen covers an area of around 155 square miles (400 square kilometres) and is the smallest of Germany's provinces.

Almost twice this size, but still minuscule compared to Lower Saxony in which both city states lie, is Hamburg, which has Germany's biggest harbour. The world's largest loading zone with its northern docklands has a strong pull on tourists. Not only are the halls and warehouses good for business – so are the façades, which imitate the Hansas in neo-Gothic. Unlike some of the other communes in the League, Hamburg's importance and mag-

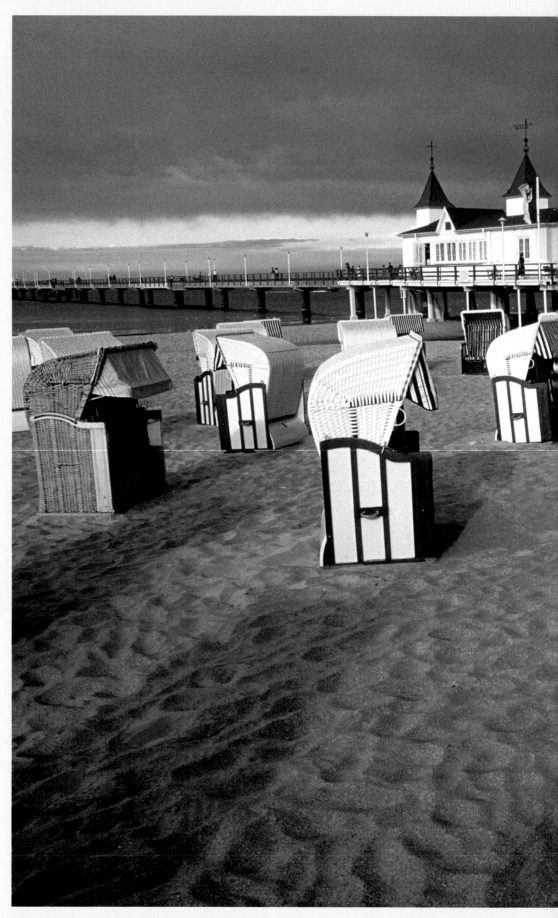

The first seaside holiday-makers came to Ahlbeck in 1852. The main attraction of the modern resort, the largest on the Baltic island of Usedom, is the pier on wooden stilts, erected in two stages in 1889. During the high season, the pier restaurant is usually so full you're lucky to find a seat.

netism is due to both the past and the present. At almost two million inhabitants, the metropolis isn't just a top international address for commerce and industry but also for art and theatre, opera and ballet. It also boasts a famous entertainment centre in the St Pauli district.

Cramped conditions and marching bands
North Rhine-Westphalia has the highest populace in Germany (18 million) who have to share just the fourth largest of all of the federal states. Conditions are particularly cramped for both man and machine in the industrial Ruhr area, Europe's vastest conurbation, where municipalities such as Bochum, Gelsenkirchen, Leverkusen and Recklinghausen have long swallowed any no-man's land which may have existed between them. Yet each year at Carnival time people happily hurl themselves into the throng. They swamp the dance halls in their masks and costumes and jig through the streets to the beat of marching bands and processional floats on Rosenmontag. The best parades are in Cologne or Düsseldorf. While we're on the subject: Cologne on the River Rhine was the biggest Roman settlement north of the Alps, with the springs at Aachen providing hours of imperial fun at the baths. The Carolingian to Gothic cathedrals in the two cities look back on a great German imperial and architectural history. Yet North Rhine-Westphalia isn't all industry and urbanity. In the volcanic northern Eifel and Sauerland, where world championships in bob sport and tobogganing are held, it also has some fine countryside.

Where witches dance
Once the Saxon rulers had been crowned kings they were drawn east to convert the heathen slaves and confiscate their land. The stone witnesses to this period line the Romantic Route as churches and castles. In Quedlinburg Prince

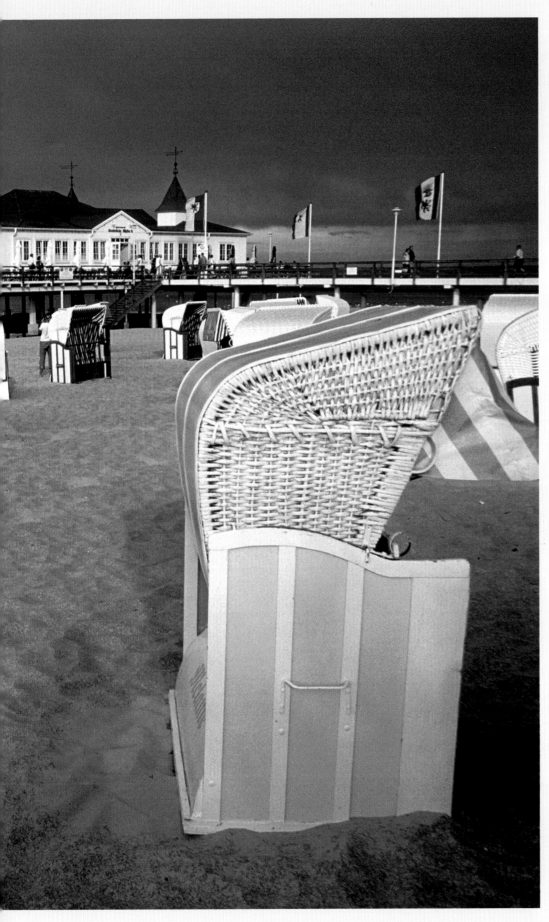

Heinrich was pursuing his favourite pastime of catching finches in 919 when news reached him that he had been elected king of Germany. His final resting place in the collegiate church atop the castle hill is one of the grand legacies of Romanesque art in Germany, as is the church of St Cyriakus in Gernrode.

Back to the Harz. Its highest peak, the Brocken, is serviced by a particularly romantic railway line, along which chugs an aged steam train. A quicker mode of transport is undoubtedly the broomstick the witches from near and far are said to use on Walpurgis Night (30 April). This is when they fly up what has been Germany's witch mountain since the Middle Ages to their cackling equivalent of a rave.

By boat to the reinstated capital

In Mecklenburg-West Pomerania it's not witches you're likely to come across, but giants. Tales of prehistoric ogres and phantom sea monsters have survived to our present day, as have more tangible relics of the past: little fishing villages with thatched roofs, unspoilt scenery, like that of the Darß, and seaside resorts which over the decades have transmuted from splendour to shabbiness. Now the coastal architecture of places such as Heringsdorf, Kühlungsborn and Ahlbeck in stone and wood once again basks in its former glory. One particularly charming location is Rügen, Germany's largest island, where precipitous cliffs of gleaming chalk are interspersed with flat, sandy beaches. This is the province where the Baltic has an inland counterpart, smaller maybe but no less idyllic. The Mecklenburg Seenplatte or lake district is a refuge for many protected species of animal and plant. Hobby sailors can glide along the lakes, rivers and canals to and beyond Berlin. In 1991, Germany's biggest community once again became capital city and heart of a reunified nation. Berlin is also the country's chief building site. The modern age, with its flash ministries, company headquarters and cultural centres, has now engulfed both east and west of a city once divided. Friedrichstraße, for example, has been given a completely new visage. Besides the better-known architectural highlights (Schloss Charlottenburg, for example, at the pinnacle of Prussian design) and ark of museums (the most famous being museum island with its top-class exhibits from the world of international art), the standard itinerary should include an excursion to the real Berlin, to soak up the atmosphere in the authentic pubs, galleries and theatres in Prenzlauer Berg, for example – with the people to match. For the more contemplative (and solitary) moments there are the lakes and pine forests of Brandenburg

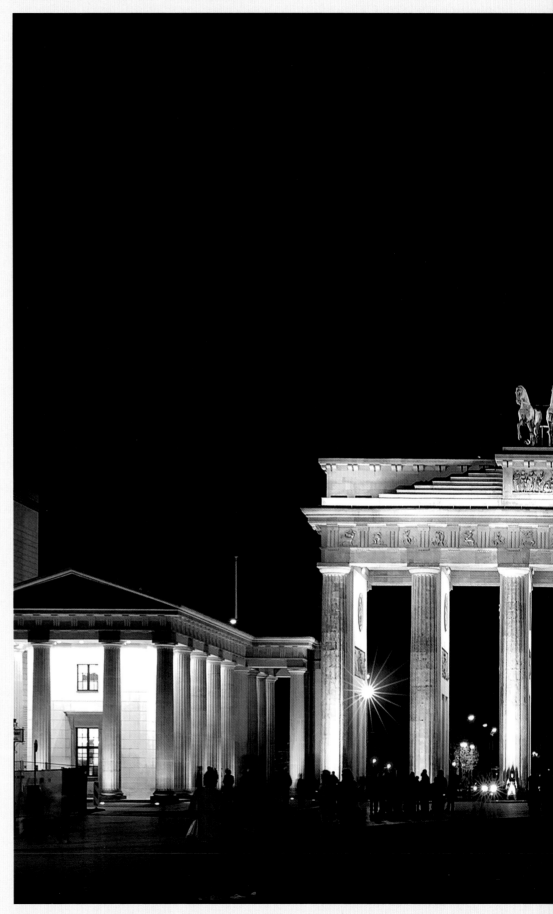

which encircle the city centre. In defiance of the old saying, here the Prussians built upon sandy ground. Frederick the Great, who loved war and hated women, is the embodiment of the Prussians' surprising rise to European power. In Schloss Sanssouci he has bequeathed to the world a place of enchantment which refuses to gel with the Prussian notion of prudence.

The land of Christmas

For many centuries the Saxons were the Prussians' strongest adversaries. Their capital Dresden flowered into the Florence of the River Elbe. Art and literature were promoted, their composers famous all over Europe. The legend of Johann Sebastian Bach lives on not just in his music but also in the Choir of St Thomas's in Leipzig. Bach was from Thuringia, which at that time belonged to Saxony and still has much in common with its neighbour. The old heartland of Luther's Reformation is endowed with a variety of beautiful countryside and a healthy architectural and spiritual heritage. The provincial capital of Thuringia, Erfurt, is one of the most historically interesting cities in Germany. Yet it's not a mutual past alone which continues to link the two federal states. They also share a long tradition which is still very much alive – the manufacture of Christmas goods. In Thuringia fascinated visitors purchase hand-blown baubles for their Christmas trees before moving on to Saxony's Erzgebirge, which with its abundance of candle-powered pyramids, wooden figures and nutcrackers, old customs and seasonal fêtes is the land of Christmas.

The beautiful Loreley

You would think that with the vast number of industrial plants clogging its banks, Germany's largest river, the Rhine, must by now resemble a sewer. Not so. The song warbled by visitors to this famous wine country, which opens "If the water in the Rhine were golden wine...", thus doesn't seem as unappetising as it might first appear. In Hesse indeed, where the dense

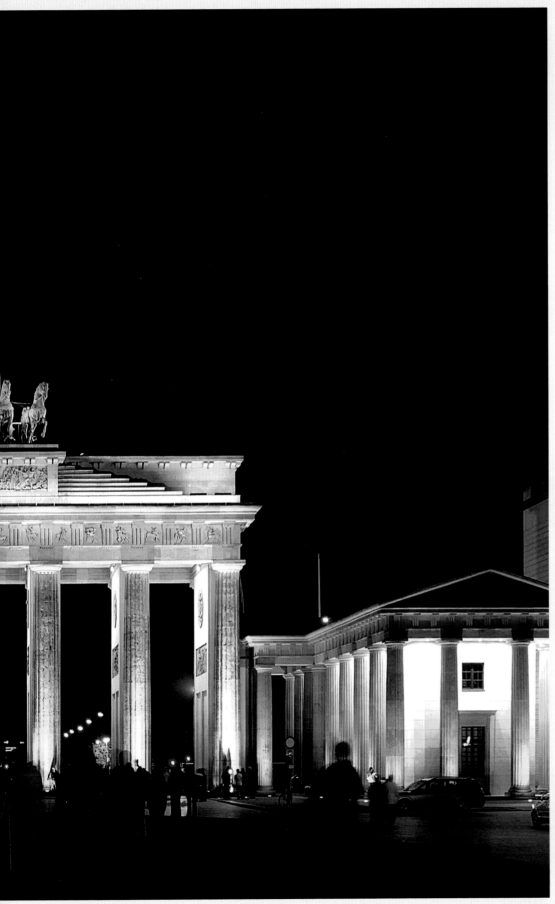

forests are the stuff fairytales are made of, it isn't that implausible to hope that one day this dream might come true. The state even has a German Fairytale Route which links up the age-old stories and little towns and leads to the castle of Sleeping Beauty, the Sababurg. There are just as many fortresses and homely half-timbered villages lining a second, equally famous road, the Bergstraße. This is at its most magical in spring, when the fruit trees smother the slopes in white.

Another legend concerns a beautiful maiden who used to sit on the steep rocks above the River Rhine and sing so enchantingly that the sailors below fell into a trance and perished in the swirling waters. Although the lady in question hasn't been seen for some time, nor has her song been heard, the magnetism of her alleged haunt is stronger than ever before. The Loreley Rock is one of the most popular places of yearning in the whole of Germany. The Rhine is indeed at its best between Mainz and Koblenz, with batteries of castles, vineyards and romantic villages. It thus comes as no great surprise that this bit of paradise on earth was so well-loved by the rulers of the Kingdom of Germany in the Holy Roman Empire that they wished to stay here even after death. The cathedral in Speyer has no less than eight German emperors and kings laid to rest in its vaults. The Romanesque cathedrals of the provincial capital Mainz and in Worms, the old abbey at Maria Laach and many other churches here powerfully mirror the thoughts and emotions of a bygone age. The oldest city in Germany is thought to be Trier, founded over 2,000 years ago by the Romans and in 285 chosen as the capital of the western reaches of their empire.

From Trier it's a stone's throw to the Saarland. For years this area was a political bone of contention for "arch enemies" France and Germany. It only became a more permanent part of Germany in 1957 by way of a plebiscite. The people here not only have an iron, steel and engineering industry which once held great significance for the area; into this nation between nations they have injected a strong dose of French savoir-vivre which has not only relaxed relations between the two countries but has also enriched the Saarland cuisine. Here there are restaurants which are so good you can spare yourself the trip to France.

The region was never a holiday resort in the classical sense of the word. Yet despite the former predominance of the coal and steel industry nature has managed to reserve a place for itself, such as in the impressive bend in the River Saar near Mettlach. And following the end

The Black Forest is a popular destination whatever the weather or season. Here there are still many of the typical long-roofed wooden farmhouses which were shared by the farmer's family and their livestock.

of the local "iron age", or rather an economic restructuring, many of the industrial strongholds have undergone a wonderful transformation, those in Saarlouis, Neunkirchen, Völklingen and elsewhere now home to museums or arts centres.

The capital of romanticism

In the romantic capital of Heidelberg there's a danger, according to a famous song, of losing your heart. Others see a greater threat of cardiac injury in the Black Forest. This range of low mountains, with its ancient pine forests and pretty villages, has earned itself a reputation as the almost perfect holiday destination. Even today things here are a bit different, the pace of life more leisurely and humane. Time hides in the wooden Black Forest clocks, waiting for the little door to open and a cuckoo to betray its whereabouts. Yet life in Baden-Württemberg can be led in the fast line; after all, this is where cars by Mercedes and Porsche are made. And where on Lake Constance scientists dabble in supersonic space technology.

A festival to beat all festivals

In Bavaria people don't always walk about in lederhosen and dirndls as the ads would have us believe. Yet at the Oktoberfest in Munich you're quite likely to find yourself surrounded by people sporting traditional dress – and drinking full-bodied beer to which the obligatory *Weißwurst* sausages must be consumed. The biggest public festival in the world takes on an added dimension by being staged in Munich. Its metropolitan flair is a mixture of Alpine *joie de vivre*, up-to-the-minute modernism and trend-setting chic. If you come to the Oktoberfest without looking round Munich, you'll have missed out. The same goes for Germany's city of dreams, Rothenburg ob der Tauber in Bavarian Franconia. It has survived since the Middle Ages unscathed, a greeting from another world.

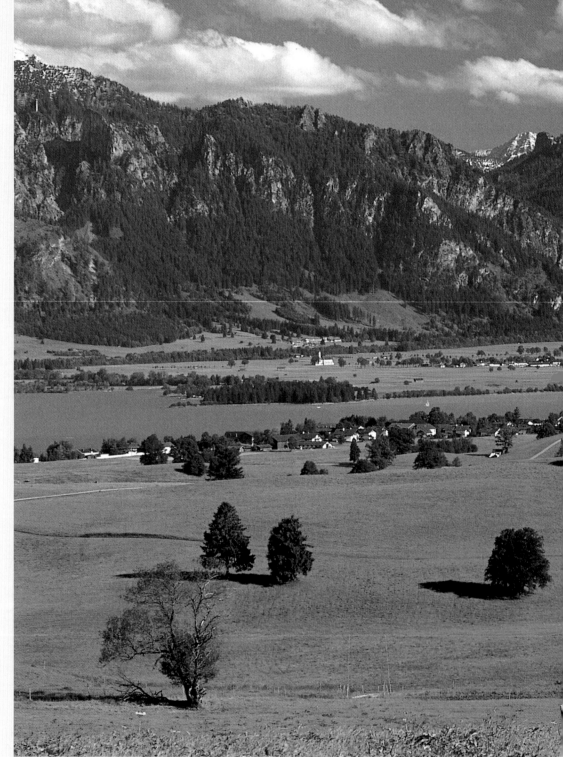

The lush, rolling hills of the Allgäu run from Lake Constance in the west to the River Lech in the east, with picturesque villages, historic towns and fairy-tale castles forming a glorious prelude to the peaked ranges of the Alps. Here, the view from Ussenburg of Rieden, the Forggensee, the Schwangau and Säuling.

Franconia was also the domain of the great German artists of the late Gothic and Renaissance. Among them were sculptor Veit Stoß and painter Albrecht Dürer, whose work and lives are inextricably linked to the imperial free city of Nuremberg. The altars and carvings of Tilman Riemenschneider, on the other hand, can be found both in and around Würzburg and in the delightful valley of the Tauber. Goethe for one was a particular fan of this archaic cultural landscape. He bought books, maps, coins and porcelain for his collections from Nuremberg and wine from Würzburg. And had Maria in his famous play *Götz von Berlichingen* knowingly proclaim: "Franconia is a divine land!"

Page 22/23:
The white chalk cliffs on the Baltic island of Rügen plunge straight down into the sea. Romantic artists and poets saw in them a sparkling white wedding dress for the union of sky and water, the ancient trees a nuptial bouquet in green.

Page 24/25:
In Frankfurt the only things which enter into a union with the sky are the buildings. The city on the River Main is – unmistakably – Germany's banking metropolis, home to the country's stock exchange and a centre of international trade.

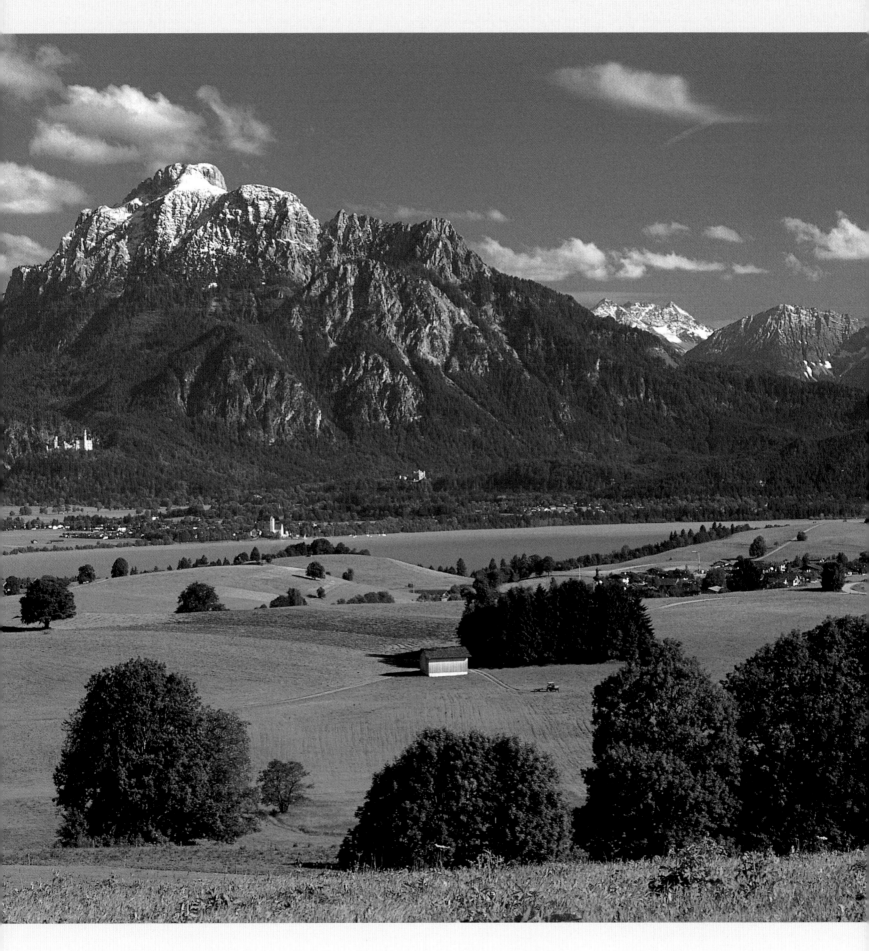

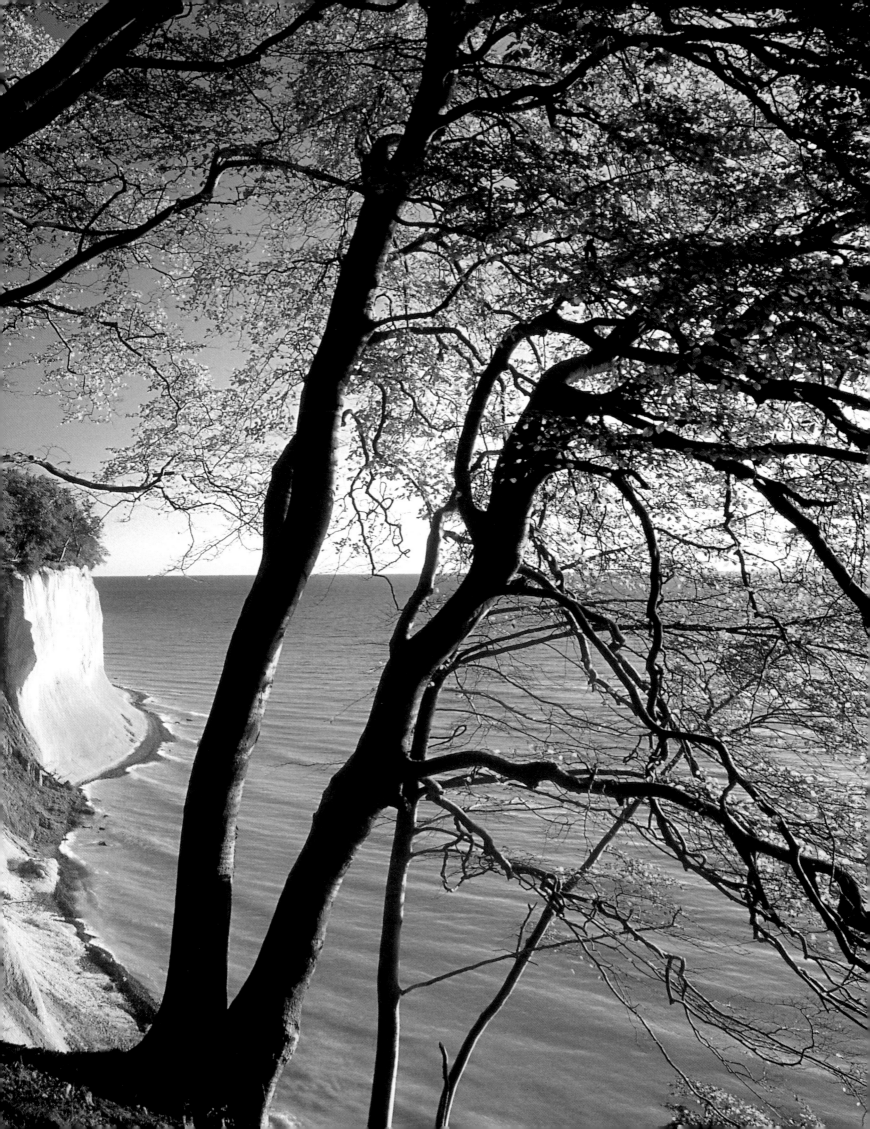

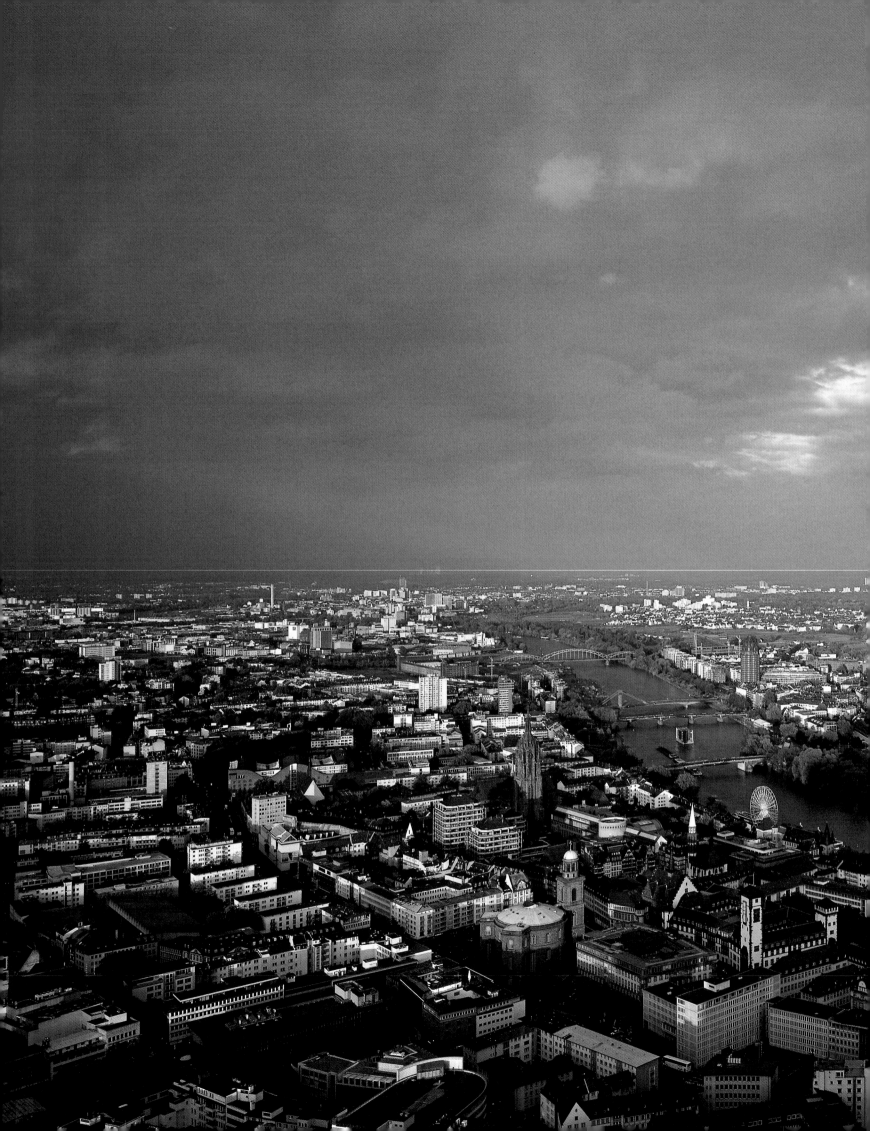

Flügger lighthouse on the island of Fehmarn. Schleswig-Holstein's only Baltic isle measures a mere 77 square miles (200 square kilometres) and lies directly between Central Europe and Scandinavia.

What kind of people choose to set up home in the middle of the mudflats of the North Sea? On tiny islands, whose names – Nordstrandischmoor and Süderoog – seem longer than the isles themselves. And where these flat, tiny strips of land are at such risk that buildings are erected on artificial hills, their inhabitants living on stilts.

It's said that a landscape moulds the people who live in it and vice versa. The inhabitants of Northern Germany, for example, are known as "fish heads", not in reference to their appearance but to their temperament. In difficult situations their motto is to wait and see, or, as they put it, to "wait and drink tea". They then roll up their sleeves and set to with a vengeance.

Over 100 years ago a tiny village in the moors around Bremen made art history. In Worpswede, painters such as Fritz Mackensen, Heinrich Vogeler and Otto Modersohn began exploring new avenues of artistic expression. They recreated the land and its people on canvas.

What the palette and paintbrush were to Worpswede, coal and ore were to the River Ruhr. The ground was turned into a giant Swiss cheese. The locals squeezed their homes in between enormous winding towers and factory buildings; work and leisure couldn't have been more closely interwoven. The giants of industry dwarfed the modest abodes of their employees, who furnished their houses with pride and panache, with miniature paradise gardens, with pigeon lofts and rabbit hutches in the shed. Life here has since changed but the local dialect remains in testimony to the past. The local word for miner is still used to describe anyone who's a friend or *Kumpel*.

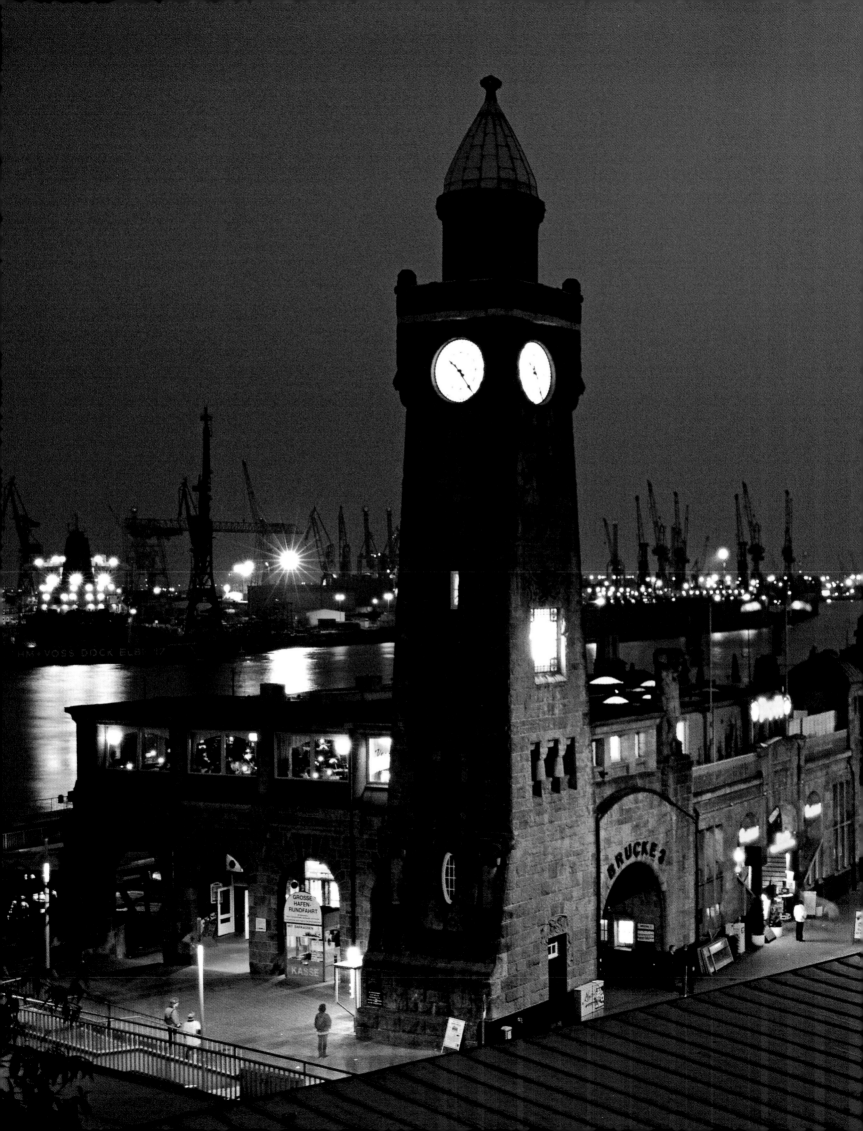

Page 28/29:
Landing stages at St Pauli. Acting as a bridge between the river and the open sea, these huge two-storey water stations, almost 2,300 ft (700 m) long, float on giant pontoons.

Below:
About every 10th job in the Hanseatic city of Hamburg is in some way still linked to the harbour, whose origins go back to the 12th century. The 'gateway to the world' is almost 33 square miles (85 square kilometres) in size.

Right and centre right:
Hamburg's container depot is among the top six in the world. Its state-of-the-art warehouses form a futuristic contrast to the Speicherstadt, erected in true Historicist style at the middle of the 19th century (centre right).

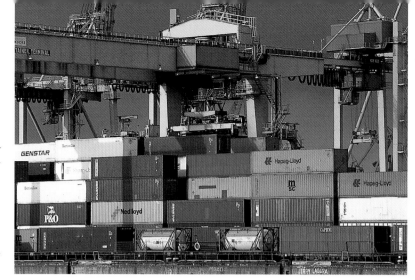

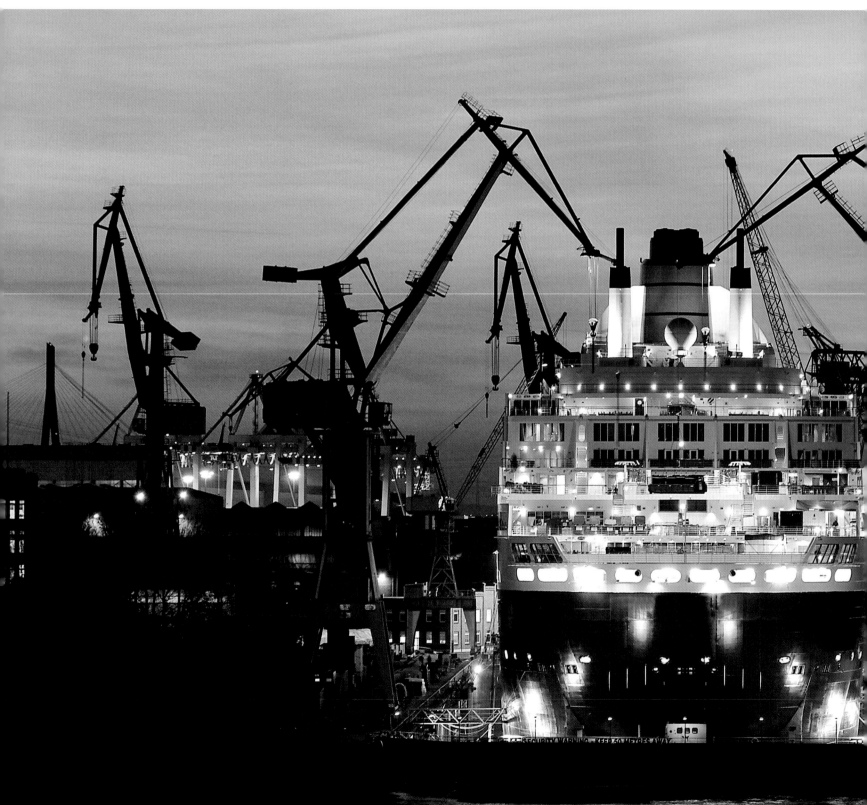

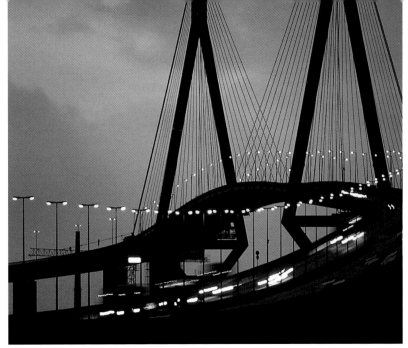

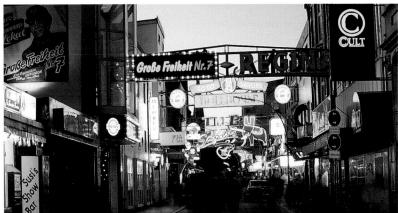

Top:
Minus its Köhlbrandbrücke, a daring, giddy construction 1,640 ft (500 m) in length which links the harbour to the hinterland, Hamburg traffic would come to a standstill. The bridge across the Süderelbe was built in 1973/74.

Above centre:
Originally set up for Hamburg's seafaring travellers, the red-light Reeperbahn has long been a centre of entertainment for sailors and landlubbers alike. The street name Große Freiheit ("great freedom") is a reminder of the privileges of 1611/12, to which the district of Altona owes its rise to prosperity.

Above:
The Davidwache at the corner of Davidstraße and Reeperbahn is probably the most famous police station in Germany, having had a starring role in a large number of films.

31

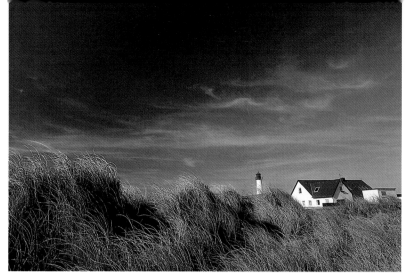

Below:
Once a commonplace affair, later relegated to the open-air museum, thatched roofs are coming back into fashion. Houses covered in this natural material aren't just for romantics; thatch also has a number of practical advantages.

Right:
As the name would suggest, the "elbow" is a narrow, curved peninsula which juts out into the sea at the northern end of Sylt. The sand dunes surrounding the Hook of East India are listed.

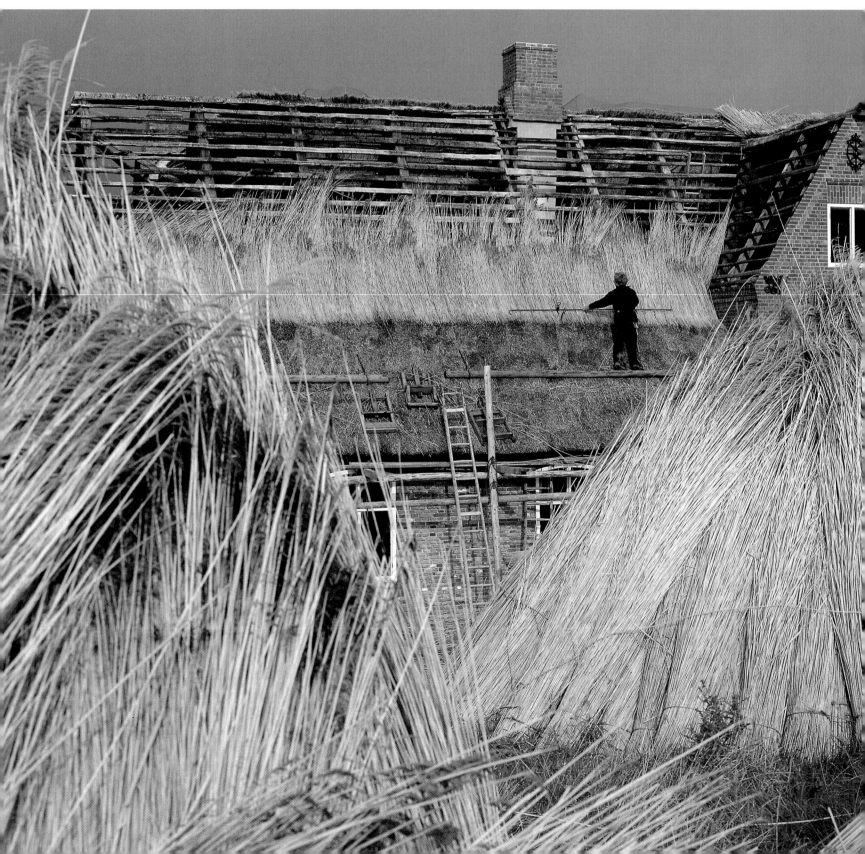

Top right:
In St Peter Ording the beach is over six miles (ten kilometres) long and in places almost 1,640 ft (500 m) wide. The North Frisian spa on the tip of the Eiderstedt peninsula is known far and wide for its unusual local sport: beach sailing.

Centre right:
Travemünde is one of the oldest, largest and most famous Baltic towns in Germany. Details of its 19th-century history and various anecdotes have been worked in the Thomas Mann novel "Buden-brooks". The beach today is around three miles (five kilometres) long.

Bottom right:
List is one of the seven resorts on Sylt, the largest and chicest of the North Frisian islands (38 square miles/100 square kilometres in surface area). Sylt's beauty lies not only in its beaches but also in its fabulous dunes, in the steep coastline of the red cliff and in the tranquil moorland encircling the villages inland.

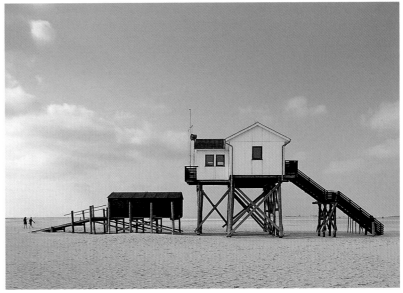

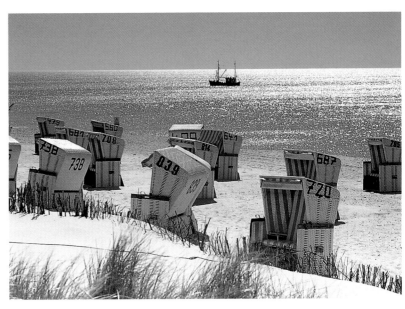

33

In the mudflats of Lower Saxony near Sahlenburg. This unique area of beach, which changes with the tides, was made a national park in 1986. Guided walks introduce you to the many amphibious life-forms which exist here.

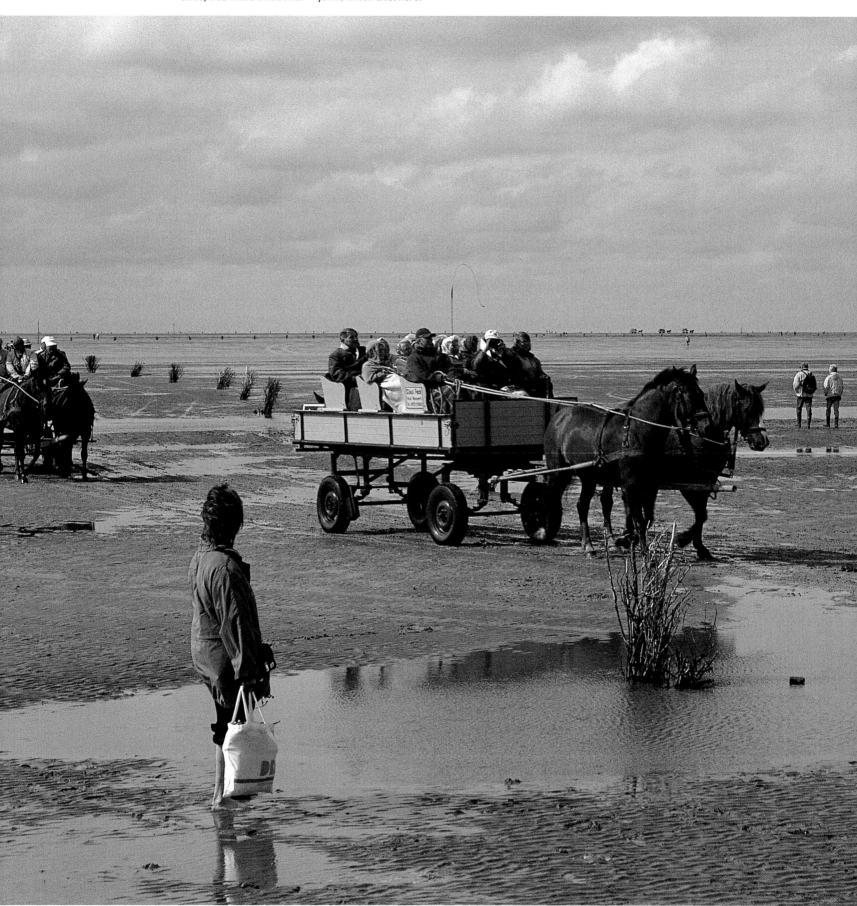

34

Until 1915, the lighthouse on top of the Pilsum dyke helped helmsmen navigate their ships safely into the Dollart from the Osterems and Westerems. Now an East Frisian landmark, the disused tower is painted red and yellow instead of the usual red and white.

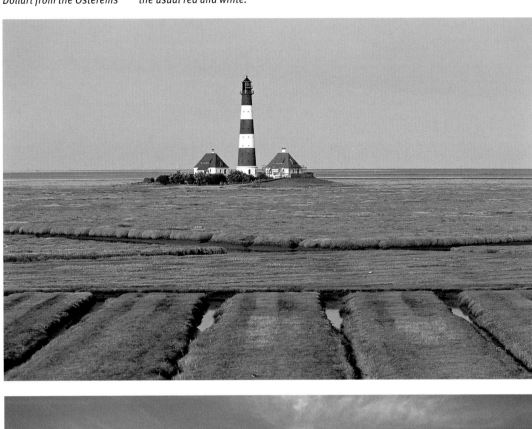

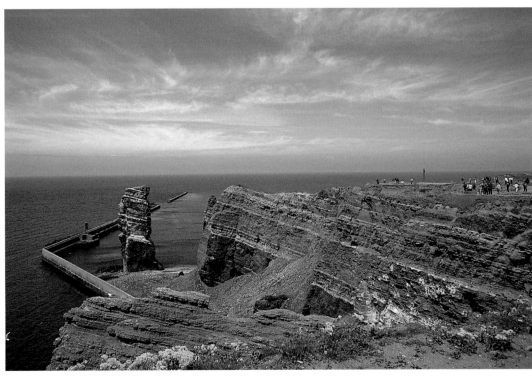

Above:

Helgoland, a crag island in the North Sea, is not even a third of a square mile (a square kilometre) in size, yet is a great tourist magnet. The coastal path along the top of the cliffs enables visitors to study the bizarre rock formations from above. Lange Anna, a free-standing obelisk formed by the sea, is the symbol of the island and was put under a conservation order in 1969.

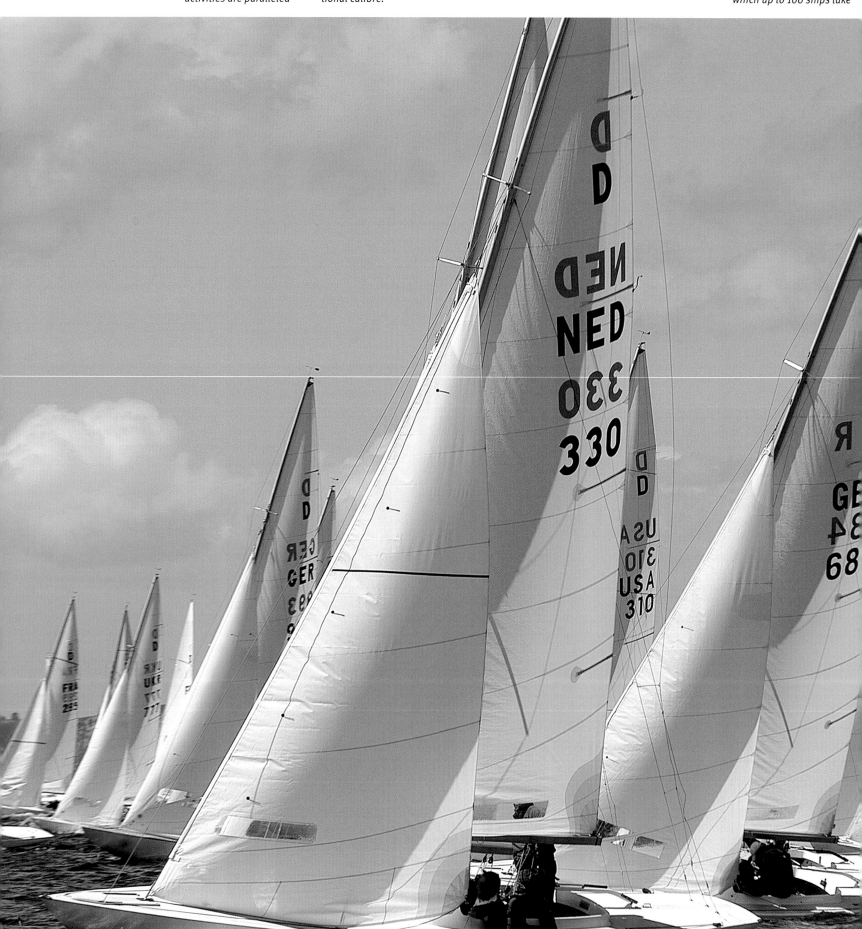

Kiel and its many visitors from all over the world have taken part in the Kieler Woche sailing regatta on the Baltic Sea each June since 1882. The sporting activities are paralleled by an extremely varied programme of top-class cultural events, making the Kieler Woche a summer festival of truly international calibre.

Top and bottom right: Over 2,000 boats and 5,000 sailors enter the Kiel regattas in every imaginable class of ship. The windjammer parade, in which up to 100 ships take

part, is just one of the week's highlights. The photo shows the Alexander von Humboldt which was launched in 1907 and is anchored in the harbour at Bremerhaven.

Centre right:
In keeping with Kiel's long tradition of regattas, in 1936 and 1972 the provincial capital of Schleswig-Holstein hosted the Olympic sailing contest.

Incidentally, there are plenty of yachts and sailing boats to see here all year round.

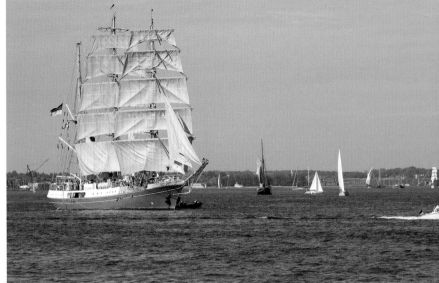

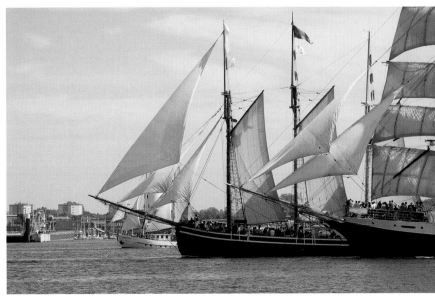

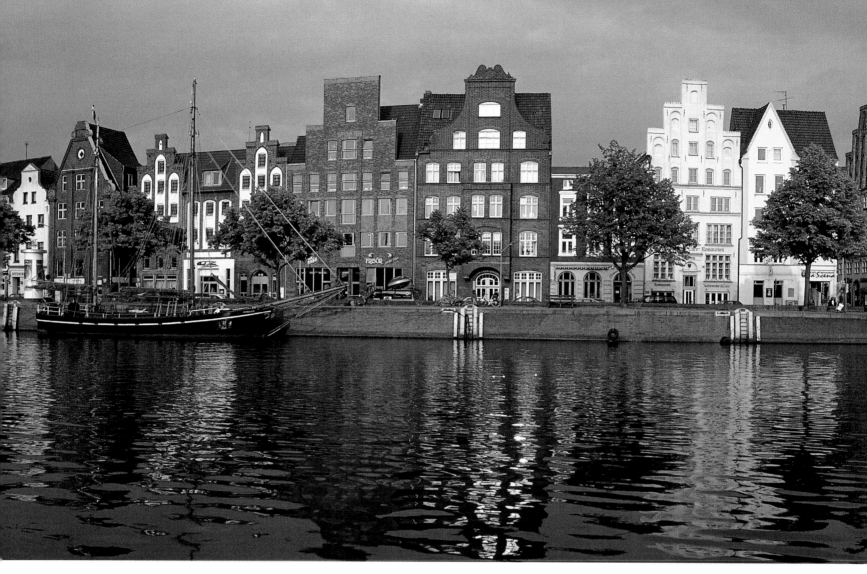

Above:
With its many old houses from the Gothic brick and Renaissance periods, Lübeck, once the 'queen of the Hansas', is one of Germany's most interesting cities. The above photo shows the Holstenhafen, around which merchant's residences and storehouses parade their splendid gables.

Right:
The irrefutable landmark of Lübeck, founded by Henry the Lion, is the 16th-century Holstentor. So many of the bricks were laid incorrectly when the gateway was built that it has subsided and now leans slightly to one side.

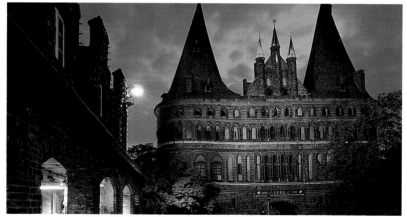

Right:
The Viking settlement of Haithabu dates back to the 9th century and even had its own mint. The remains of the site have been excavated and partly reconstructed, producing many finds which are on display here at the museum. The absolute highlight is the magnificent Viking longboat.

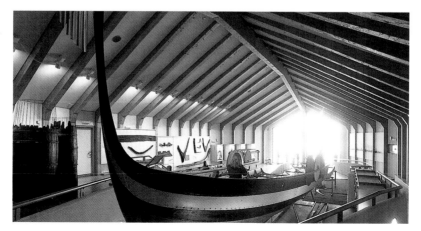

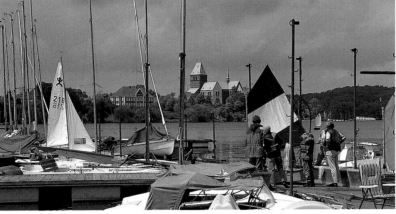

Page 40/41:
Bremen's market place, seen at its best. The huge stone figure of Roland (1404) symbolises urban independence from the rule of the archbishops.

Left:
The cathedral in Ratzeburg towers majestically above the town and harbour. The famous building, pre-Lübeck, demonstrates how simple bricks can be put to monumental use. The outstanding Romanesque edifice goes back to the duke of Lower Saxony, Henry the Lion, for whom Ratzeburg was his last place of refuge before he was banished to England in 1181.

Left:
The island of Fehmarn can boast two superlatives; it's not only the sunniest area in Germany, but also the one with the least rainfall. Among the 42 villages is Orth in the west of the island, shown here with its harbour.

Below:
Affluence came to the old port of Flensburg through its trade with the West Indies. The town experienced a boom from 1440 to 1867, when it was under Danish rule.

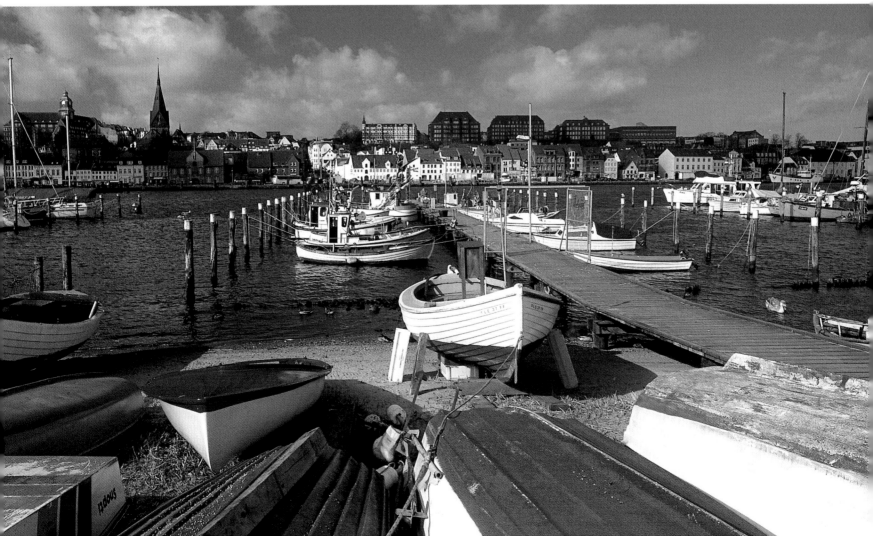

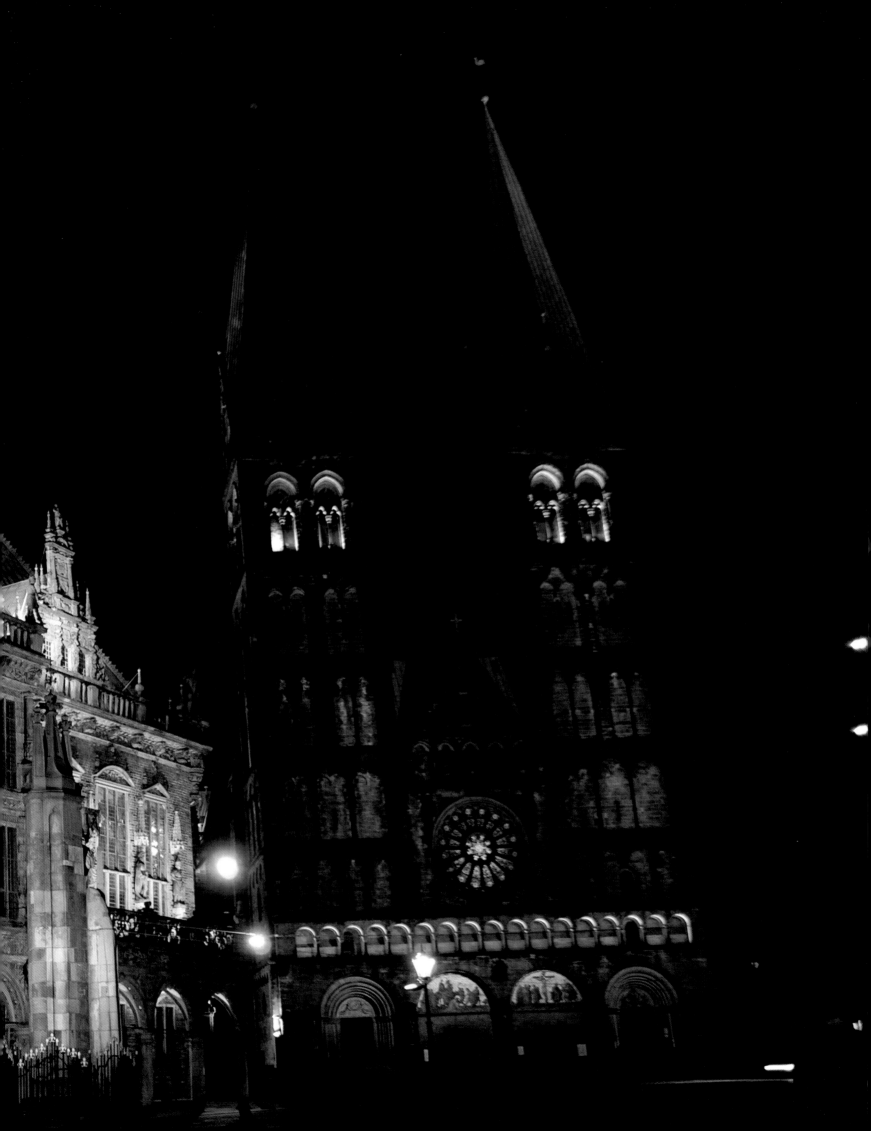

JOHANN WOLFGANG VON GOETHE AND FRIEDRICH VON SCHILLER

On November 7 1775 Goethe arrived in Weimar – and caused something of a sensation. Or rather, his clothes did. He was dressed like a parrot in his blue-and-yellow Werther suit, sported by the hero of his epistolary novel *The Sorrows of Young Werther* published the previous year. Far from disclaiming the autobiographical nature of his book, the author openly admitted to it, later saying that he let his unhappy, lovelorn protagonist die so that he could continue living.

Although Goethe had received a personal invitation to Weimar from 18-year-old Duke Karl August himself, to the courtiers and citizens of the minuscule royal capital he was the man they loved to hate. Bringing the bard to Weimar was, in their opinion, simply asking for trouble! Supposedly acting as chief educator to the prince, Goethe turned out to be wilder than the regent himself. One winter the young duke and his mentor strapped wooden ice skates to their shoes and skidded about on the flooded, frozen meadows along the River Ilm, spending more of their time prostrate than upright, much to the scandalised amusement of hundreds of onlookers.

Luckily for Goethe, he not only managed to curry favour with Karl August but also with a more mature, extremely influential member of the court, Charlotte von Stein. It's to her that credit must undoubtedly go for forming the Sturm-und-Drang poet in such a way that Weimar became not just an episode but the main chapter in his life.

Besides his antics at court, the "young wild one" also dabbled in politics. He quickly found himself elected to join the Secret Council, Weimar's government. Starting out as a mere counsellor to a legation of the council, the pinnacle of his political career was as the highest servant to the duchy – as head of government. His interests and hobbies were unbelievably manifold and interwoven. Not only did he make big politics in the little city of Weimar, introducing one top play after another to the stage; he was also a successful scientist. He discovered the intermaxillary bone in humans, published a *Theory of Colour* and made various other important contributions on geological and biological topics. Unlike many, he was capable of being productive in a number of diverse fields – and in many cases also proved himself a pioneer.

Goethe was naturally a very different character from Schiller. The latter wasn't invited to Weimar, but came to be near the man he admired in the hope that his idol might help and support him. Which he indeed did. 1794 marked the beginning of a close friendship between the two greats of German literature. Following a period as a history lecturer in Jena, Schiller settled in Weimar permanently in 1799. He and Goethe often met, discussed various subjects, got worked up about the same things and competed with each other with their plays. Their main venue was the theatre in Weimar, of which Goethe was director until 1816. He walked out when one of the duke's actress mistresses brought a trained dog onto stage to take on the main role.

Unlike Goethe, Schiller, who was plagued by constant ill health and financial worry, couldn't allow himself such affronts. He had to take whatever work came his way. In 1804, for example, when hereditary prince Karl Friedrich married Maria Pavlovna, daughter of the tsar of Russia, Goethe was first asked to pen an ode to the happy couple. Only when he refused was Schiller asked if he would compose a suitable piece.

Schiller's difficulties in Weimar didn't end with his death. He succumbed to a serious lung infliction on May 9 1805, but was buried three days later, one hour after midnight, at the cemetery of St Jacob's, in a communal tomb reserved for those who had no family grave of their own.

A good two decades later, when 23 skulls were excavated from the vault, the largest was thought to be Schiller's. In 2008 DNA analysis proved this wrong; the same went for his other bones. Schiller's coffin in the royal vault of Weimar, where Goethe's mortal remains are kept, will now have to stay empty.

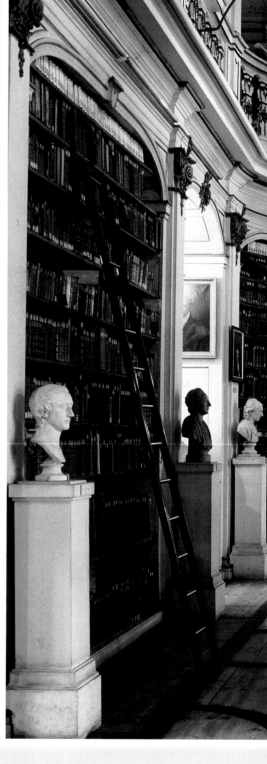

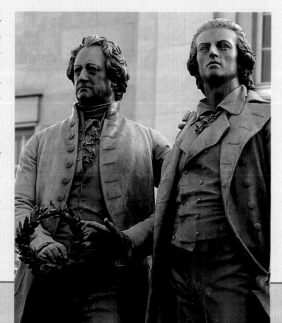

Left:
The statue of Goethe and Schiller in front of Weimar's national theatre was created by famous Saxon sculptor Ernst Rietschel in 1857.

Above:
The library in Weimar named after Duchess Anna Amalia holds the largest collection of classic German literature.

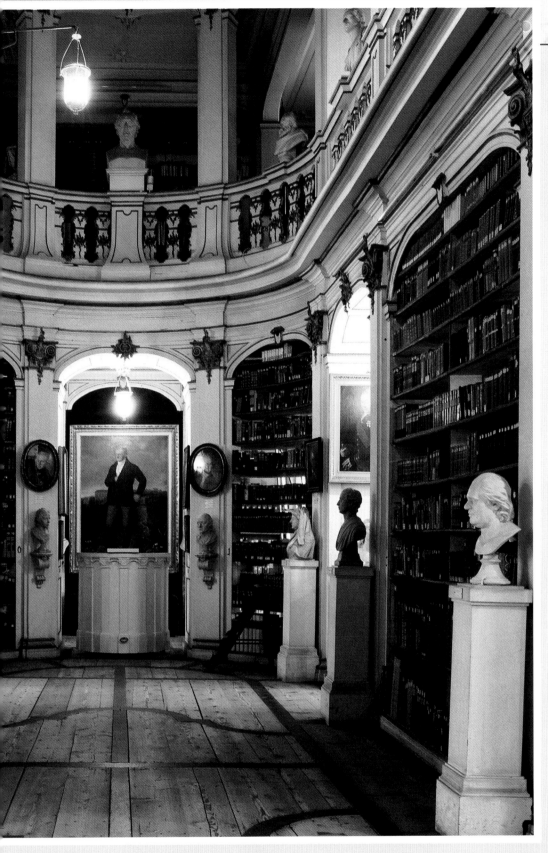

Johann Wolfgang von Goethe

August 28 1749: born in Frankfurt am Main.
Studies law in Leipzig, Frankfurt and Strasbourg (1770).
Here he meets Herder and the poets of the Sturm und Drang. First literary work back in Frankfurt. His novel "The Sorrows of Young Werther" makes him famous throughout Germany (1774).
1775: moves to Weimar at the invitation of Grand Duke Charles Augustus. He is soon involved in all major governmental matters.
1786–1788: flees the claustrophobic court of Weimar for Italy.
1788: first meets Schiller.
1790: "Urfaust" is published.
1791–1816: director of the theatre in Weimar.
1806: marries Christiane Vulpius, worker at a paper flower factory, with whom he has lived for many years.
1807–1833: his autobiography, entitled "Poetry and Truth," is published.
March 22 1832: dies in Weimar.

Friedrich von Schiller

November 10 1759: born in Marbach on the River Neckar.
1773–1780: studies law and from 1775 onwards medicine at the Karlsschule in Württemberg.
1782: after the premiere of his play "The Robbers" the young army doctor is now famous. Schiller seizes the opportunity to desert.
1789: made professor of history in Jena at Goethe's behest to secure Schiller a steady income.
1790: marries Charlotte von Lengefeld, an officer's daughter from Rudolstadt in Thuringia.
1791: his tuberculosis worsens.
1794: increased friendship with Goethe. Collaborates with him on the theory of literature and the writing of ballads.
1799: final move to Weimar.
May 9 1805: dies in Weimar. Schiller is particularly famous for his plays (the Wallenstein trilogy, "William Tell" and "Maria Stuart").

Left:
The Schiller National-museum in Marbach on the Neckar River fondly commemorates the town's greatest personality.

Right:
Goethe's study in his house on Frauenplan in Weimar. The poet wrote standing up at his desk.

Hanover, once the royal seat of the Welf dynasty (1636–1866), was granted its town charter in the 13th century. It was made the provincial capital of Lower Saxony in 1946. The fate of the community of 500,000 is determined at the Neues Rathaus on Maschteich. Much of the town's historic core was destroyed in the Second World War, allowing a more generous layout of the post-war buildings which replaced them.

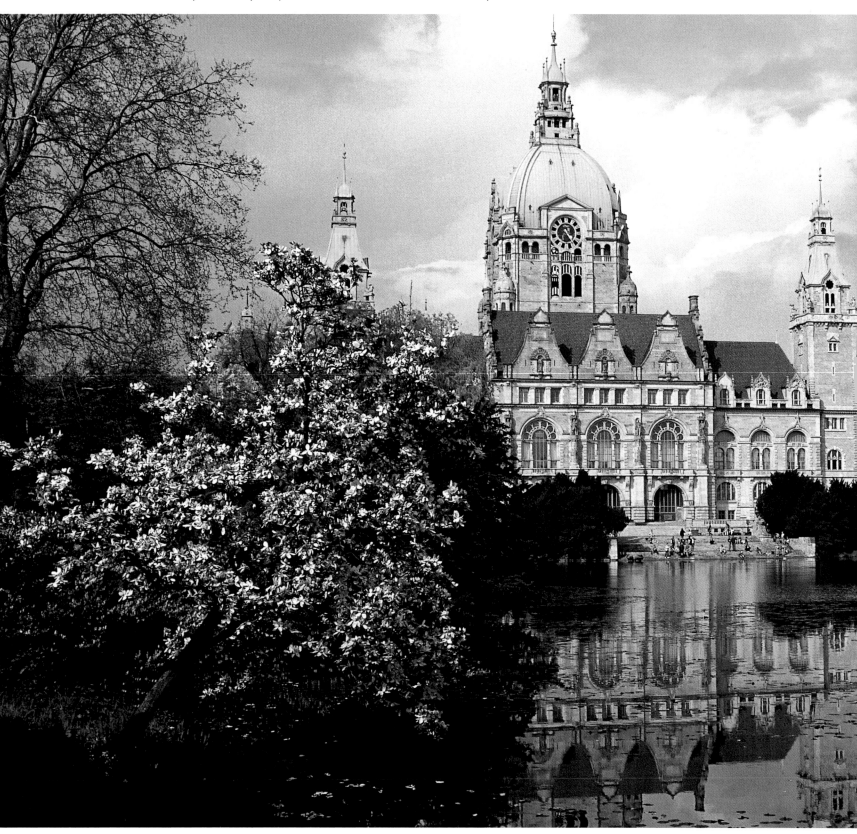

Right:
One of Hanover's greatest attractions is the baroque Großer Garten in Herren-hausen. Among the guests

of electoral princess Sophie (1630–1714) to stay at the palace were philosopher Leibniz and composer Handel.

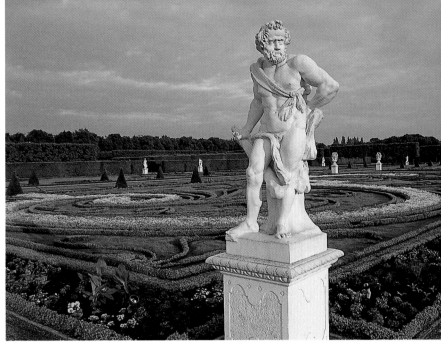

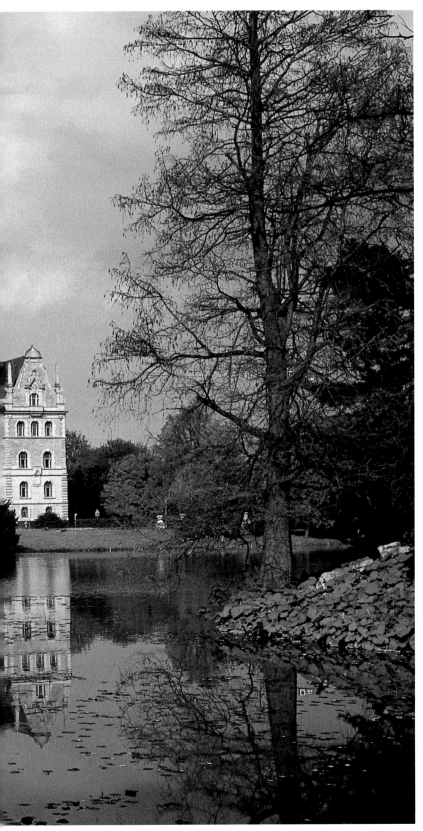

Above:
Wolfsburg is home to a strange combination: Volkswagen cars and the muses. The architecture of the art museum (1994) is as interesting as its contents. The glass canopy which spans the individual sections of the building seems to rest weightlessly on 18 slim pillars.

Left:
View of the conference hall at the Hanover trade fair, one of the largest major centres of business in the world. It not only attracts managers and bankers, but also many interested visitors.

45

The Elbe, Germany's second-largest river, rises in the Bohemian mountains and flows into the North Sea at Cuxhaven. It changes frequently along its course, shaping the countryside and the lives of the people it passes on its journey. Here the river runs through the flatlands of northern Germany.

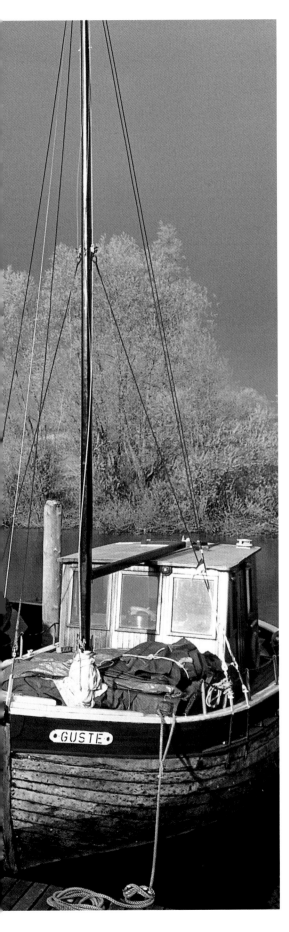

Below:
Sand, fine grass, juniper bushes, flocks of sheep and lonely farmsteads are the melancholy trademarks of the Lüneburg Heath between Hanover and Hamburg. The area was once covered in dense forest, felled to provide fuel for the fires salt-makers kept burning under their extraction pans. The heath could thus be said to be the work of man.

Above:
In bad weather or at dusk the heathlands seem eerie and almost threatening, making them a popular setting for tales of ghosts and murder. In the summer, however, when the heather is in full flower, glistening in the bright sunshine, the heath glows crimson.

Below:
Celle, on the southern edge of the Lüneburg Heath, is one of the old towns in Lower Saxony whose half-timbered buildings have been wonderfully preserved. The old town was laid out in the 14th century and extended in the 16th; the fine gabled house fronts all look out onto the street.

Right:
The cathedral at Hildesheim was founded in 872. Badly damaged during the Second World War, it was quickly restored to its former glory. Its Ottonian and Romanesque furnishings and the cathedral treasure are among the most valuable surviving works of medieval sacred art in Germany.

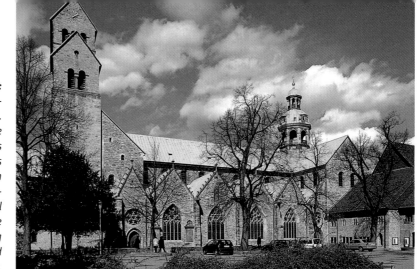

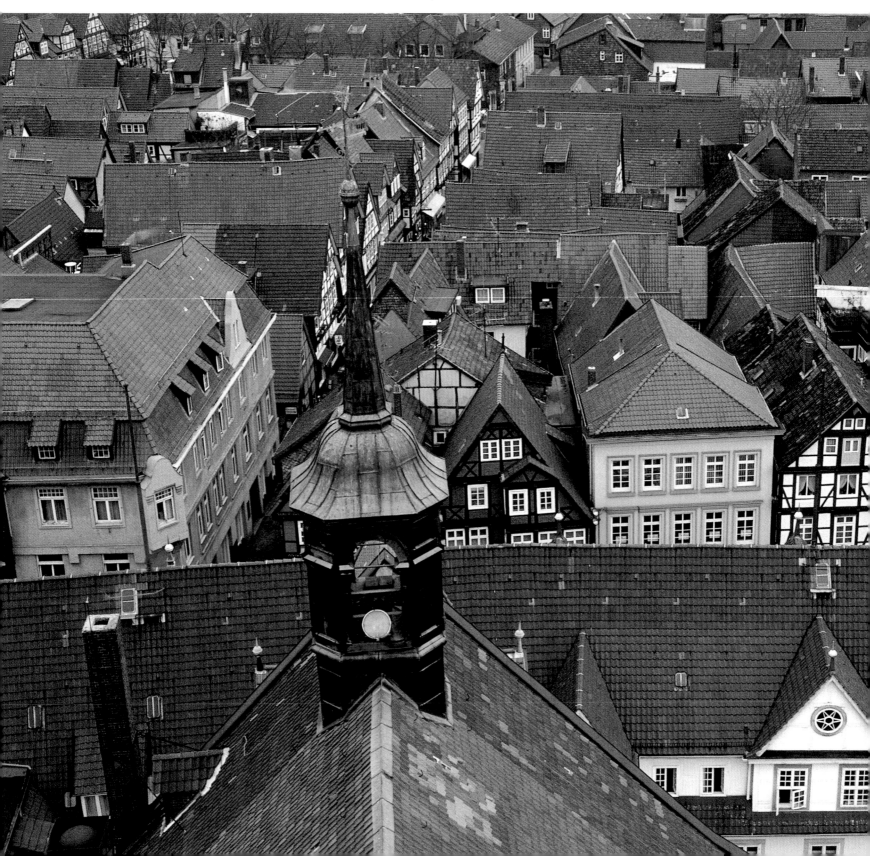

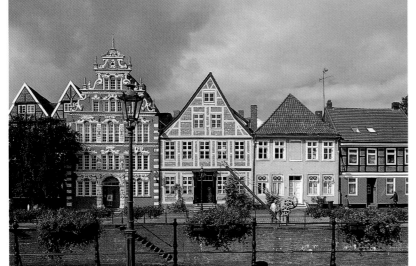

Left:
In the mid-12th century Stade was given the right to hold a market and a court of law and also to mint coins and levy tolls. A member of the Hanseatic League, it was the centre of maritime trade for southern Lower Saxony and the main market town in the Lower Elbe region.

Below:
To famed natural scientist Alexander von Humboldt, Hannoversch Münden was one of the most seven magnificently situated towns in the world. Located at the confluence of the Werra and Fulda rivers, the half-timbered array of the historic centre takes some beating.

Below centre:
Lüneburg is an old Hanseatic town on the northern reaches of the Lüneburg Heath. It survived the Second World War largely unscathed and unlike many of its northern German counterparts has thus kept its medieval centre.

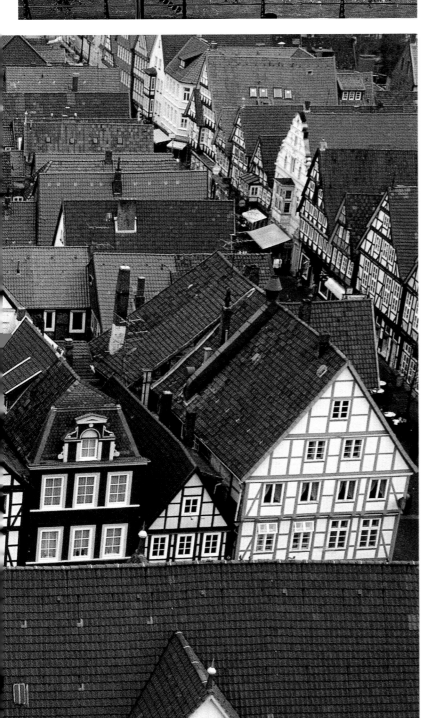

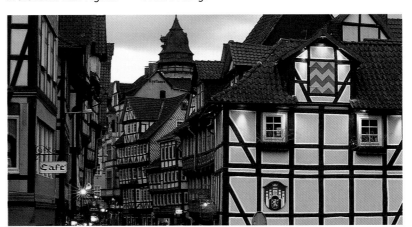

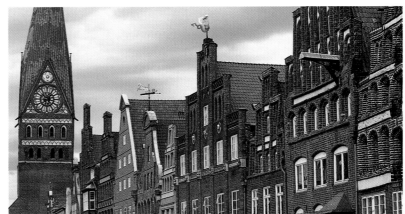

Above:
Barkenhoff in Worpswede belonged to painter Heinrich Vogeler, who with his friends and like-minded individuals transformed the old farm into the epicentre of the famous artists' colony.

Below:
The municipal art collection of the city of Bonn, capital of Germany for four decades, moved into this museum opened in 1992. The building's modern architecture is animated and vibrant, cheerfully defying the formalist cool of some contemporary structures.

Right:
The theatre in Düsseldorf was founded by Louise Dumont and Gustav Lindemann in 1904. The traditional company moved to its present location on Gustav-Gründgens-Platz in 1971.

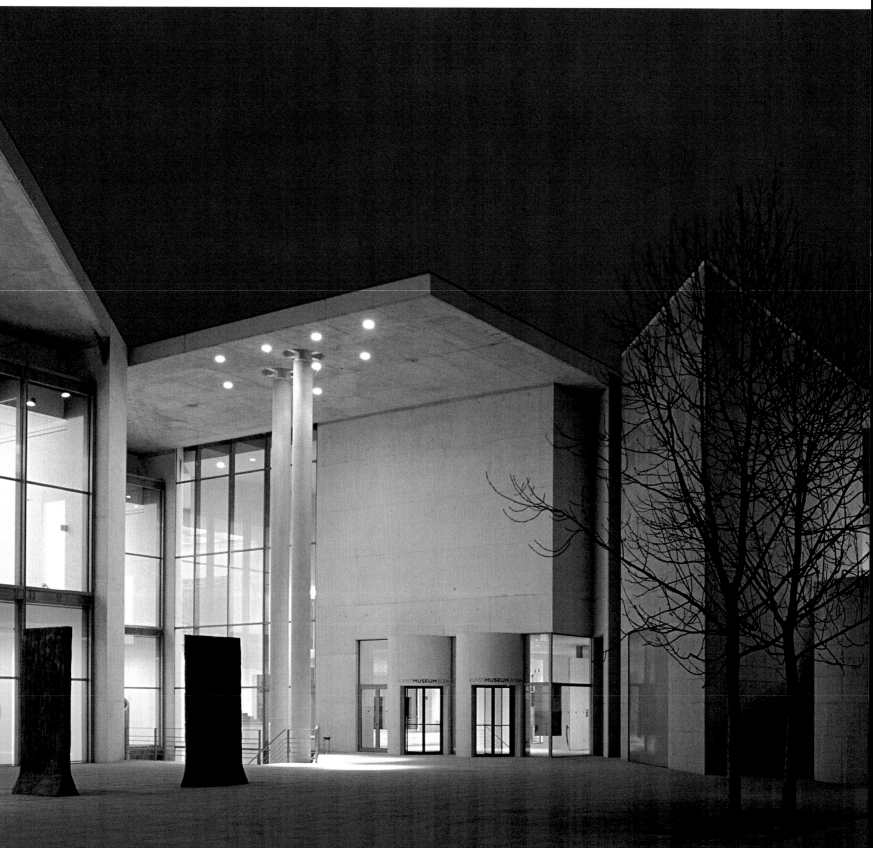

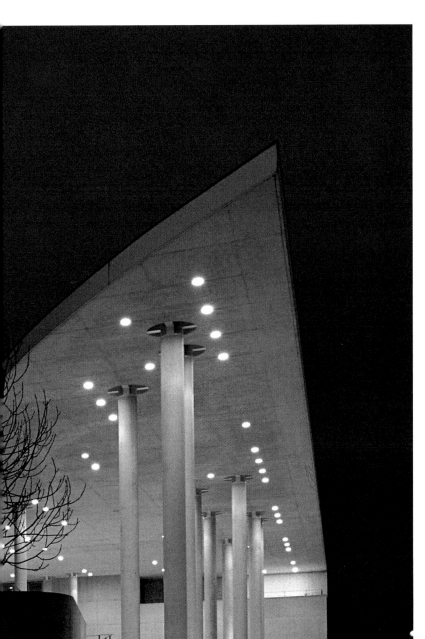

Below:
With one half convex and the other concave, the stairs at the art museum in Bonn have rightly been proclaimed an architectural masterpiece. Joining the foyer and rooms of exhibits, the construction is a real eye-catcher.

Below centre:
The new Design Centre of North Rhine-Westphalia in Essen used to be a mining company boiler house. English star architect Lord Norman Foster has managed to restore and convert the enormous complex to suit its new function in keeping with true Bauhaus tradition.

Bottom:
Essen was ruled by "canon king" Alfred Krupp. His Villa Hügel, built in the Ruhr hills near Bredeney from plans he had drawn up himself, was made over to a public foundation in 1953, which since that date has used the building as a centre for the arts.

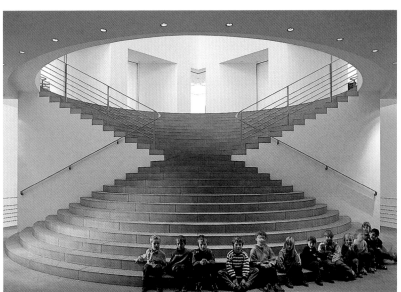

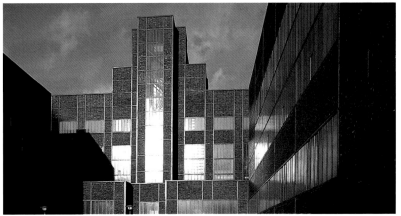

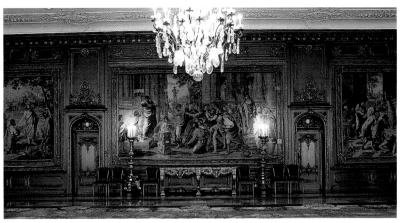

51

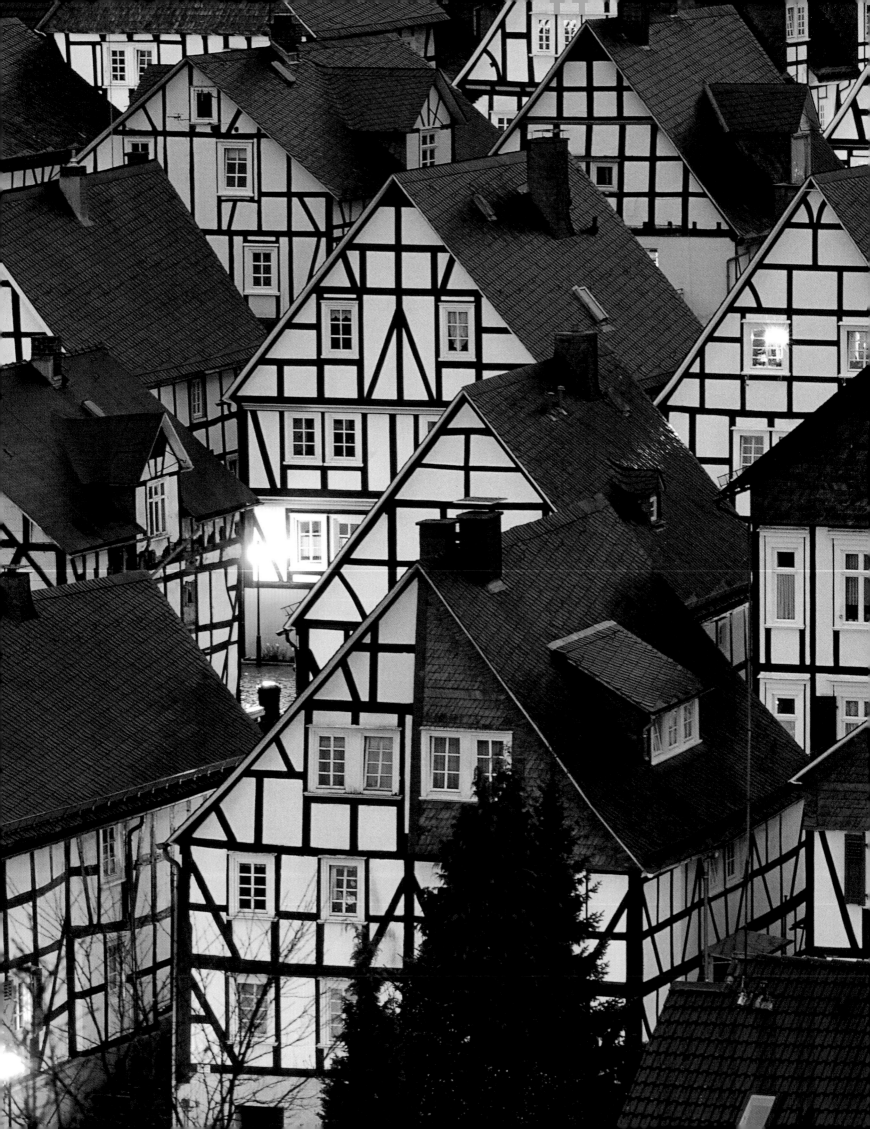

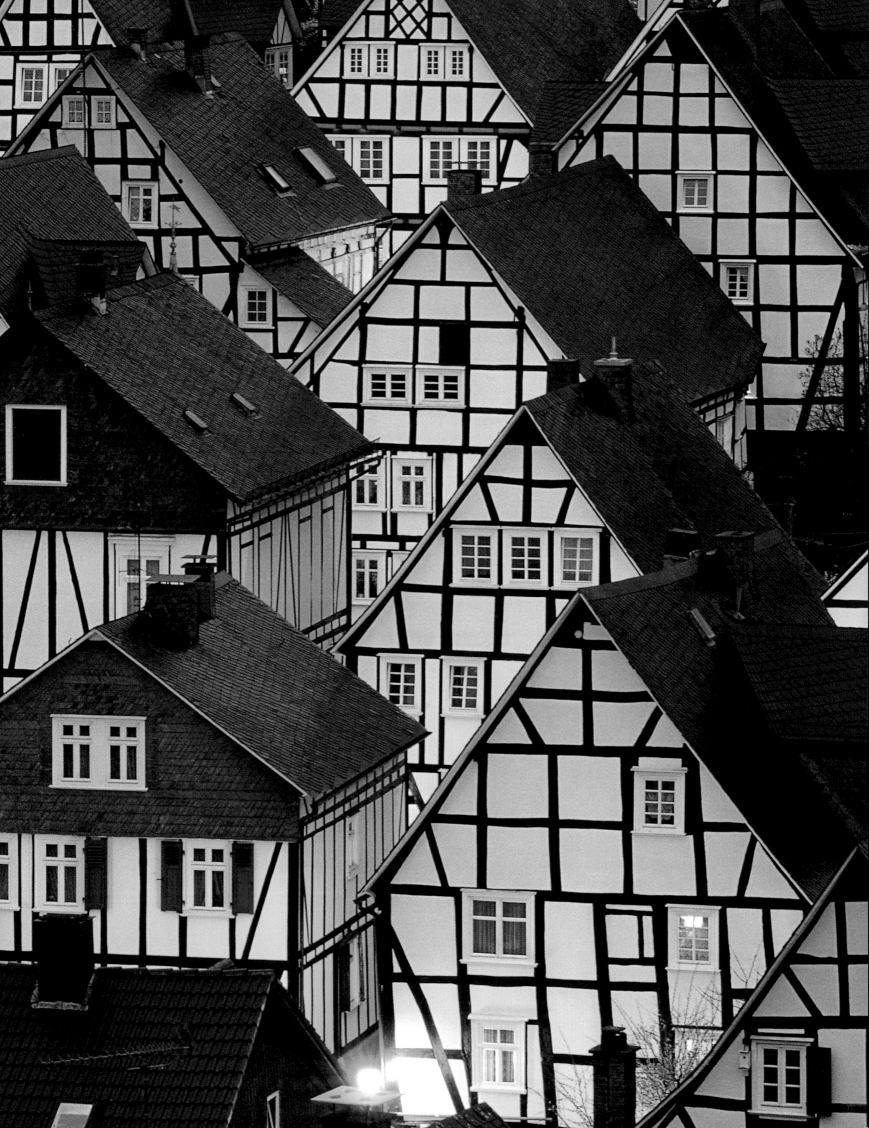

Page 52/53:
Roofs of bluish-grey slate and gleaming white facades criss-crossed with dark wooden beams are the traits of the old part of Freudenberg in the Siegerland.

Below:
Shrouded in legend and the subject of many different interpretations, the Externsteine near Detmold dominate the eastern reaches of the

Teutoburg Forest. This fabled cluster of rocks fascinates nature-lovers and mystics alike. The monoliths are known to have been an early place of heathen worship.

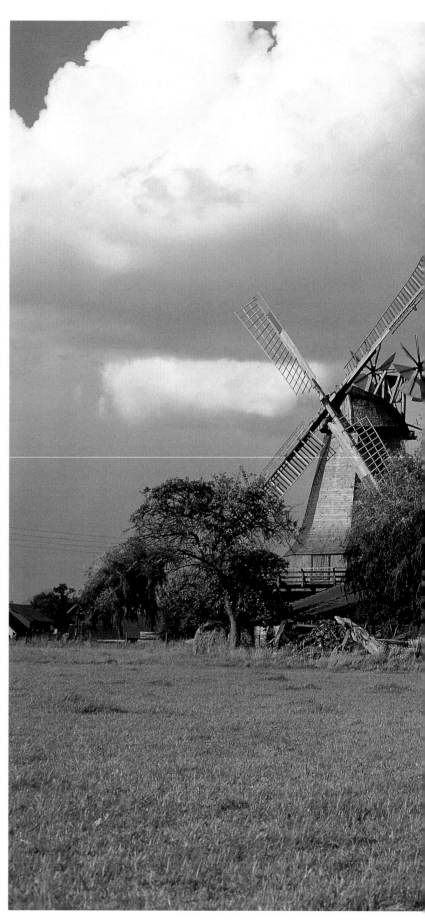

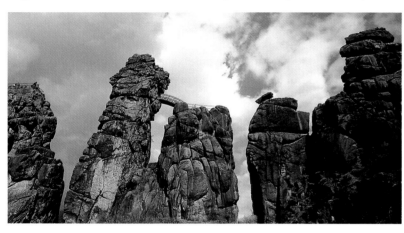

Above centre:
On the Lower Rhine at Xanten. The Rhine waterway was an important artery for the Romans who transported troops and goods along it. Their Colonia Ulpia Traiana later became Xanten.

Above:
The scenery along the Lower Rhine may not be as dramatic as that of the middle section of the river, yet it has its own persistent charm. Ancient meads

have remained, such as those near the Bislich islands, preserving the river's authentic character and providing sanctuary for a number of plants and animals.

For over 700 years the landscape of northern Germany was scattered with windmills, like the one here at Petershagen. Now very much a rarity, the creak of sails in the wind, turning heavy stones to grind the corn, is a thing of the past.

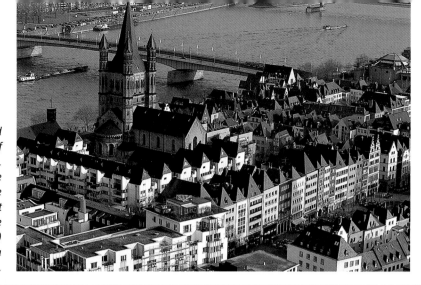

Right:
Even in the Middle Ages, Rhine metropolis Cologne was considered to be one of the largest and richest cities in the west. The development of both the town and its inhabitants has been guided by the river, whose floods have tested the patience and ingenuity of the people of Cologne for centuries. When the waters rise, the parts of town nearest the river (here the Alter Markt with the Romanesque church of Groß St Martin) can only be reached via makeshift footbridges.

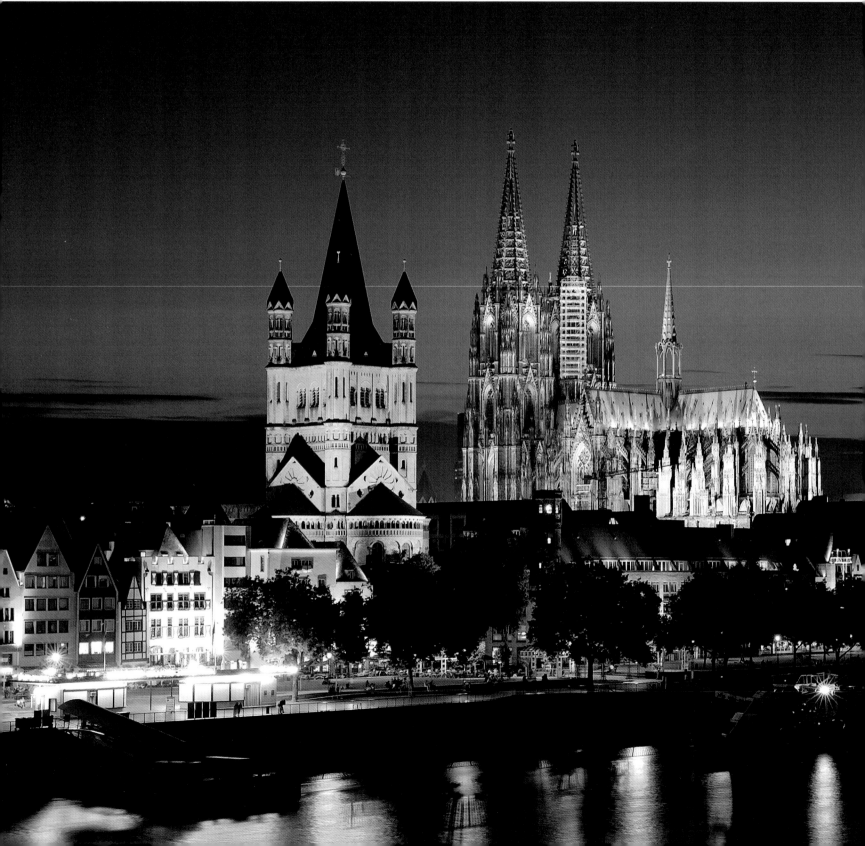

Below:

Even though it's considerably shorter than the television tower, Cologne Cathedral is indisputably the city's local landmark. Following 600 years of building activity, the largest Gothic church in Germany wasn't completed until 1880. Its lavish interior reflects the significance and power the diocese held in the area.

Right:

For a taste of that proverbial Rhineland joie de vivre, come to Cologne or Düsseldorf during Carnival. The highlight of the silly season is the procession on Rosenmontag before Lent – here in Cologne – when the whole town is out on the streets celebrating.

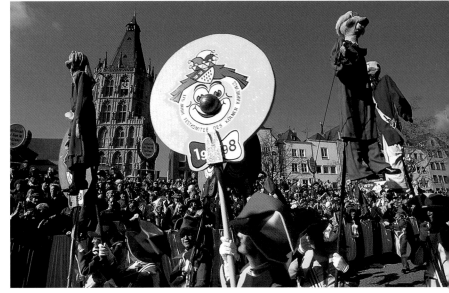

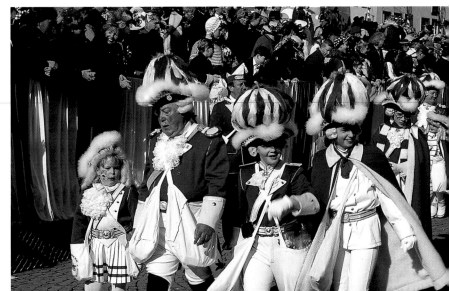

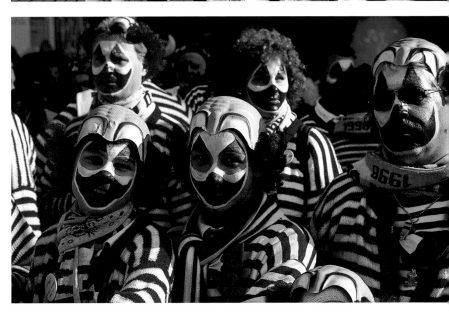

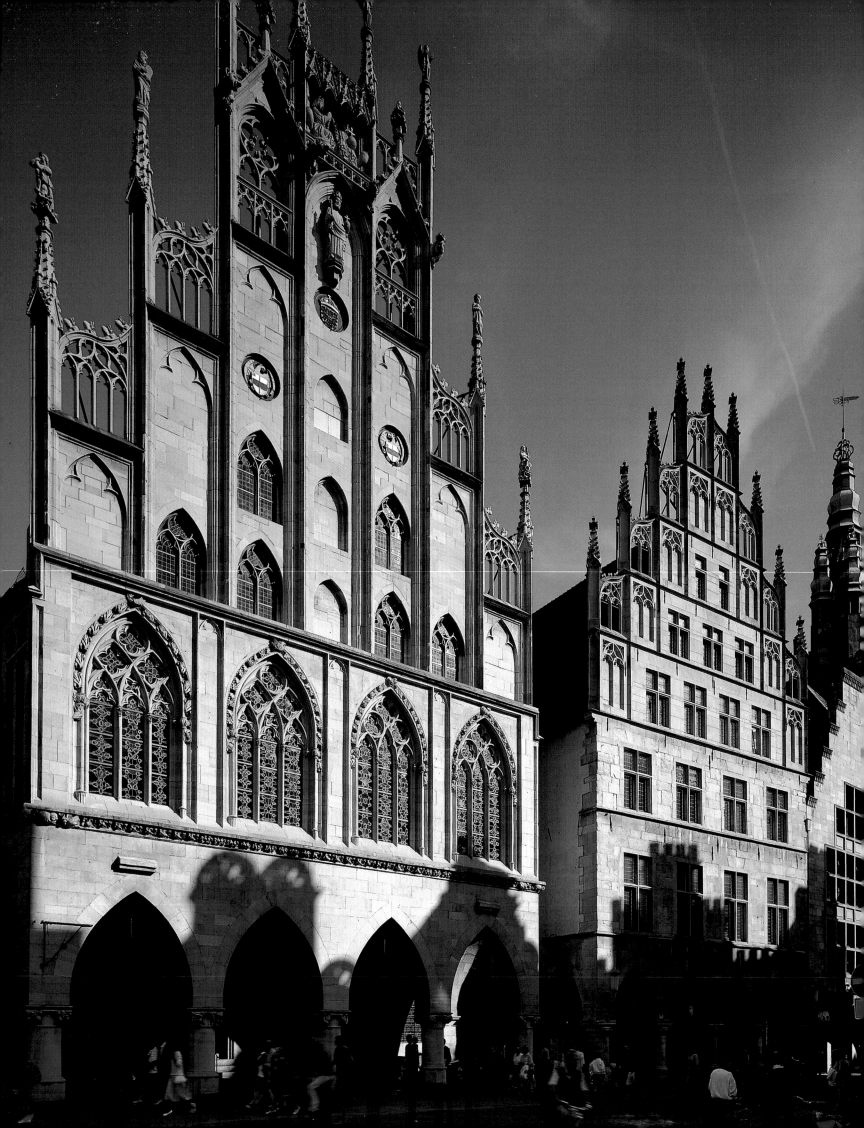

Left:
The old diocesan town of Münster. The historic heart of the city is said to be one of the most beautiful in Germany. The Gothic town hall witnessed the signing of the Peace of Westphalia in 1648, which brought an end to the Thirty Years' War.

Below:
Raesfeld is not just one of the most resplendent moated castles in Westphalia, but also a place of great historical importance. During the Thirty Years' War, field marshal to the emperor, Count Alexander II von Velen, turned the estate into an imperial centre of politics and the arts.

Below:
Haus Bodelschwingh is another of the many moated strongholds distributed around the Westphalian countryside. Where there were no hills or mountains to offer natural protection, water was used as a method of defence.

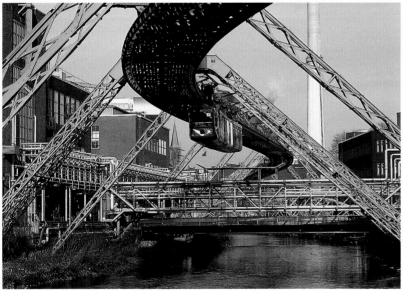

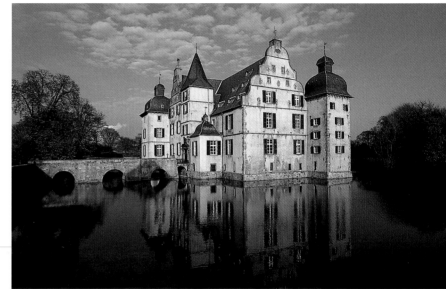

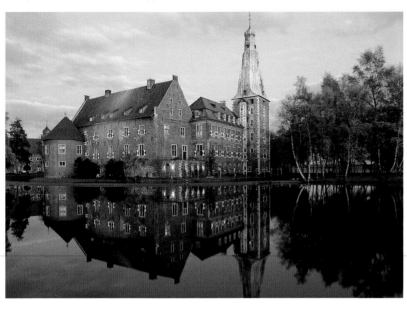

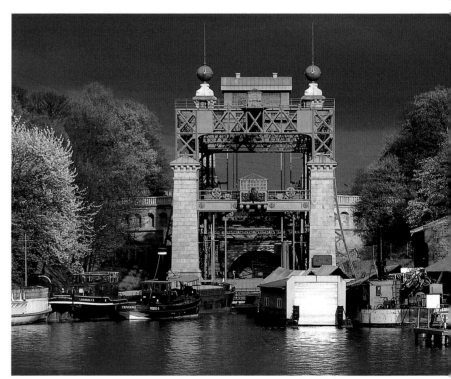

Above:
Wuppertal, in the Bergisches Land, is a city with a long tradition and an extremely unusual form of transport. Its futuristic suspension railway was installed in 1900 by engineer Karl Eugen Langen. Although the public transport system is now a century old, it still glides between the houses. "It may be old iron", say the locals proudly, "but it's not rusty!"

Above:
The first of its kind in Germany, built between 1894 and 1899, the ship hoist at Henrichenburg on the Dortmund-Ems Canal was in operation until 1962. It was used to lift ships from one level of the canal to another. The subject of great engineering interest, the plant can be visited as part of the Westphalian Industrial Museum.

From the Baltic Sea to the Rennsteig Ridge

Known as the "musical corner" of the Saxon Vogtland, the Musikwinkel jutting into Bohemia has absorbed the musical traditions of its neighbour. Markneukirchen and the surrounding villages are home to a number of instrument makers, often sought out by great virtuosi commissioning them to built the perfect violin.

Following the Reunification of Germany there was a lot of refreshing of geography to be done on both sides of the border. There was the wonderful architecture of the old Hanseatic towns of Rostock, Stralsund, Wismar and Greifswald to be discovered. Hymns of praise were composed for cobbled streets which elsewhere had been covered in tarmac, considered more suitable in the age of the automobile. The bone-shaking action of the suspension was a bit of nostalgia to be relished, as was the unique experience of passing under the leafy archways of ancient trees.

Today people are pretty familiar with both parts of Germany. They not only cherish the cobblestones but also the brand-new surfaces covering the many tourist trails devoted to a particular topic. One of these is the Silver Route which joins up the rich mountain towns of Saxony's Erzgebirge. During Advent, when snow dusts the fields and trees and carved decorations light up the windows, this effuses a very special atmosphere.

Those who prefer to travel on foot have also unearthed their own favourite bits of greater Germany. One destination which has attracted an especially large number is the Thuringian Forest and in particular its legendary mountain hiking route, the Rennsteig. First mentioned in 1330, its actual age is as much a mystery as why it exists at all. Along the 100-odd miles (168 kilometres) of the ridge you may not always be alone but you're always on top of the world. Literally. And, filled with a deep feeling of satisfaction and of being at peace with everyone and everything, also spiritually.

Below:
Stralsund in Mecklenburg-West Pomerania shouldn't be missed! Its joining of the Hanseatic League in 1293 marked the beginning of several hundred years of success and prosperity, the architectural legacy of which includes over 400 listed historic buildings. Here Altefähr.

Right:
Caspar David Friedrich, the famous Romantic artist, often chose the ruined Eldena monastery near his native Greifswald as the subject of his paintings. The former Cistercian abbey was founded in 1199 and played a leading role in converting West Pomerania to Christianity.

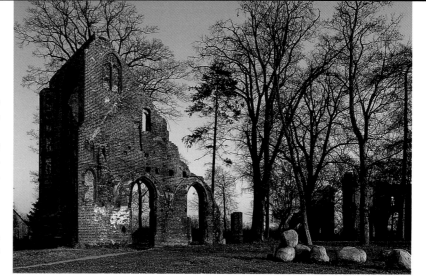

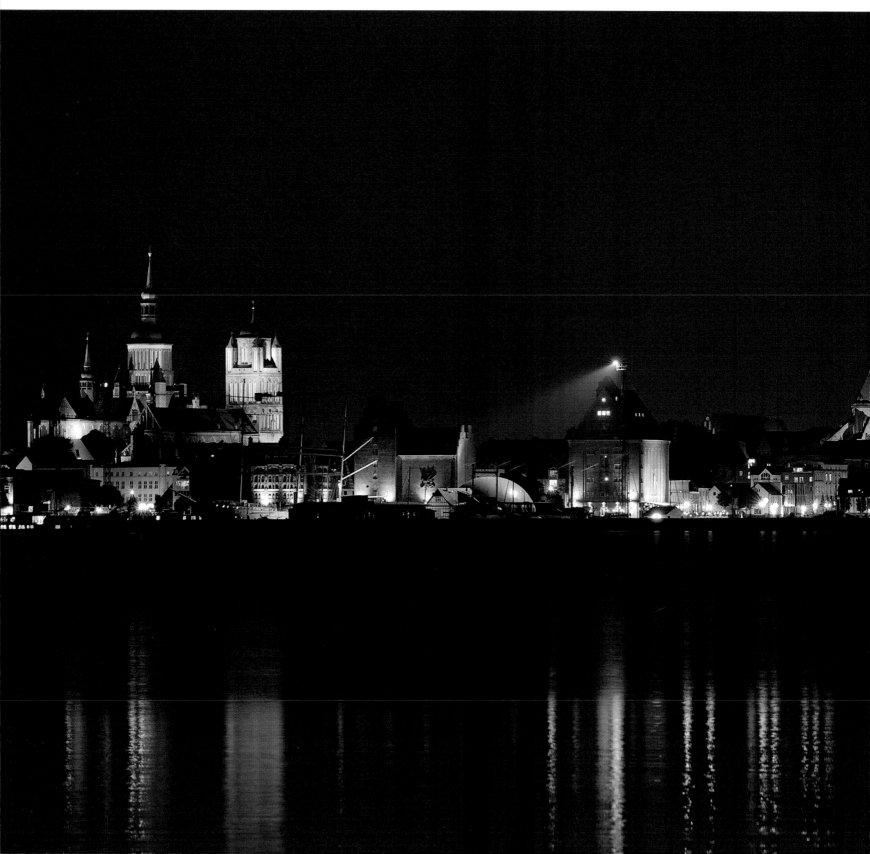

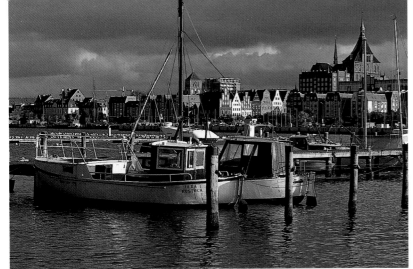

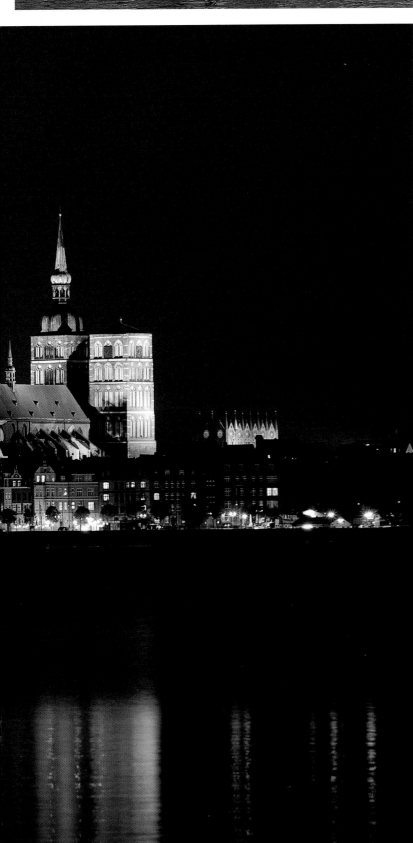

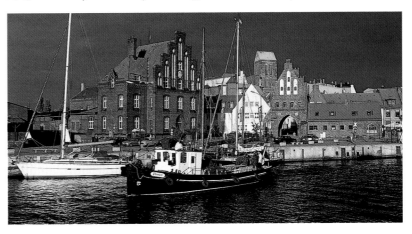

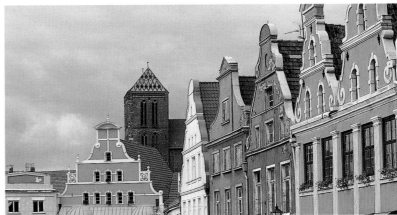

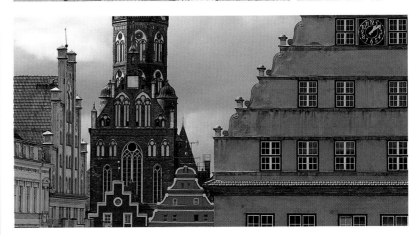

Below:
The island of Rügen is one of the most popular holiday resorts on the Baltic coast. The amount of water which has penetrated the land and vice versa is so great that no town or village is further than five miles (eight kilometres) from the coast. The fishing village of Baabe (its beach is shown here) is one of the resorts which has only fairly recently joined the ranks of the spa towns.

Right:
Twin lighthouses on Kap Arkona. The smaller of the two was erected in the neo-Classical period and is the work of none other than famous Prussian architect Karl Friedrich Schinkel. From here it's a mere stone's throw to the much-admired chalk cliffs which drop down a sheer 164 ft (50 m) into the swirling sea.

Far right:
The restored pier in Sellin shines brightly once more. The fishing hamlet, nestling between the southern slopes of the Granitz and Selliner See, was unheard of until 1895, when the first guests arrived here on the narrow-gauge railway.

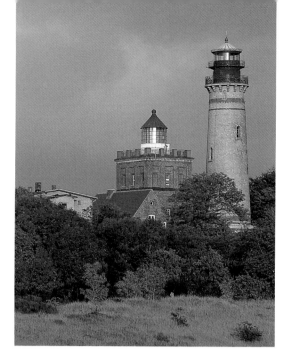

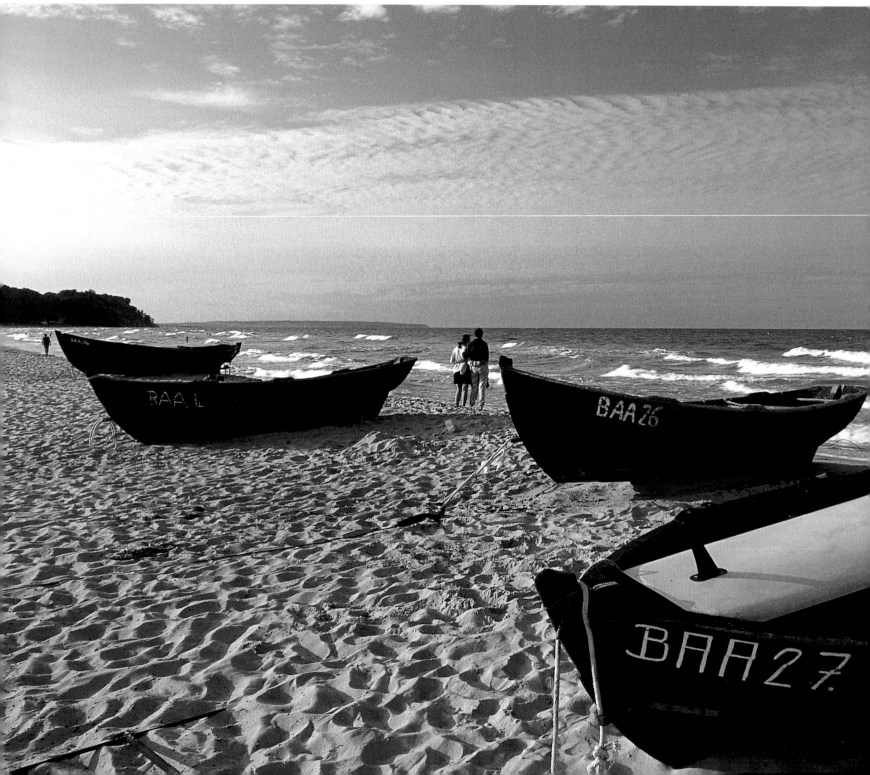

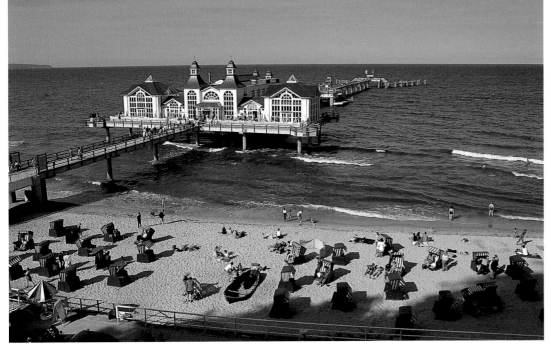

Below:
The Kaiser Wilhelm Hotel and Villa Germania are just two of the buildings in Bansin which have finally awakened from a long, deep sleep. The much-frequented resort on the Baltic coast is in the east of Usedom and, like its neighbours Heringsdorf and Ahlbeck, has a fine sandy beach.

Below centre and bottom:
The first tourist to visit the little fishing village of Ahrenshoop on the Darß peninsula in 1880 was a painter. He couldn't have imagined in his wildest dreams that so many would follow him here. The artists' colony dates back to the turn of the 19th century and is still patronised by famous names in art and literature.

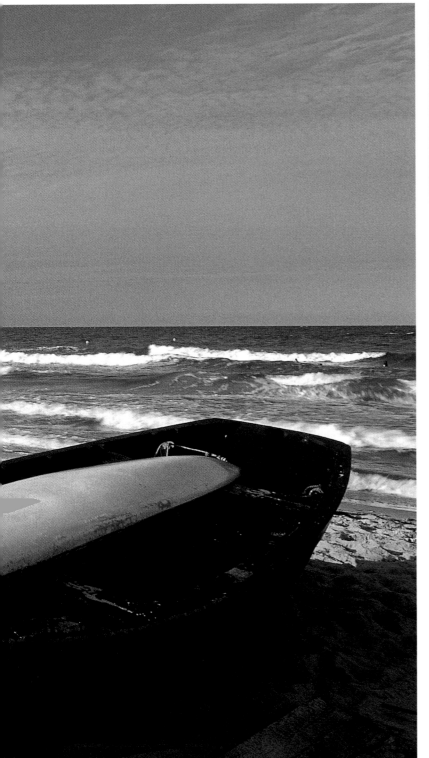

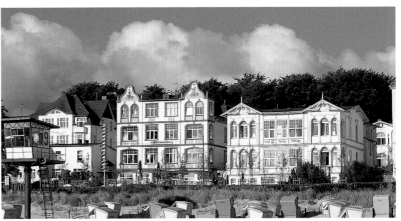

The spacious grounds and palace of Schloss Sanssouci in the old Prussian capital of Potsdam are an absolute must. In the middle of the 18th century, King Friedrich II took the planning of this masterpiece of Frederick the Great Rococo into his own hands, proving with the sumptuous palace interiors and gardens that he wasn't just a man of war but also one of artistic ability.

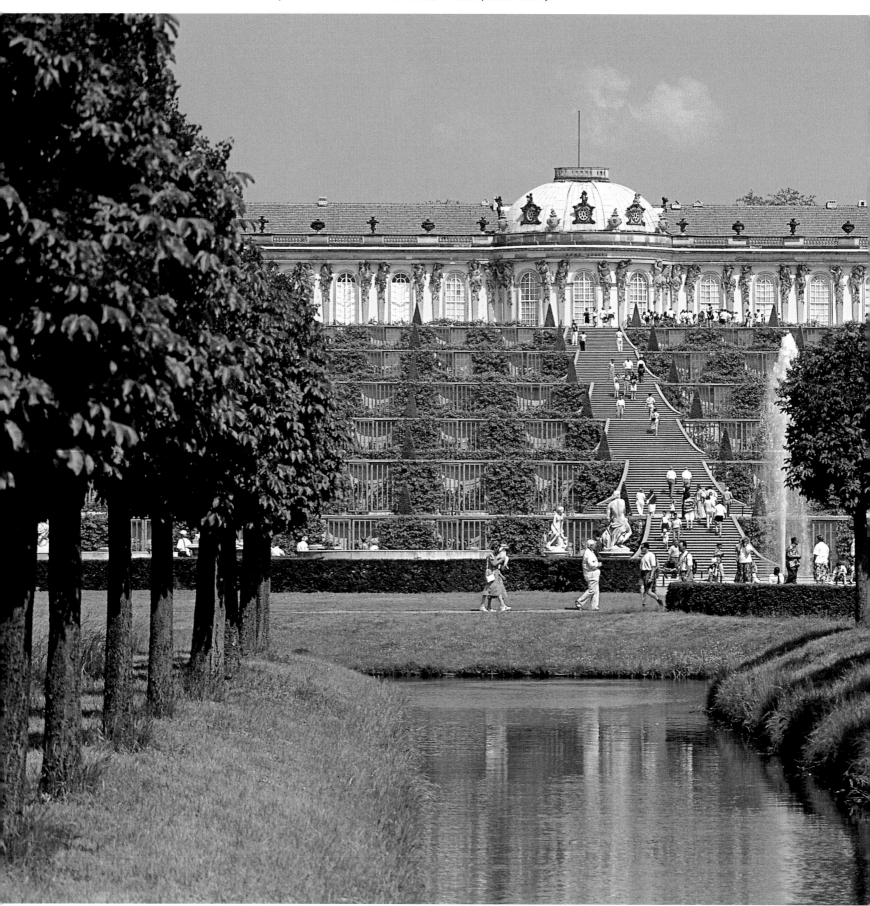

Below:

Following Germany's expansion eastwards, the first German city east of the Elbe was Schwerin, quickly becoming the seat of the local count in 1167 and a diocesan town in 1171. The residence of the dukes of Mecklenburg, preserved in all its finery, was modelled on Chambord in the Loire Valley and built between 1843 and 1857. The plans were provided by a number of famous contemporary architects, among them Gottfried Semper.

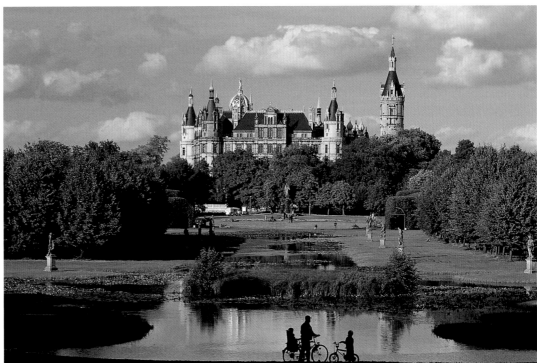

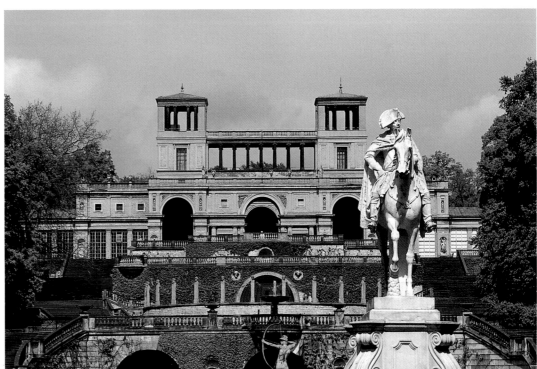

Above:

The new orangery at Sanssouci is the result of an artistic dream harboured by King Friedrich Wilhelm IV, an expression of Germanic longing for Italy. The orangery quotes buildings of the Italian Renaissance, one example being the Villa Medici in Rome, and was constructed from 1851 to 1857.

Below:
The little town of Werder, situated on an island in the River Havel, is known for its orchards and fruit wine. The blossom on the fruit trees is celebrated at a special festival here each May. In keeping with its local produce, the church has a wooden depiction of Christ pressing fruit.

Below centre:
The leafy waterways between Lübbenau and Lehde are the roads of the Spree Forest, an area dominated by water. The unrivalled biotope of the Spree Delta is, however, slowly bursting at the seams. The flood of visitors wanting to be punted along the tree-covered canals in traditional flat-bottomed boats, at least, is proving too great for the region to cope with.

Bottom:
Theodor Fontane is the poet of the Mark Brandenburg. There are still plenty who follow his "Walks through the Mark Brandenburg" which he notated in the travel journal of the same name. His native town of Neuruppin erected a monument to him in 1907.

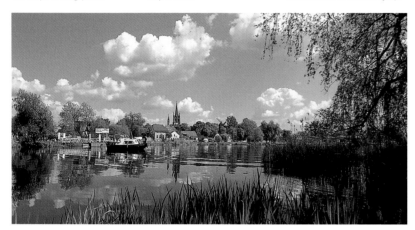

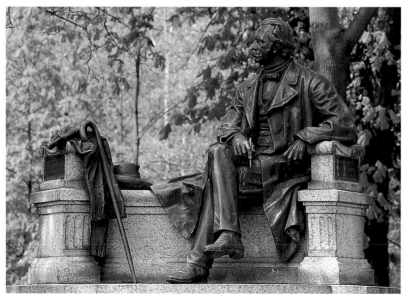

Schloss Branitz lies just outside Cottbus. The building, embellished by Gottfried Semper, is girdled by an elegant park designed by the owner of the palace, Prince Hermann von Pückler-Muskau. The famous landscape gardener is laid to rest in his park in a pyramid of earth, surrounded by water.

Page 70/71:
The Reichstag was built from plans by Paul Wallot between 1884 and 1894. Following its redevelopment by Lord Norman Foster it was reopened as the seat of German government in 1999.

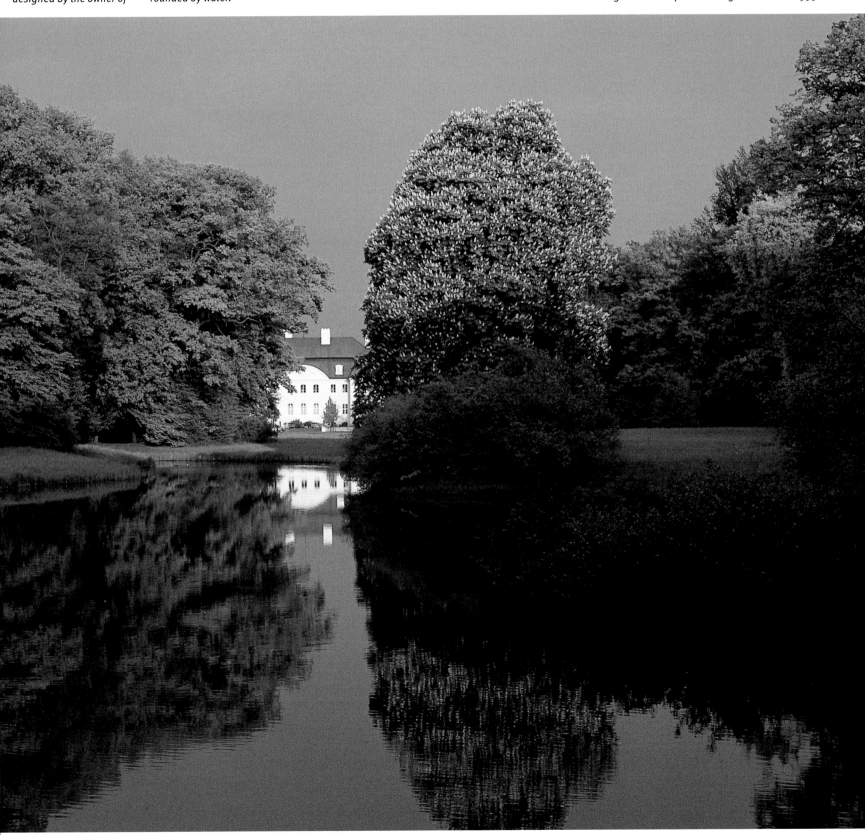

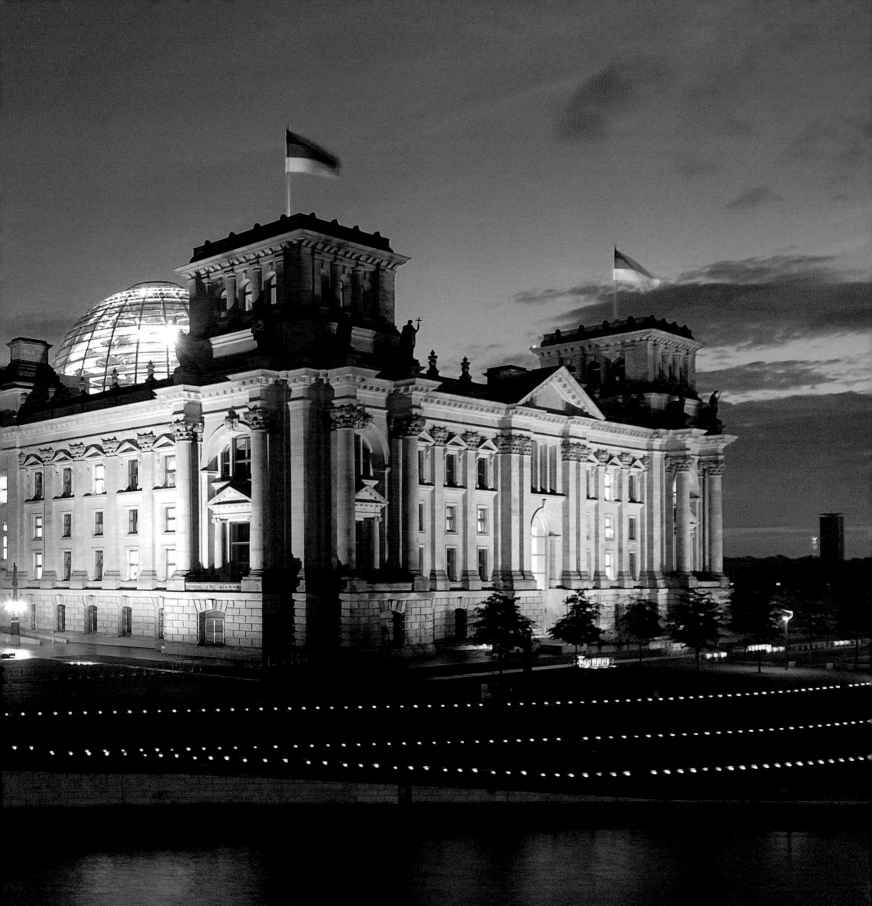

Below:
Schloss Charlottenburg, built by King Friedrich I at the end of the 17th century for his wife, Charlotte, is the perfect architectural embodiment of the absolutist Prussian conception of the state.

Right:
The Memorial Church to Kaiser Wilhelm on Breitscheidplatz was built at the end of the 19th century and badly damaged in the last world war. The remains, known as the "hollow tooth", were integrated into the new church, built between 1959 and 1963.

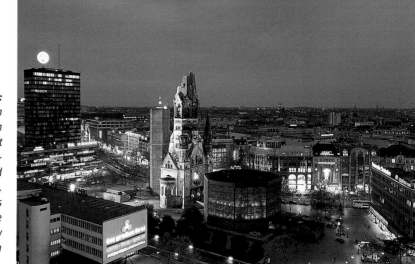

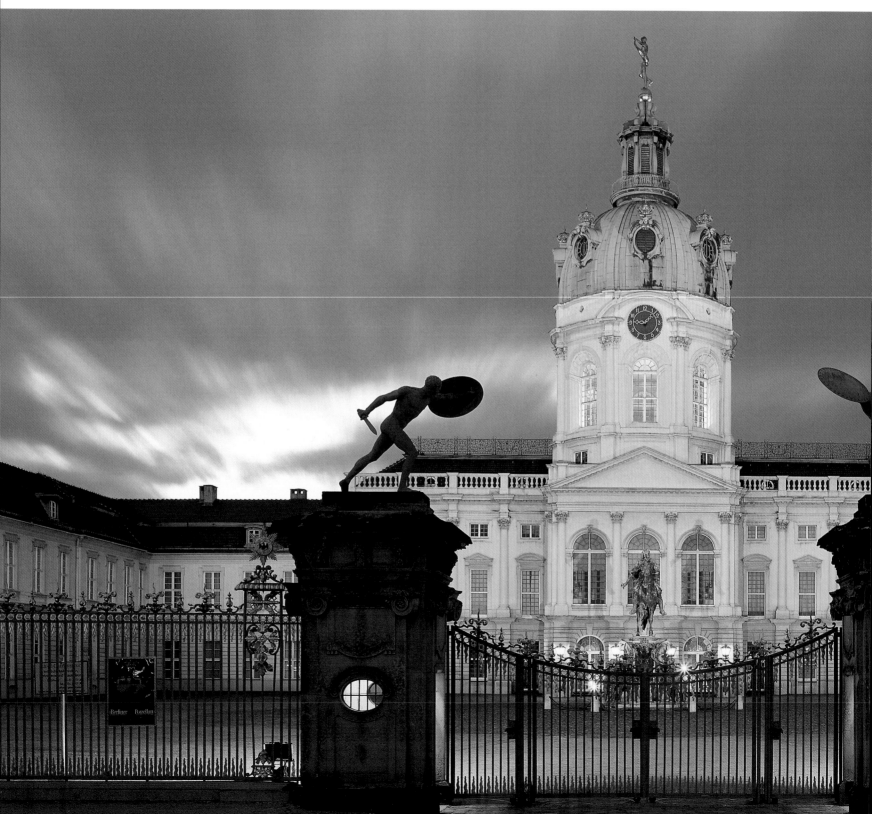

Left and page 74/75:
In the Berlin of the 1920s Potsdamer Platz was the busiest crossroads in Europe. On the division of Germany it existed in name alone; on the fall of the Berlin Wall it became the biggest building site on the Continent. Today the 'new centre of Berlin' is once again one of the liveliest spots in the capital.

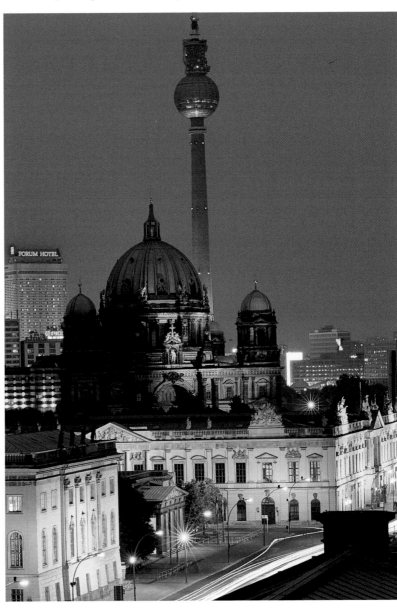

Above:
Perspectives old and new: Berlin Cathedral on Gendarmenmarkt once monopolised the city's historic silhouette. In its day, the television tower on Alexanderplatz was an object of prestige for the GDR.

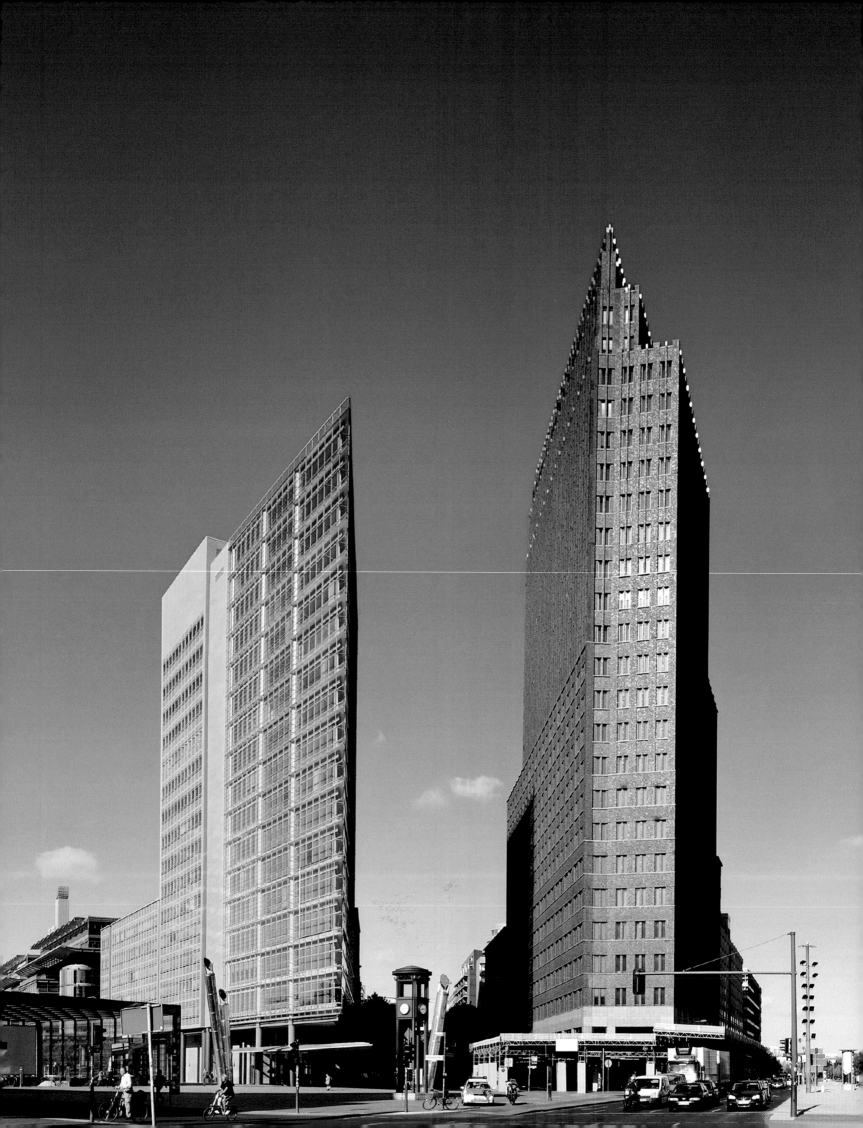

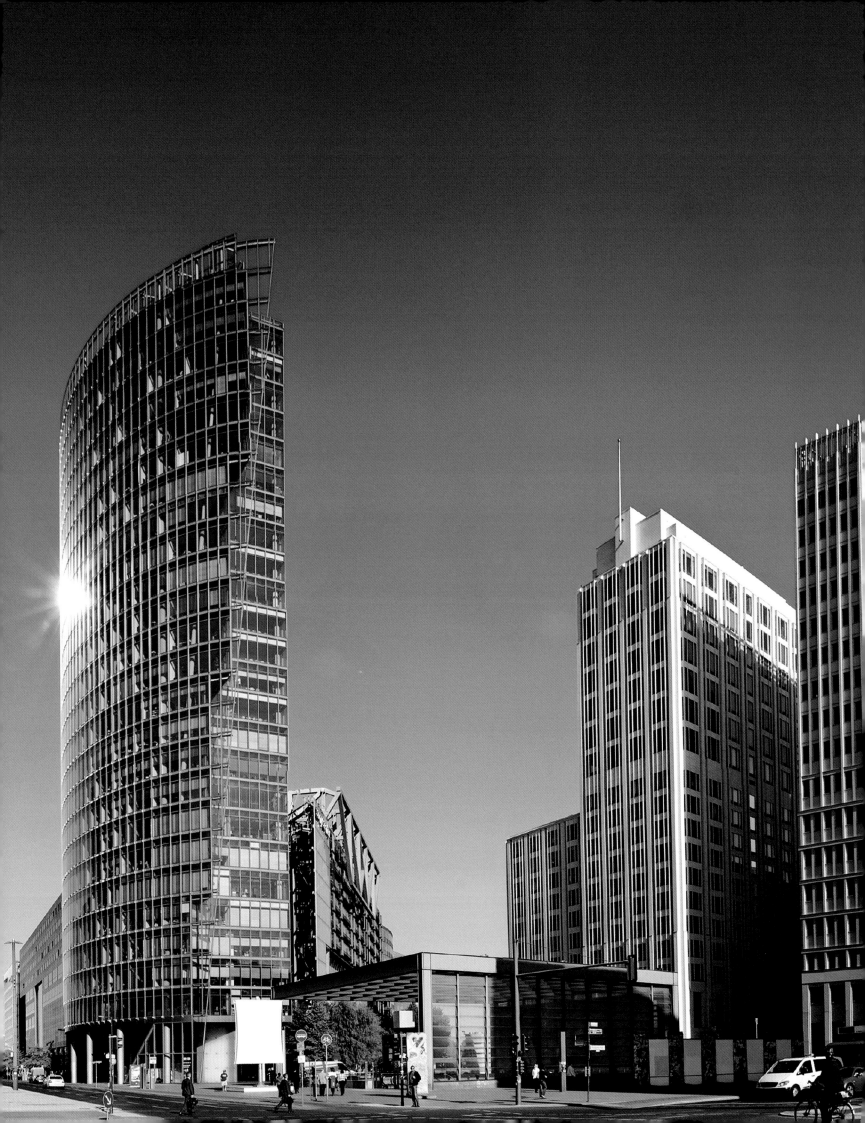

Below and centre right:
*The Elbsandsteingebirge
with its bizarre rock forma-
tions and dense areas of
forest was given the name
Saxon Switzerland in the*

18th century. The Bastei bridge is 636 ft (194 m) above the Elbe and affords grand views of the table mountains on the far side of the river.

Top and bottom right:
There are magnificent views from the fortress of Königstein of the Elbe Valley and the Lilienstein (top). The rulers of Saxony retreated to the mighty stronghold in times of conflict, dragging their state coffers and art treasures with them and leaving their subjects to suffer the ravage and pillage of war.

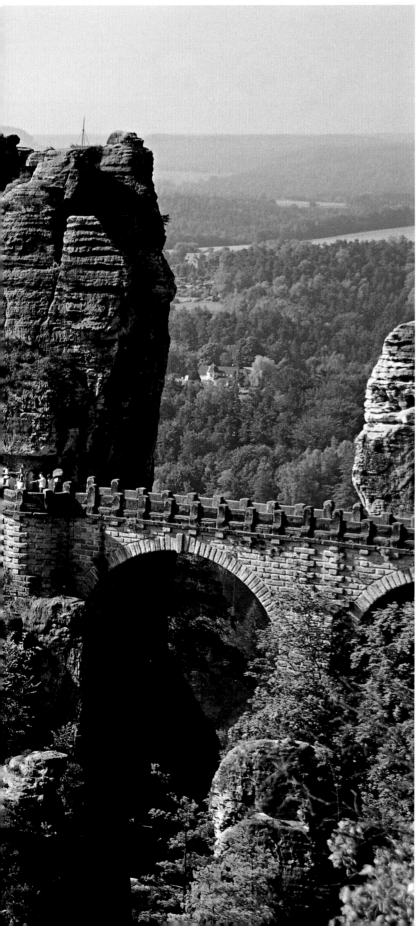

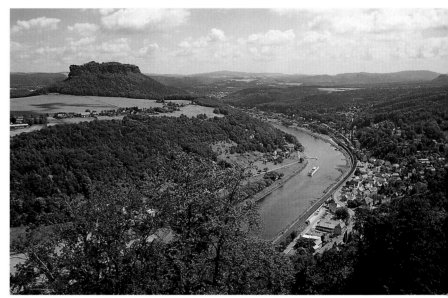

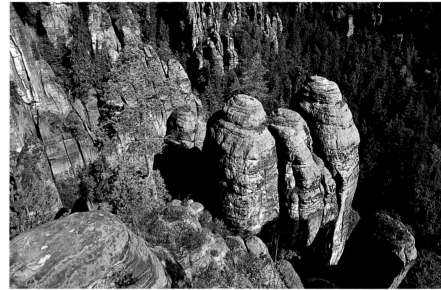

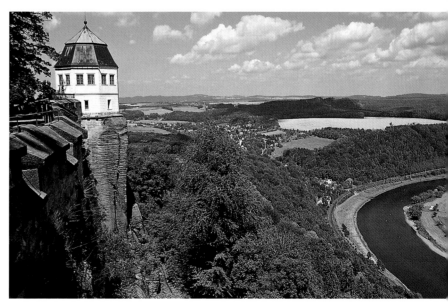

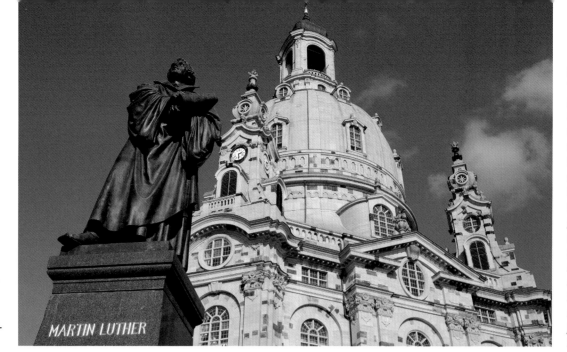

Below:
The famous panorama that together with its many artistic treasures has earned Dresden the epithet of 'Florence on the Elbe'. From left to right: the Schloss, Hofkirche, Semperoper and Augustus-brücke.

Left:
The Frauenkirche is one of Dresden's most distinctive buildings. Completely destroyed in 1945, the ruins were left standing in the heart of town as a memorial. On the fall of the Iron Curtain private campaigning brought in donations from all over the world and rebuilding began. The church was reopened in 2005 just before Dresden's 800th anniversary celebrations. The blackened masonry has been rescued from the rubble of the old Frauenkirche.

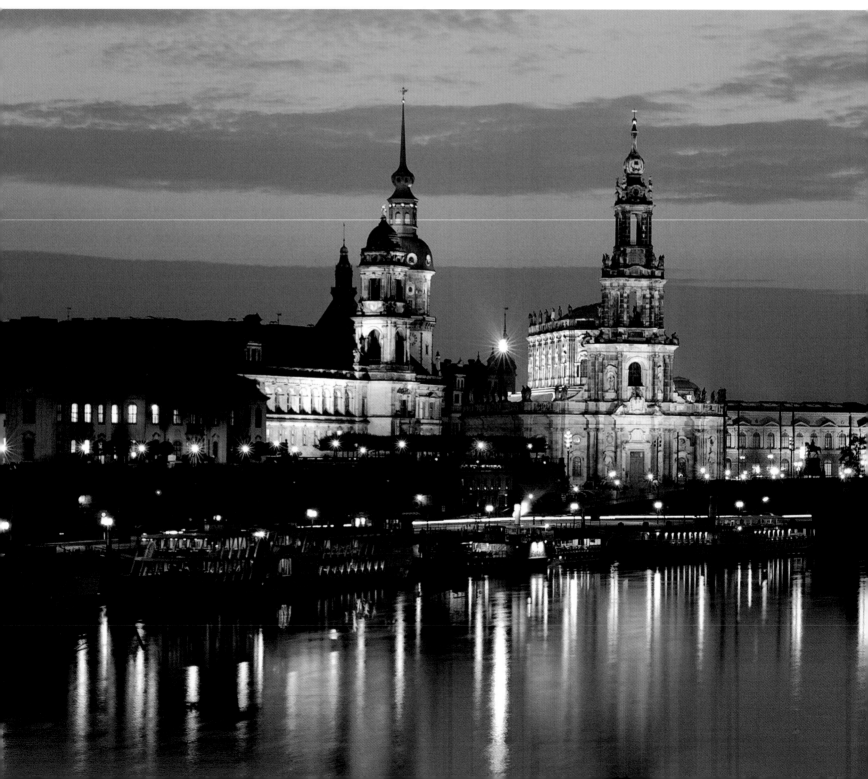

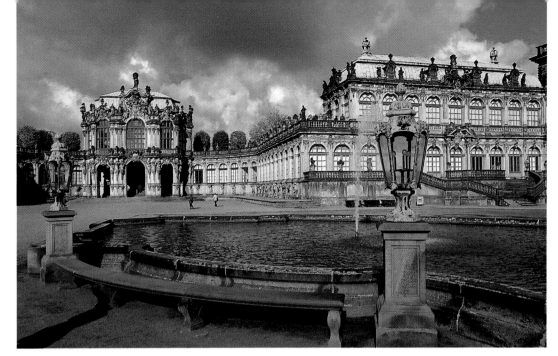

Left:
Dresden's splendid baroque residential palace is the Zwinger, built by royal architect Matthäus Daniel Pöppelmann from 1711 to 1728. Its structure and valuable museum collections are impressive.

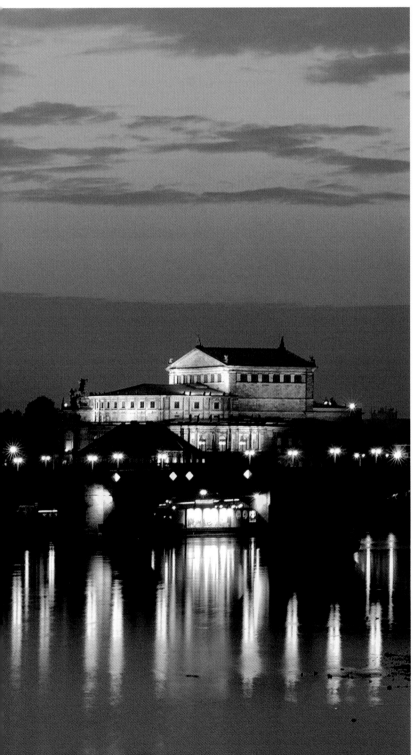

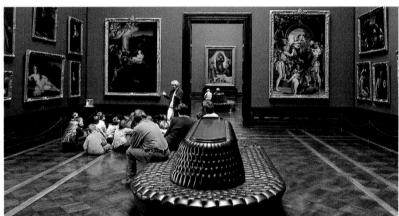

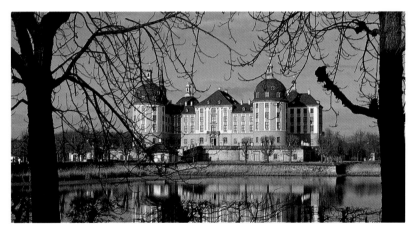

Above centre:
"This picture alone represents an entire artist's world", enthused Goethe on seeing Raphael's Sistine Madonna, the most famous work of art at the Alte Meister gallery in the Dresden Zwinger. The collection, begun under Augustus the Strong, is one the world's most significant.

Above:
The Moritzburg hunting lodge in the Dresden green belt was also the work of patron Augustus and architect Pöppelmann. The palace, surrounded by a wonderful park, is a real tourist magnet. The lodge was named not after the man who completed but the one who began construction on it, Duke Moritz (1542–46).

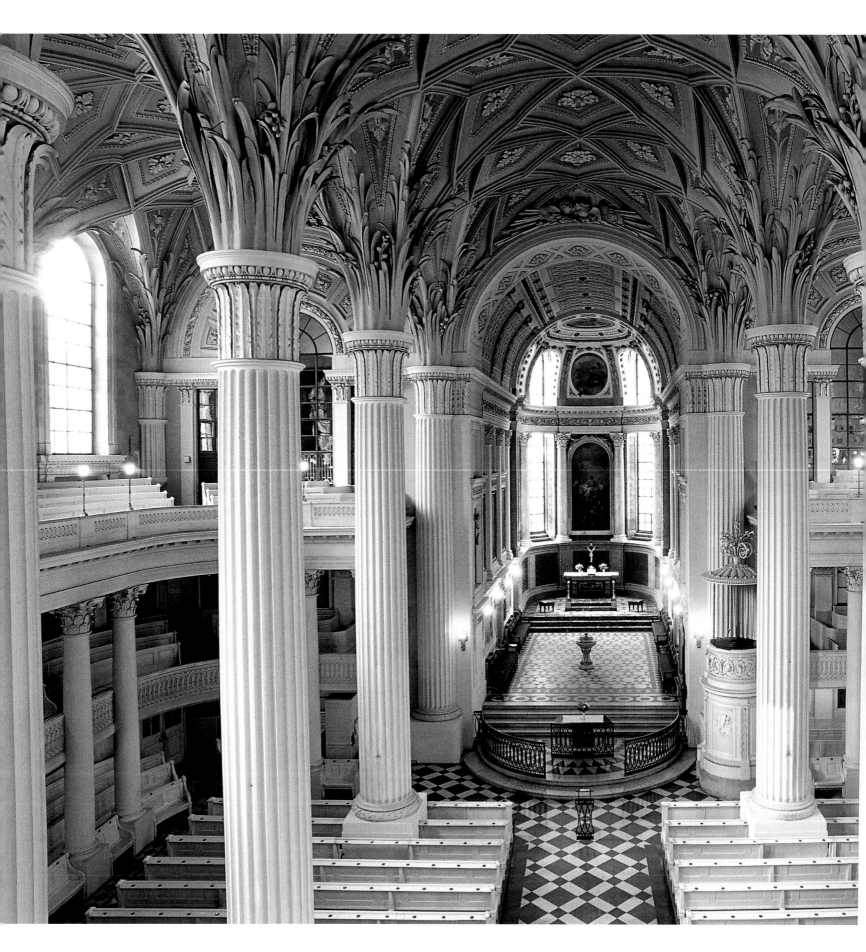

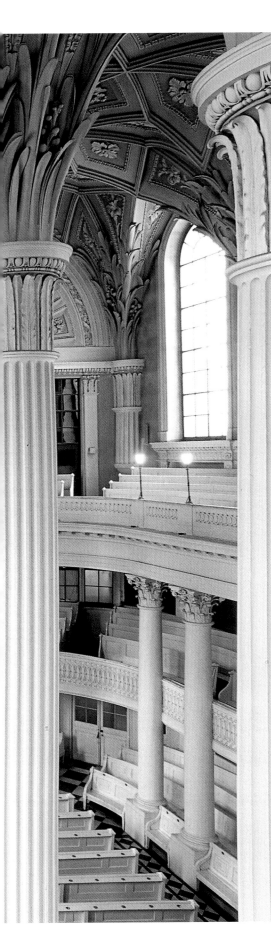

Left:
Leipzig's Nikolaikirche, the oldest and also largest house of worship in Leipzig, was the place of inception for the peaceful revolution of 1989. On 9 October, 70,000 people marched from the church through the middle of town, triggering the enormous social changes which then occurred in East Germany.

Below:
Leipzig's City-Hochhaus skyscraper, also known as the '(sharp) tooth', is over 500 ft (155 m) high and belongs to an American investment bank. The Gewandhaus concert hall (left), home to the orchestra of the same name, squats contentedly beneath it, with the opera house in the foreground.

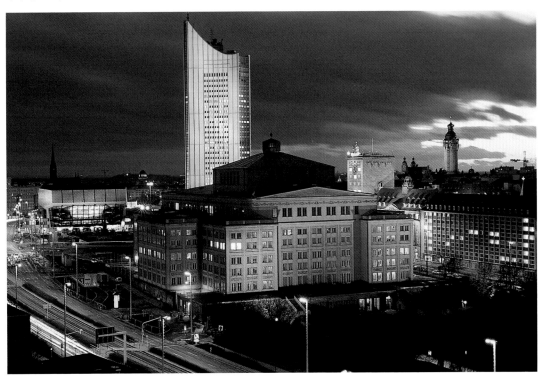

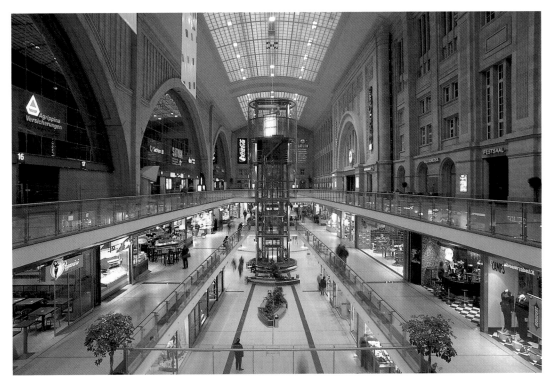

Above:
The design of Leipzig's main station from 1915 proves that iron and glass need not necessarily be cold and rigid, but can be used artistically in playful animation. The station includes a shopping centre, which now straddles several floors.

CASTLES ON THE RHINE AND SAALE

Germany wouldn't be romantic Germany without its castles. Yet less than two hundred years ago many of these medieval strongholds lay in ruins, dynamited by their enemies or simply abandoned by their owners. The country, a motley collection of independent states, some quite tiny, was gripped by a similar, political lethargy. The concept of the strong nation state was either a dream for the future or an unreliable memory of the past. The 'rediscovered' Middle Ages were a far cry from the rose-coloured reconstructions dreamt up by 19th-century idealists. Knights in shining armour were often wolves in sheep's clothing. Yet the walls which had witnessed the past without the Romantic frills were to benefit from this utopianism. Crumbling fortresses were suddenly very much in the public eye; some were rebuilt, often beyond recognition, and others were at least secured before they fell into further disrepair.

There are several classic areas of castles in Germany, the best-known being the Middle Rhine. The picturesque valley from Mainz to Koblenz, best seen from aboard a pleasure boat, is positively littered with fortresses. They have defensive names like Ehrenfels, Rheinstein, Gutenfels, Marksburg, Stolzenfels and Lahneck or, in one case, the *feindliche Brüder* ("enemy brothers"). The most unusual is undoubtedly the one built like a stone ship in the middle of the Rhine, Pfalzgrafenstein or Pfalz near Kaub.

As one can guess, this poetic landscape does not have a peaceful origin. Down the centuries territories were guarded by castles on both sides of the old River Rhine border. A stronghold high up above the valley floor was not only a mark of patriotism but also of financial surety. The tolls and other tributes paid by the sailors and merchants who passed by provided local castellans with a steady source of income. The second heavily-castled river, the Saale, is in the east of Germany. Reference to its many fortified residences is made, among other places, in a famous song which proclaims: "On the white strands of the Saale stand castles proud and bold." In the 10th century the river was a national boundary, which separated Franks, Thuringians and Saxons on one side from Slavs on the other, until Saxon emperors wishing to extend their lands marched east. The smaller Saale can of course hardly compete with the mighty Rhine for size and impressiveness, yet it does have qualities of its own. It first meanders through the mountains and then swells out into two (artificial) lakes with a fjord-like shoreline. The castles themselves are just as old, historically interesting and romantic as their Rhineland counterparts. Schloss Burgk, for example, boasts the biggest kitchen fireplace in Germany and the heated chamber in Orlamünde is where the White Lady, Germany's most famous castle ghost, was first spotted. Other Saale fortresses well worth visiting are Burg Ranis, Heidecksburg, the ruins Rudelsburg and Saaleck and Giebichenstein near Halle. The unchallenged castle queen of the Saale Valley is Leuchtenburg near Kahla.

For a lot of castles within a relatively small area there's what is rather exuberantly known as Franconian Switzerland. The area between the towns of Bamberg, Erlangen and Bayreuth has a multitude of valleys and hills which needed defending. This explains the prolific number of strong houses, with Unteraufseß, Greifenstein, Egloffstein, Gößweinstein, Rabenstein and Pottenstein among them. From the air it looks as though someone has tipped a box of toys out onto the countryside, maybe belonging to a giant who liked to build castles and then violently smash them up...

It's quite understandable that with so many to choose from, selecting the most beautiful castle in Germany is not an easy task. This claim to fame must inevitably be shared by two top candidates. The first contender is Burg Eltz, the prototype medieval fairytale castle in the Eifel hills. Eight residential towers adorned with turrets and oriels make up a breath-taking, superlative whole. Joint first place in the superlative stakes goes to the Wartburg high up above Eisenach. In addition to its romantic appearance and setting, the Wartburg is also a symbol of cultural and historical significance for Germany.

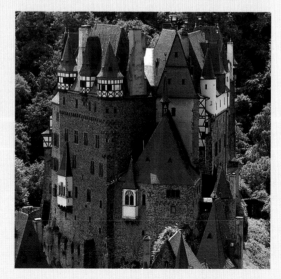

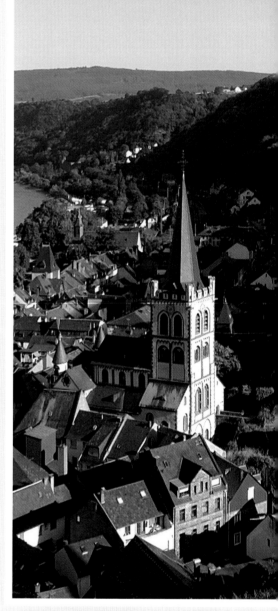

Left:
Burg Eltz near the Moselle River is the prototype medieval castle.

Above:
The legendary castle of Stahleck above Bacharach boasts grand views of the River Rhine.

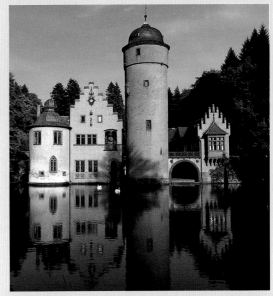

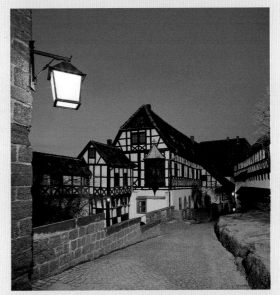

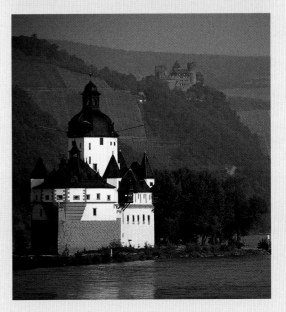

Top right:
Schloss Mespelbrunn
lies hidden away in the
Spessart Forest.

Centre right:
The Wartburg above Eise-
nach has come to stand for
the freedom and unity of
Germany.

Right:
Like a ship in a storm:
the Pfalz at Kaub.

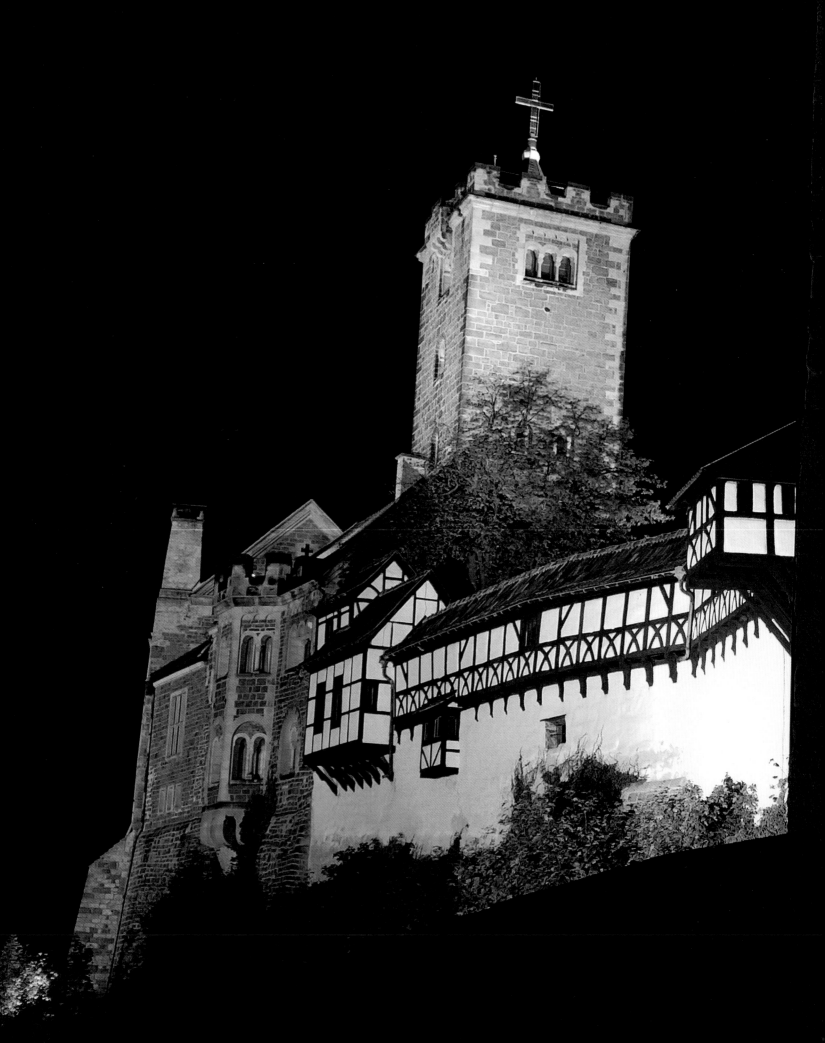

Page 84/85:
The story goes that the Wartburg was founded in the 11th century. Legend also has it that in 1207 a minnesinger competition was held here. The six famous participants allegedly included Walther von der Vogelweide and Wolfram von Eschenbach. The loser, Heinrich von Ofterdingen, would have perished had he not been snatched from the clutches of death by the magician Klingsor.

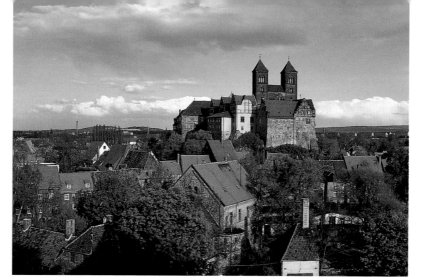

Left:
The collegiate church of St Servatius on the castle hill in Quedlinburg is an 11th-century basilica. In the hall crypt of this striking Romanesque building Heinrich I, king of Saxony, and his wife Mathilde lie buried. The ancient cathedral jewels are particularly valuable.

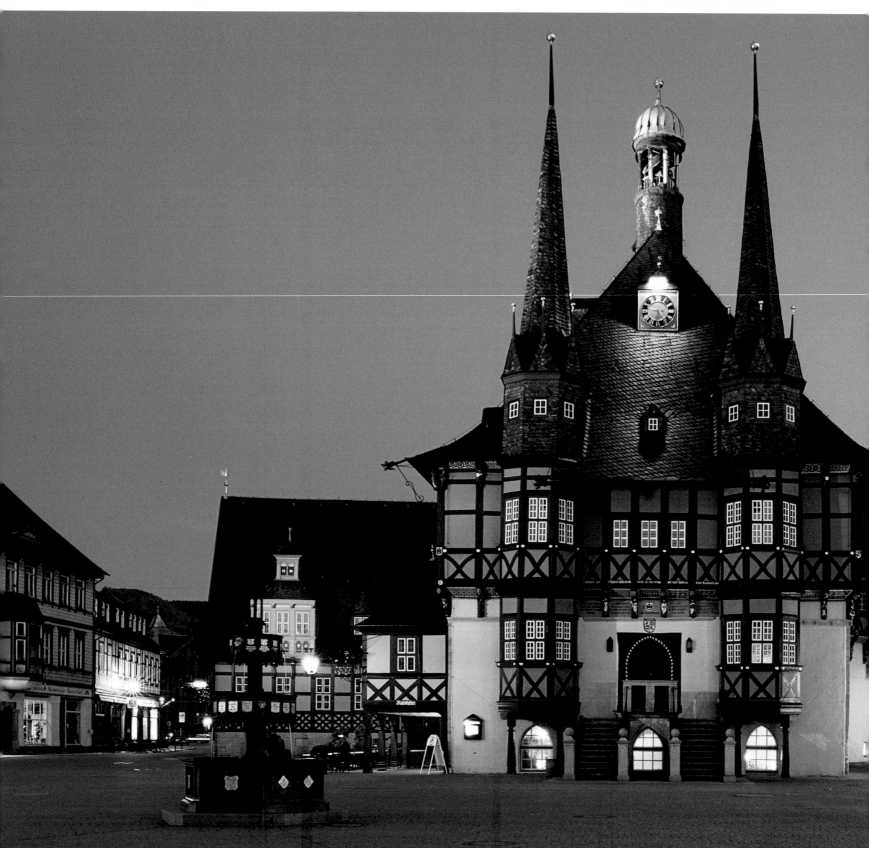

Below:
Wernigerode goes back to the 10th century. Its citizens and local potentates worked in close collaboration to build up their home. The tremendous town hall from the end of the 15th century, for example, was erected on the foundations of the counts' Romanesque casino.

Page 88/89:
The history of Saxony began 1,000 years ago on the castle mound in Meißen. The picturesque silhouette is dominated by the Gothic cathedral, one of the stylistically most perfect of its kind, and the late Gothic fortress of Albrechtsburg, the first palace to be built in Germany. It was within these walls that Augustus the Strong had the first bone china manufacturer's in Europe opened in 1710.

Below:
View of the market place in Wittenberg with a statue of Luther in the foreground and the mighty westwork of the Marienkirche where the Reformer preached. His famous theses, in which he attacked the indulgences of the papacy, were pinned to the door of the palace chapel.

Below centre:
Picturesque Finkenherd at the foot of the castle hill in Quedlinburg is said to be the place where Saxon Prince Heinrich was told he had been elected king of Germany. At the time he was indulging in his favourite pastime: catching birds.

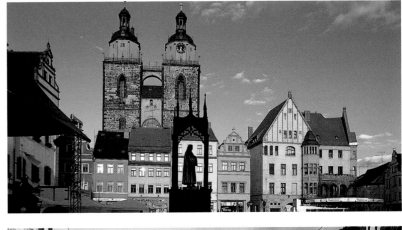

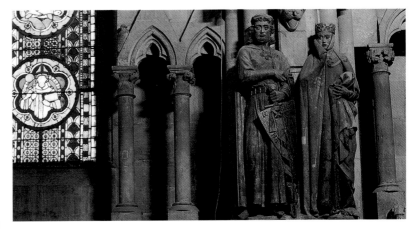

Above:
In the west choir of Naumburg Cathedral visitors can study one of the most poignant artistic messages of the Romanesque period. Stone figures of the church patrons, the most famous of which bear the names Ekkehard and Uta, tell of a cold warrior and his beautiful, vulnerable wife.

The forest has played a major part in the mythology, history and economy of Germany. It thus comes as no surprise that the largest expanses of woodland are not in Bavaria or Thuringia, but in Hesse. It's believed that the Hessian Odenwald was the site of a number of stories in the *Song of the Nibelungen*, that epic of early German literature. This is also where the babbling brook is said to be that medieval hero Siegfried was murdered at.

Another area where natural sources are of great local significance is the north of Bavaria. Here, the ancient cathedral city of Bamberg and the formerly Prussian town of Kulmbach front Upper Franconia, world-famous for its beer. Nowhere else in Germany have the clear springs to supply so many breweries producing an unbelievable variety of beers. Many of the small, family-run businesses make both the beverage and the traditional bar food they serve in their establishments: bread baked in their own ovens, meat, sausage and ham from animals they slaughter themselves.

The topographical highlight of the south are the Alps, the highest being the Zugspitze at 9,721 feet (2,963 metres). Water sports fanatics can pursue their favourite line of activity on Lake Constance, Germany's largest inland waterhole, whose shores are divided on the German side between Baden-Württemberg and Bavaria.

If this isn't enough and you want something really final, then it's not far to the "view of the end of the world" from here. For this you have to go to Baden, where the palace and gardens of Schloss Schwetzingen pay homage to the golden age of 18ᵗʰ-century Palatinate. Here, in a leafy avenue, plants and paintings cleverly create the illusion that you are looking at Paradise.

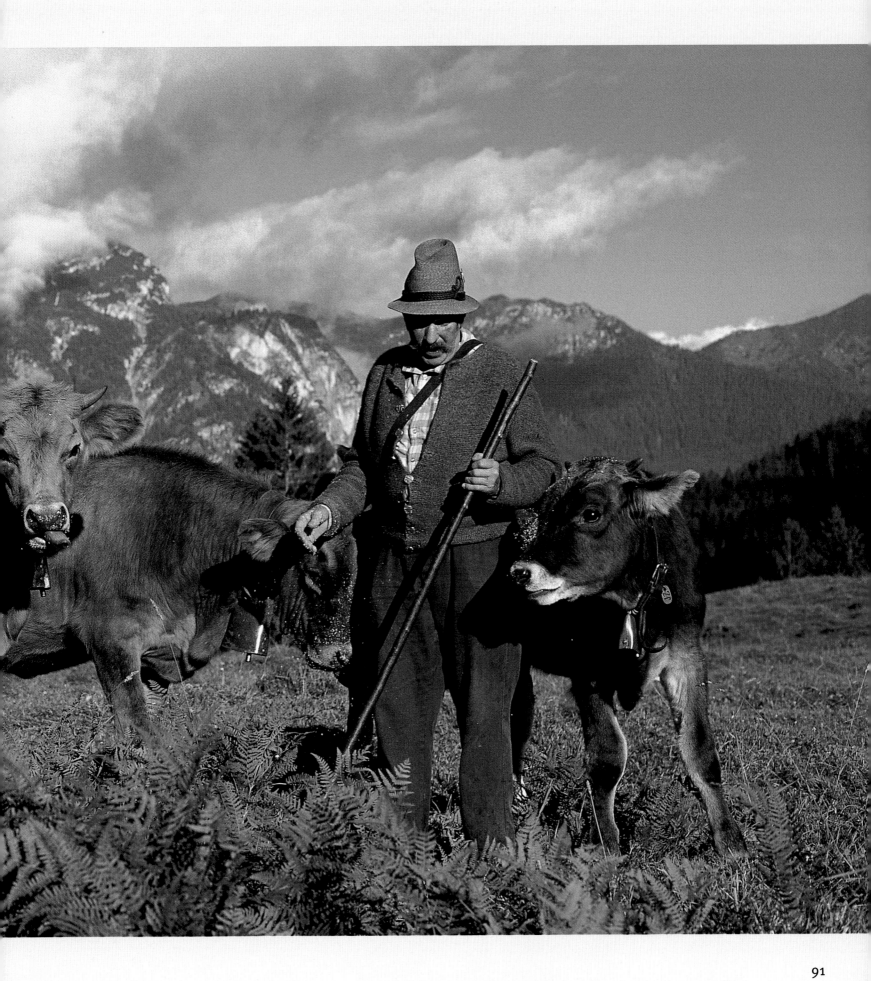

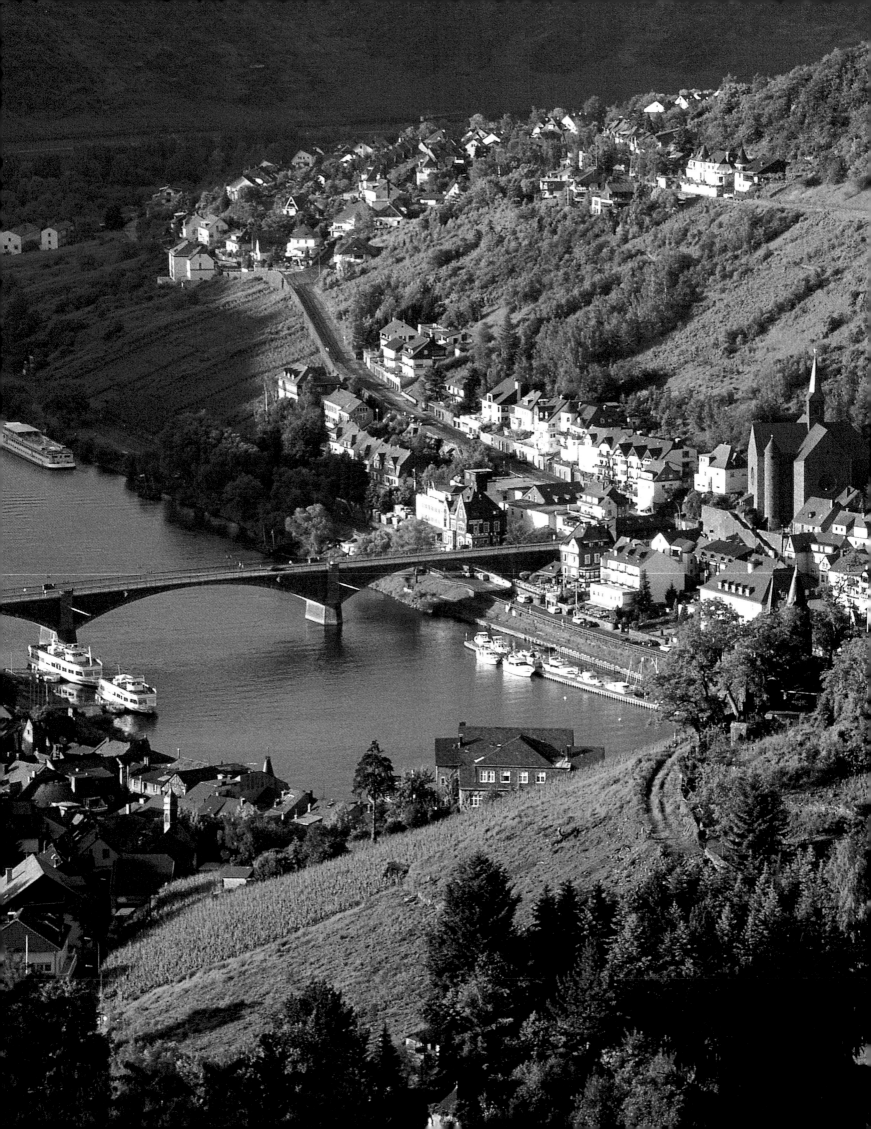

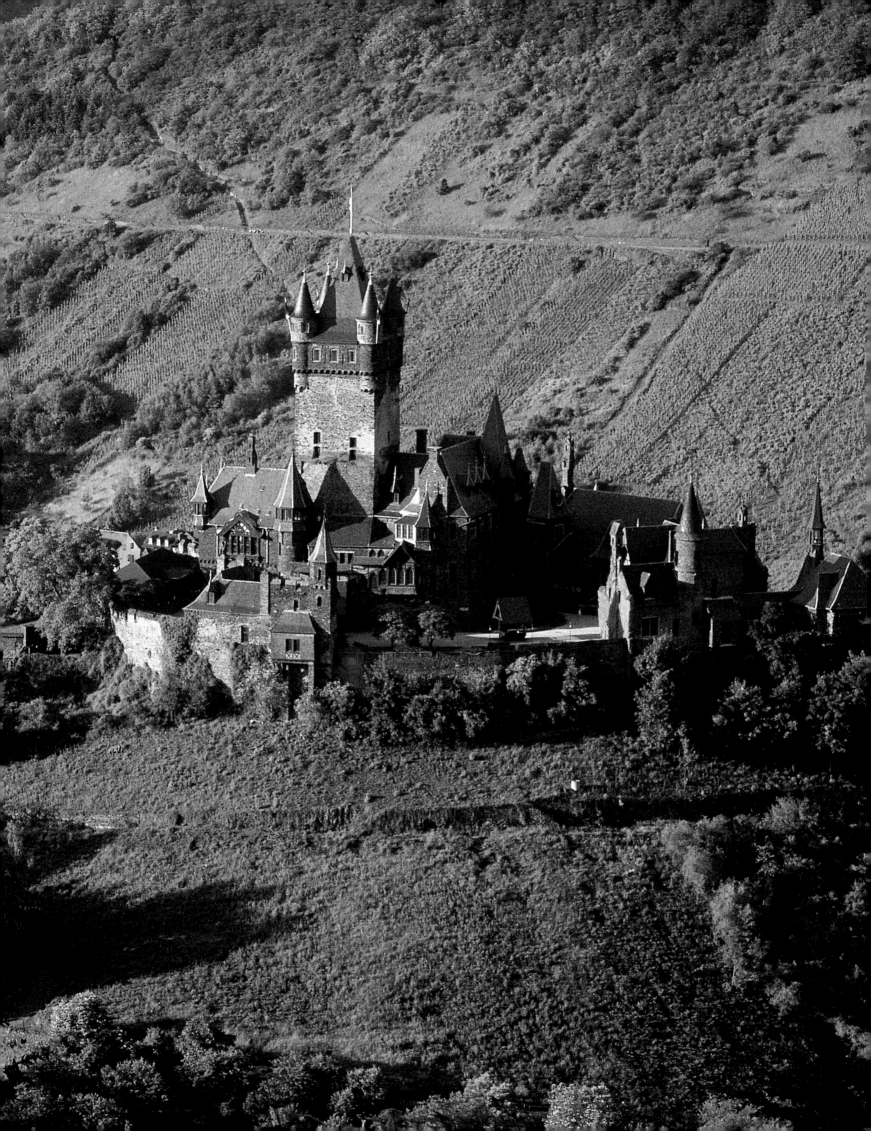

The abundance of castles
on the Middle Rhine is
legendary. Wherever you
look there are medieval
fortresses, some as majes-
tic ruins on rocky outcrops,
others in the middle of the
river, like the Pfalzgrafen-
stein at Kaub.

Right:
It's a known fact that the
Rhine and wine go well
together. Bacharach, with
a 1,000 years of history
behind it, has long been
said to produce a particu-
larly good vintage. Its
vineyards are offset by an
extremely artistic backdrop,
consisting of the ruined
Wernerkapelle and the old
Staufer fortress of Stahleck.

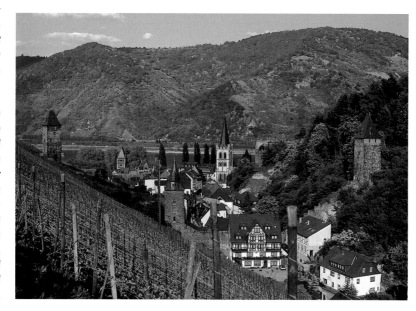

Right:
Ancient 'golden' Mainz is
the provincial capital of
Rhineland-Pfalz and a
diocesan and university
town. The Romans made
the settlement at the con-
fluence of Main and Rhine
the capital of their Germa-
nia Superior province. In
c. 1450 Gutenberg invented
the European printed book
here. Mainz's main attrac-
tion is the Romanesque
cathedral, whose construc-
tion spanned nine
centuries.

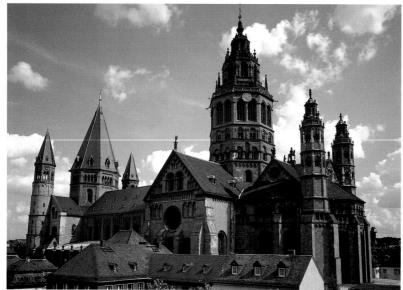

Right:
Going to Trier, the oldest
city in Germany, is like
being transported back to
the days of the Romans.
The absolute highlight
is the Porta Nigra in the
heart of town, the north
gate and largest surviving
Roman arch in the world.

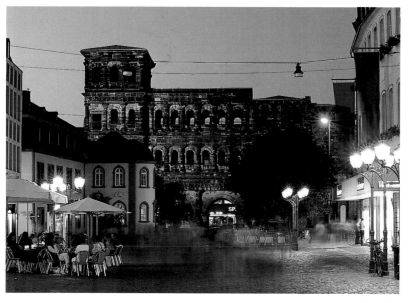

94

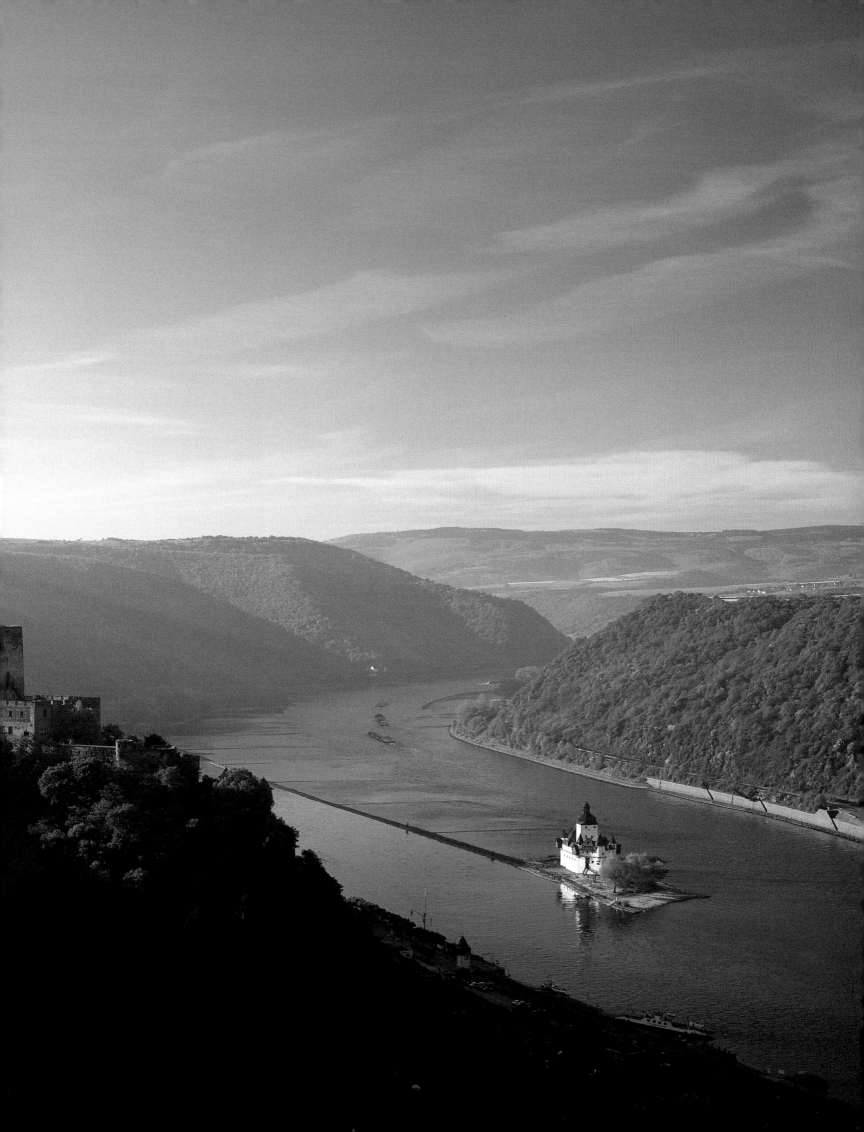

GERMANY AND WINE

From time immemorial, Bacchus and Gambrinus have been wrestling for favouritism among the people of Germany. To be more exact, it's not actually the gods themselves who are engaged in healthy competition, but the beverages they represent: wine and beer. Wine was probably the first of the two to be planted in Germany and also the one to suffer a terrible catastrophe in the 19th century, when the vineyards were almost completely decimated by the dreaded vine pest. Since then, cultivation of the grape has been on a much smaller scale.

In more recent times, a striving for quality among a number of young vintners has earned wine from Germany a good reputation. New methods in the growing and processing of wine and the limiting of the yield per hectare have in the past few years proved successful. Riesling from the Rheingau and Moselle-Saar-Ruwer area enjoys international acclaim; red Spätburgunder from Baden or the Palatinate, which used to be called "liquid jam", need no longer shun comparison with its French neighbours. This new self-confidence has also traversed to the elevated spheres of state receptions, where guests of the Bundesregierung are handed glasses of wine from Germany and nowhere else.

Many locals and tourists not only cherish the drink itself but also the ancient landscapes sculpted by centuries of viniculture. The atmospheric little wine villages are particularly popular during the grape harvest in autumn, when people come together to celebrate the new wine and – amid much merriment – themselves and their friends.

Germany's winelands are the northernmost contained areas of vineyard in the world. Consequently, the period of vegetation is comparatively short and the weather (frost in spring and autumn, the cold in winter, periods of rain or drought in the summer) poses a great problem. For this reason vines are only grown on the flat in Rheinhessen and Rhine Palatinate; they otherwise adorn sunny ranges of hills and precipitous slopes facing southeast to southwest.

One of the largest areas of cultivation (Germany's "chamber of wine") is the Palatinate. The forests of the Palatinate, the Vosges and the Haardt boast an almost Mediterranean climate which produces hearty, light, sweet wines. The region stretches from Schweigen on the Alsatian border to the gates of Worms. The picturesque towns and villages of Bergzabern, Edenkoben, Hambach, Dürkheim (Germany's biggest wine-growing community), Herzheim and Bockenheim are linked by the German Wine Route.

Northerly Rheinhessen produces sweet, lively, fragrant vintages. Famous dramatist Carl Zuckmayer not inappropriately described his homeland's native tipple as "laughing wine". Among the best-known vintner villages in Rheinhessen are Alsheim, Oppenheim, Nierstein, Ingelheim – and Bingen. It's no great coincidence that mystic and Benedictine abbess Hildegard of Bingen (1098–1179) prescribed wine for medicinal purposes. Legend even has it that she once saved the area from the plague with the juice of the grape.

Wonderful tales of wine-cum-magic potion are also common to Franconia, whose areas of vineyards surrounding the city of Würzburg were much bigger in the Middle Ages than they are now. What hasn't changed is the high standard of Franconia's wine and a local dictum which claims that it can heal the sick. So that there's no mistaking the curative, it comes in special round flagons with a name which in itself smacks of witches and bubbling cauldrons: "pouch of buck" (*Bocksbeutel*).

Yet the area which grandly claims to be the "hub of German wine culture" is not any of those already mentioned. Nor is it one of the no less prominent regions of Baden-Württemberg, the rivers of the Nahe, Moselle, Saar, Ruwer and Ahr nor the tiny Middle Rhine with Bacharach and all the others. Germany's number one in wine is the Rheingau. The spectrum of admirers and patrons of its alcoholic refreshment ranges from the Romans to Charlemagne, from the Cistercians at the monastery in Eberbach to the Benedictines on Johannisberg, from Goethe to Queen Victoria. The queen indeed was a particular fan of bottles from Hochheim, bequeathing to the English-speaking world the word "hock" as a general designation for wine from the area.

There are also two minute wine-growing areas in the east of Germany. Vines thrive along the River Elbe near Meißen and at the confluence of Unstrut and Saale – and they're not the worst of vintages either...

Left:
Wine cellars often have some real treasures stashed away in their vaults.

Above:
In the Markgräflerland rolling hills mark the transition from Rhine plateau to Black Forest. In this

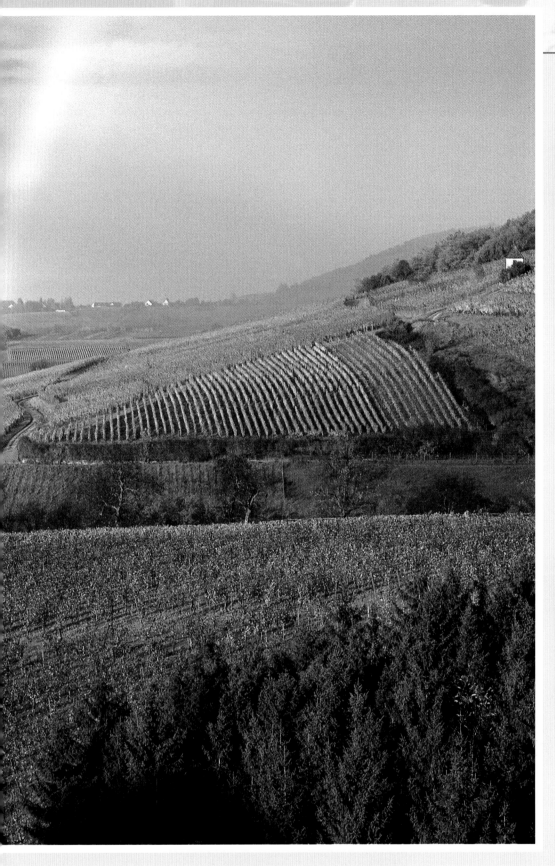

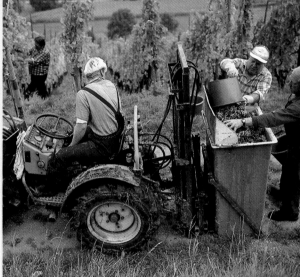

area blessed with plenty of sunshine – here with Ballrechten in the background – viniculture is tradition.

Top right:
The discerning look of the vintner, checking the colour of a young wine.

Centre right:
All hands on deck for the grape harvest!

Right:
A lot of hard work is necessary before the grape becomes wine.

97

Right:
Even if its contemporary skyline suggests quite the opposite, the city of Frankfurt is over 1,200 years old. Frankfurt is the birth- place of Goethe and of civic parliamentarianism, instigated in 1848 almost 100 years after Goethe's birth at the Paulskirche national assembly.

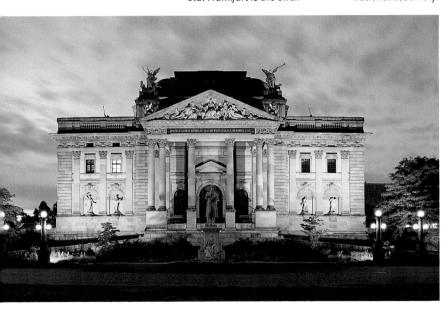

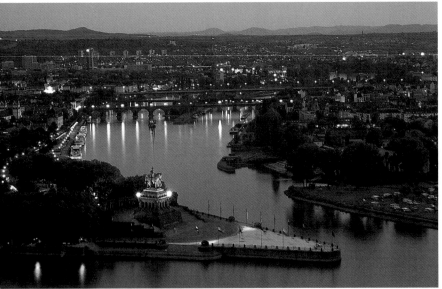

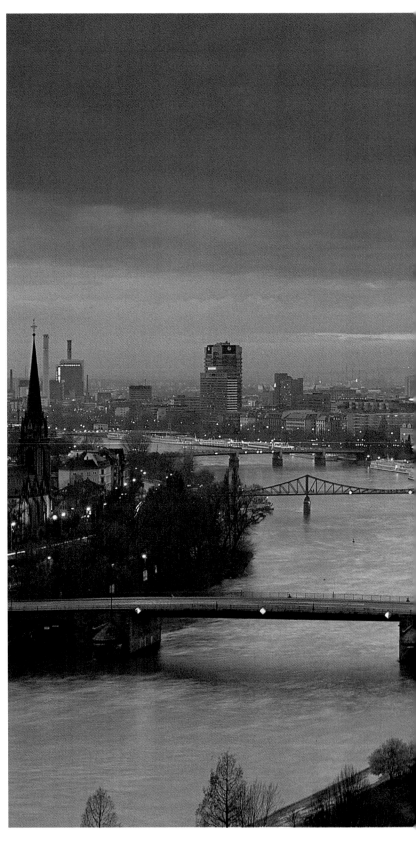

Top:
Wiesbaden, the capital of Hesse, lies at the base of the Taunus Mountains. The healing waters of the Roman spa, which in the 19th century made the town one of the most luxurious health resorts in Europe, still bubble up from the ground. The state theatre of Hesse is from this period.

Above:
The Moselle flows into the Rhine at the Deutsches Eck in Koblenz. From here the two rivers branch off into some of the most wonderful valley scenery in Germany. The town itself has much to offer: a medieval city centre which goes back to the Romans, old churches and the popular Festung Ehrenbreitstein.

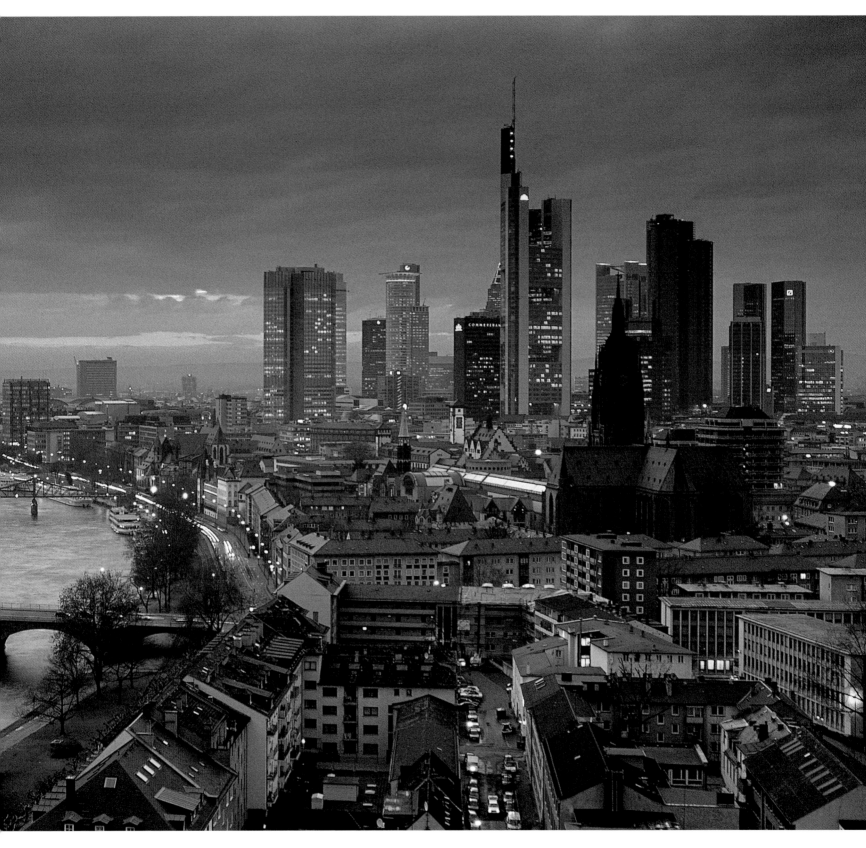

Page 100/101:
View of Freiburg from
Lorettoberg. The church
steeple, "the most beauti-
ful tower in the Christian

world", as historian
Jakob Burkhardt put it,
climbs 377 ft/115 m up into
the sky and is visible for
miles. The belfry is part

of the famous minster
Unserer Lieben Frau,
on which building was
begun in c. 1200.

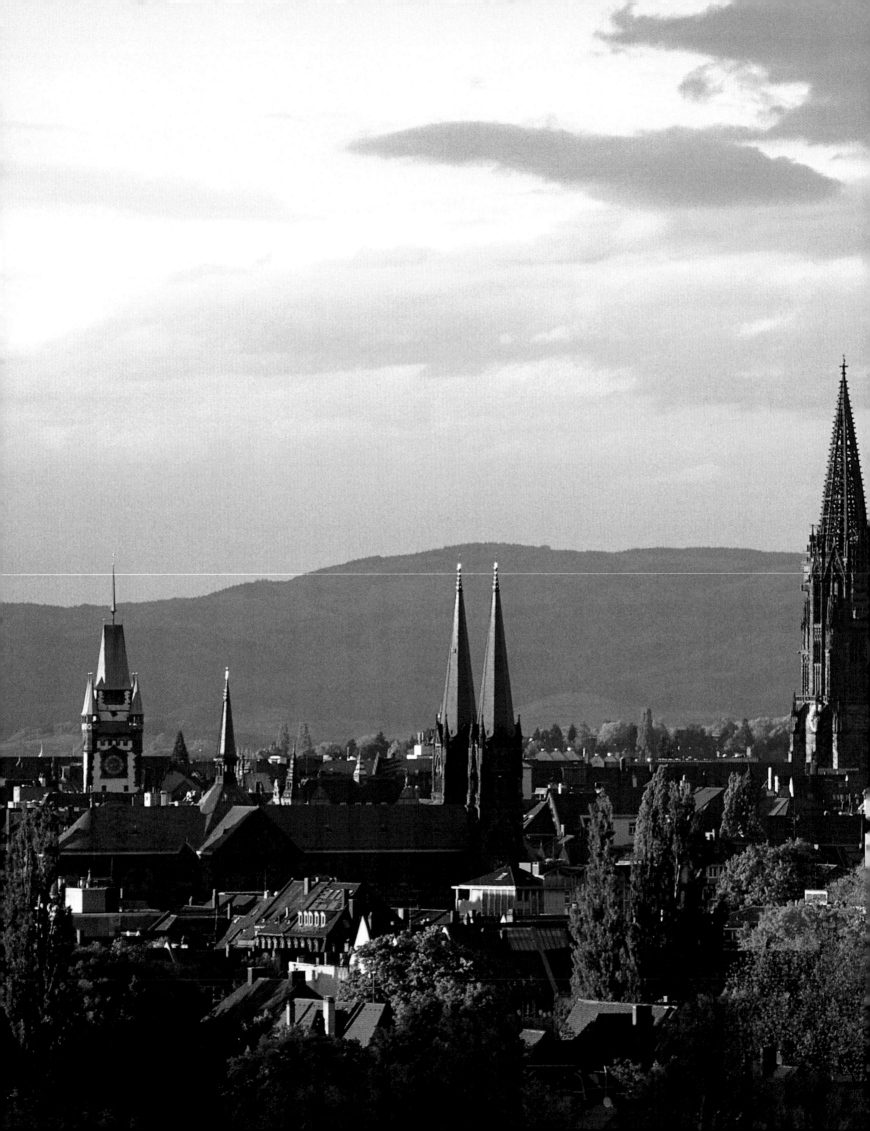

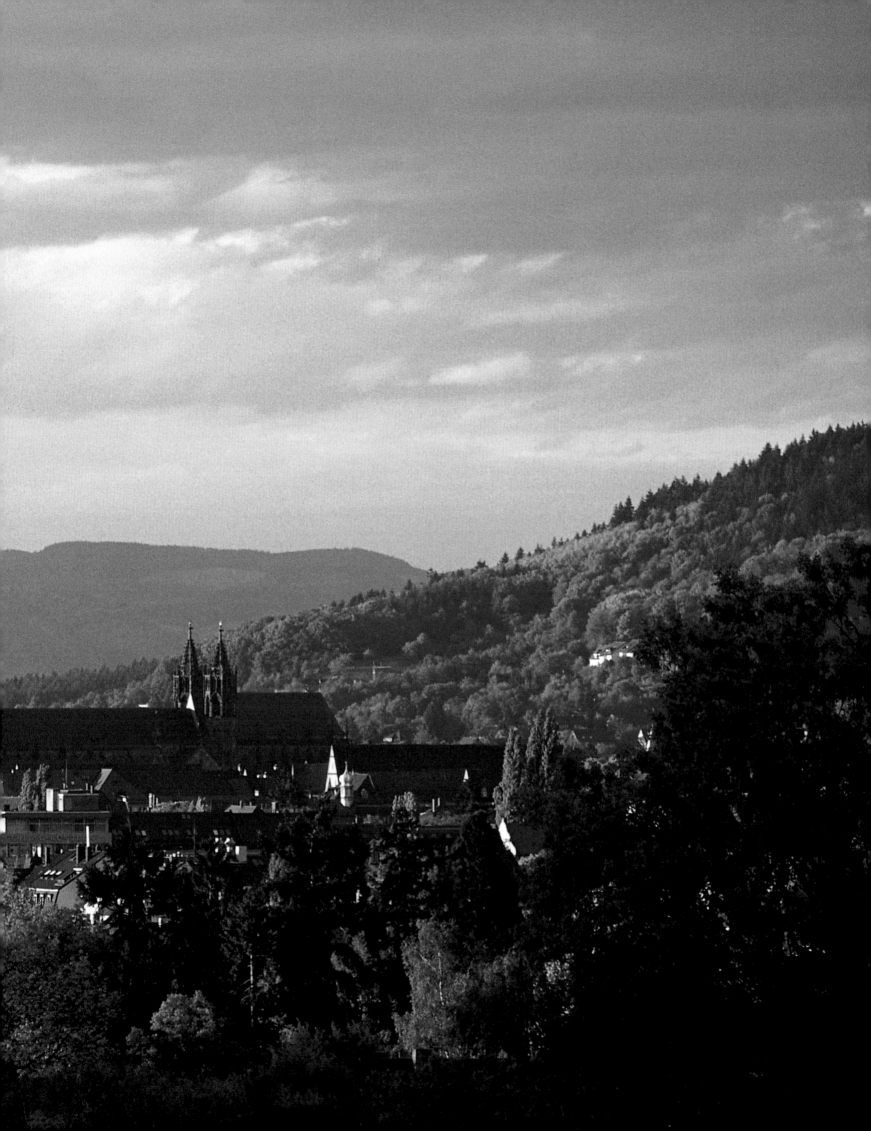

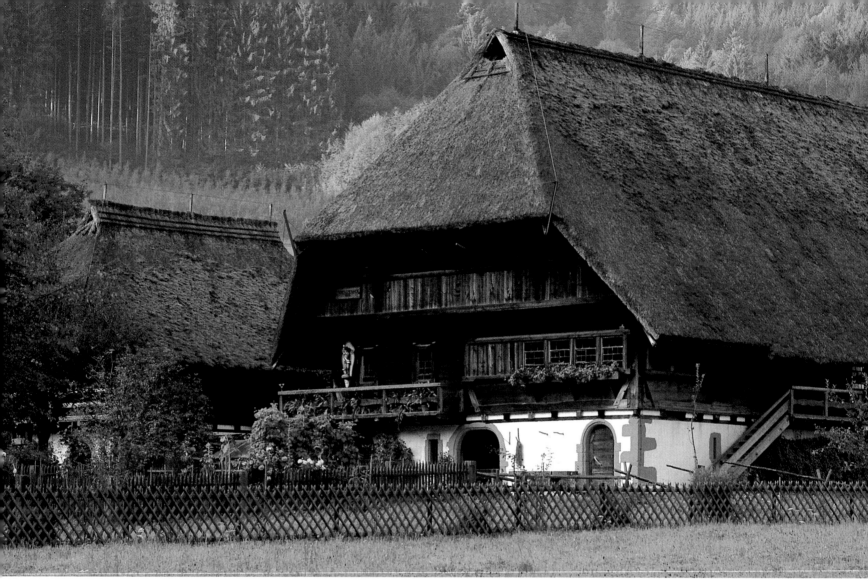

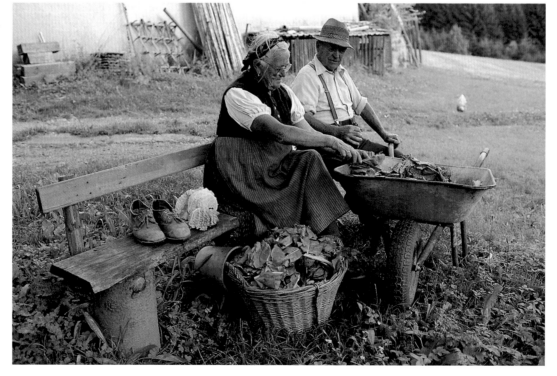

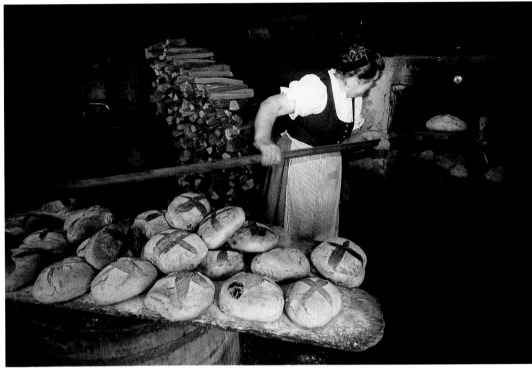

Left:
Even if it takes a lot of time and effort, bread here is still home-baked on a daily basis according to the old custom. Local bakers swear that not only do their loaves taste better and have more flavour, but also that they keep longer.

Below:
A harmonious unison of hills and valleys, of field and forest, of nature and mankind such as this can be found in the Middle Black Forest, near Land-wasser in the Oberprech-tal, an offshoot of the Elz Valley.

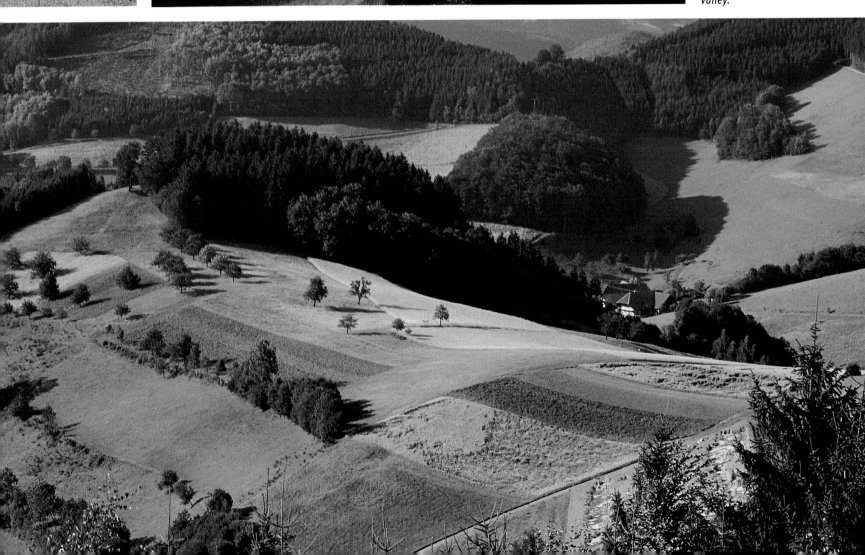

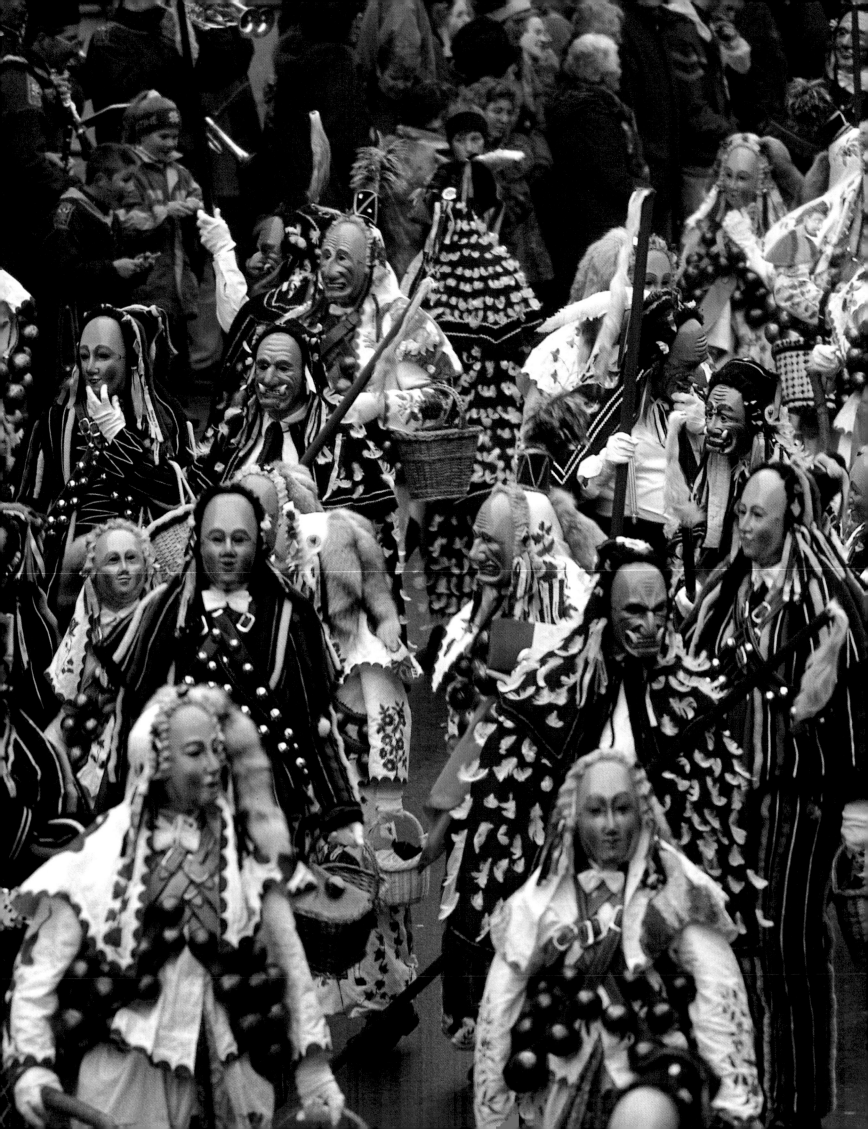

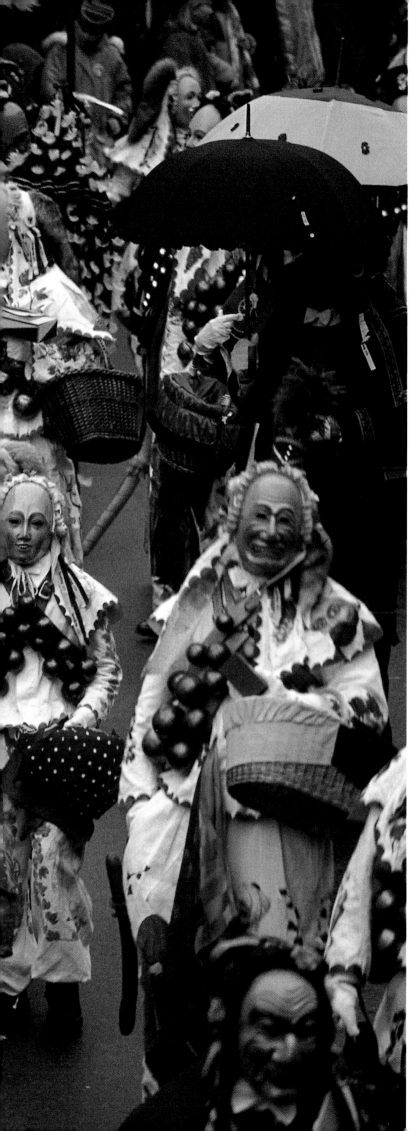

Left:
The venue is the old free city of Rottweil, the date Rosenmontag, eight o'clock in the morning, the event the Narrensprung, the procession of fools, one of the most popular of Swabia's Alemannic Carnival. For many in the Black Forest and its neigh-bouring areas, such as in the ancient ecclesiastical territories along Lake Constance, this is the fifth season of the year.

Below:
Fasnet traditions date from way back when, as do the wooden masks and costumes. Devils, witches, demons and other ghoulish figures rattle noisily through the streets, driving out winter in anticipation of spring. The proceedings call for plenty of Carnival pranks, cunning and clam-orous merriment.

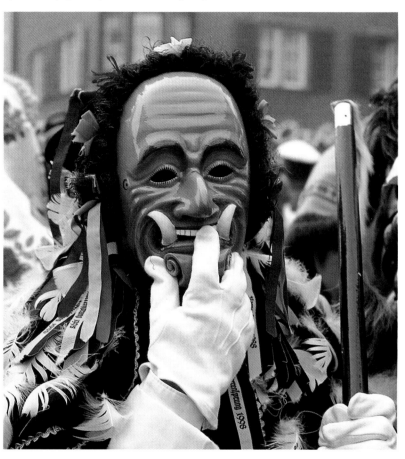

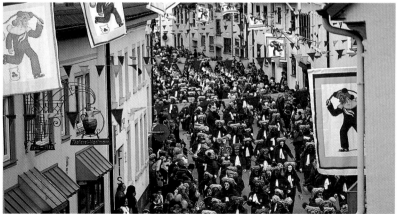

Above:
At the stronghold of Carni-val tradition in Elzach the eerie figures parade after dark. Lights illuminate the ghostly scene, which is enough to unnerve even the most stalwart of spec-tators. As opposed to Carnival in the Rhineland, Swabia's Alemannic ver-sion is darker, older – and far less adulterated.

105

Below:

The castle in Meersburg is the oldest inhabited fortress in Germany. Its history goes back to the 7th century. The rooms open to the public include the chamber Annette von Droste-Hülshoff worked and died in. In the 19th century, the female poet was one of the first to penetrate the then male world of literature.

Right:

One of the many high points along the German shore of Lake Constance is the pilgrimage church of Birnau, built by the nearby Cistercian monastery at Salem in extravagant Rococo in c. 1750.

Centre right:

The mild, sunny climate of Lake Constance provided the ideal conditions for Count Lennart Bernadotte to energetically put his idea into practice – that of turning the island belonging to Teutonic Order of Knights into a floral paradise surrounded by water. Mainau's carpets of blooms can be admired from April to October, with some of the hothouses open throughout the winter.

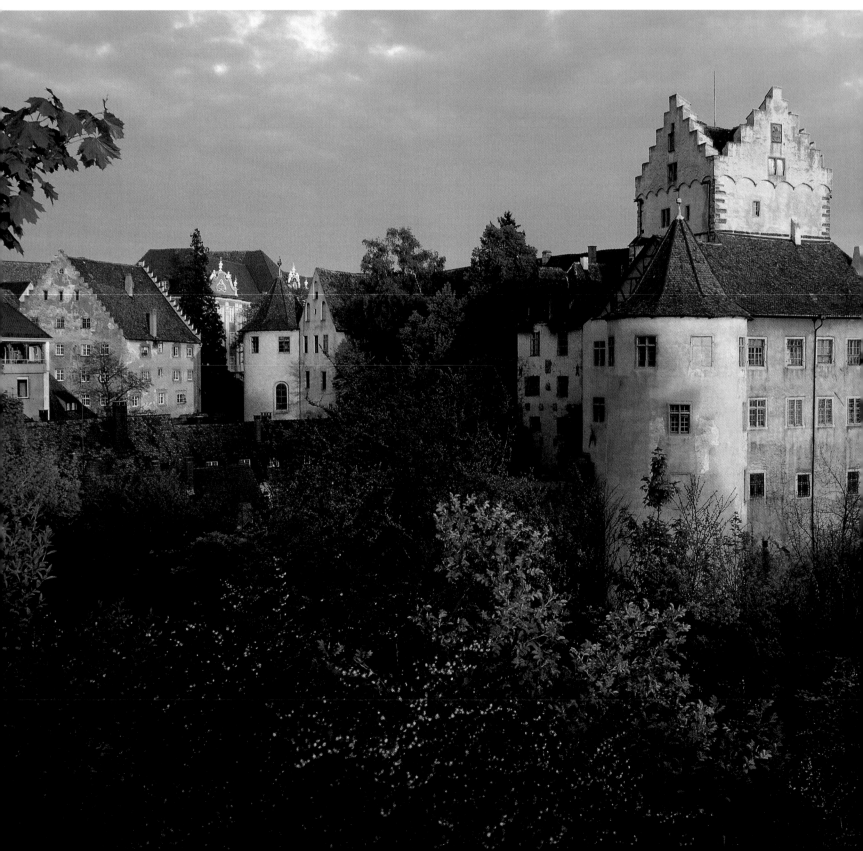

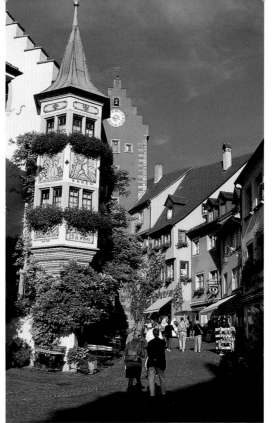

Left:
If you go to Meersburg, don't just visit the castle. A stroll along the shores of the lake or a trek up through the steep narrow streets of the old town are just as rewarding. The hotchpotch of architectural styles ranges from Gothic and Renaissance to baroque and Biedermeier. The Obertor with the Hotel Bären oriel is just one of the many photogenic spots.

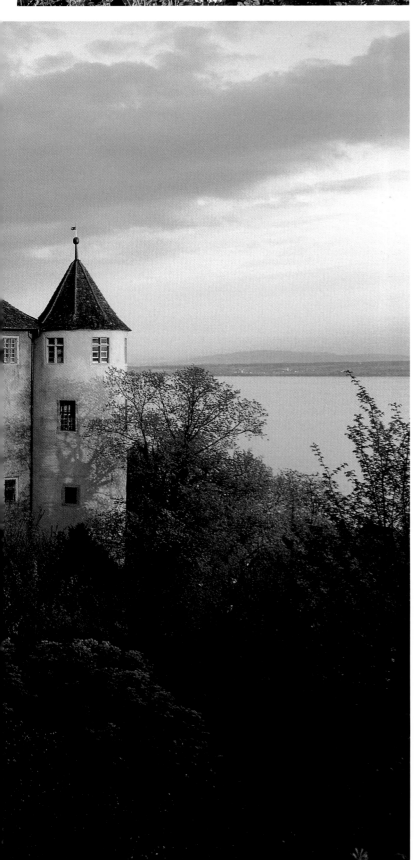

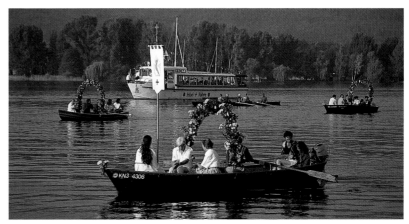

Above centre:
Radolfzell on the Mettnau peninsula has not one but three patron saints: Theopontus, Senesius and Zeno. Each year on the third Sunday in July a festi-val procession through the old town is held in their honour. The following day, Hausherrenmontag, the people of Moos row across the Zeller See in boats adorned with flowers.

Above:
View of Überlingen from Wallhausen across Lake Constance. The old free city is a place of nostalgia and gourmet restaurants.

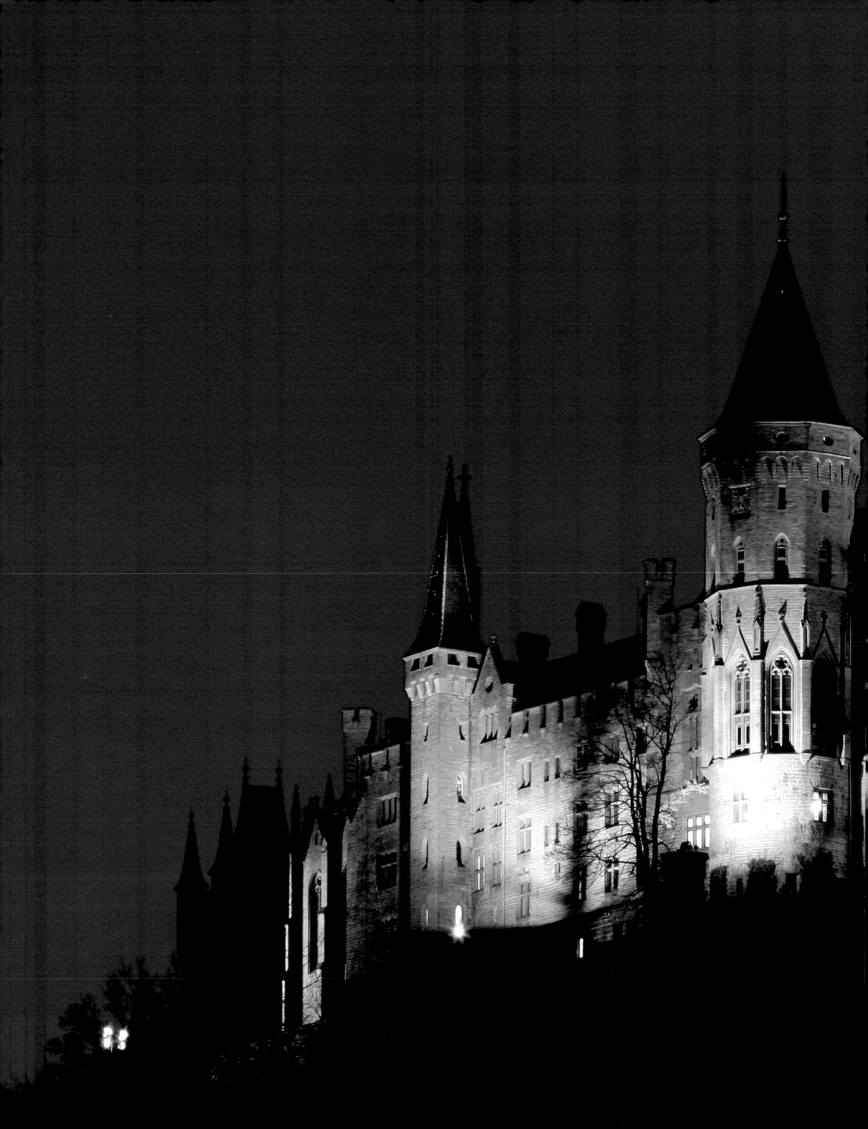

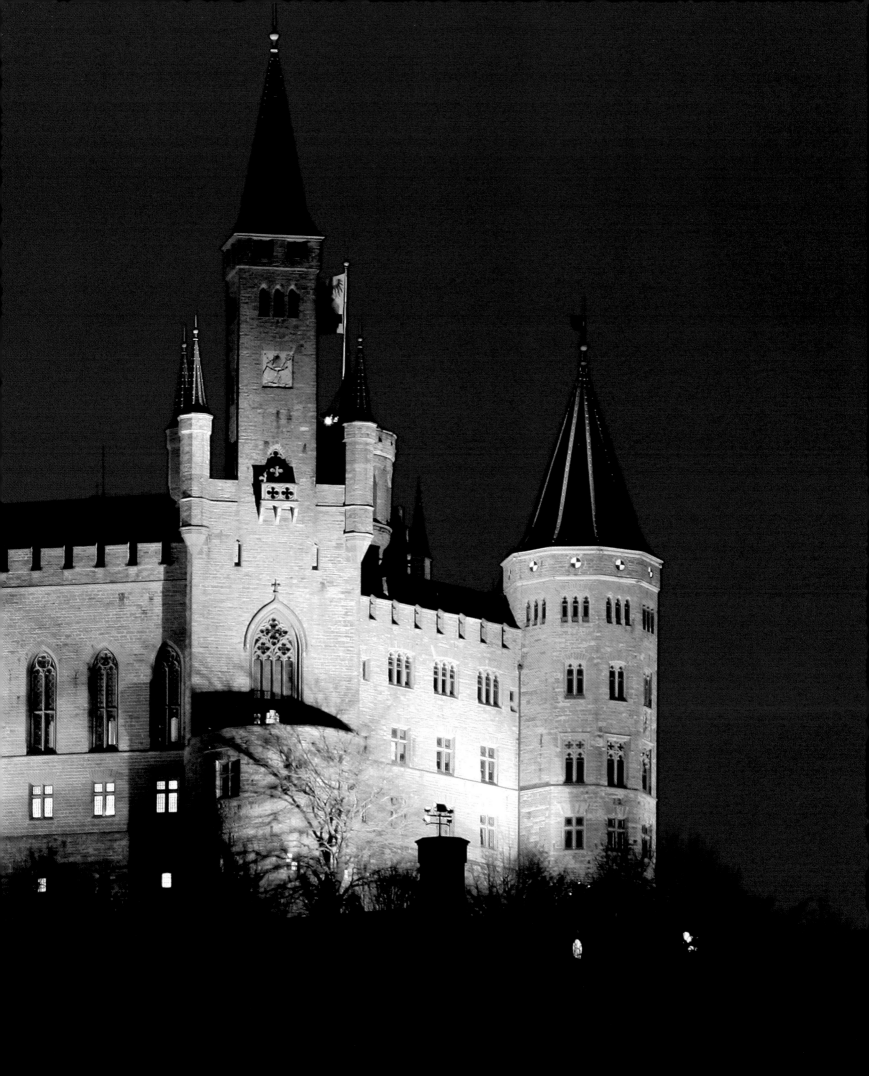

Page 108/109:
Burg Hohenzollern was erected in neo-Gothic in the west of the Swabian Alb and finished in 1867 after 17 years of building. Each year around 500,000 visitors make the trek to the top of the hill to savour the romantic medievalist fantasies "created by a Prussian crown prince and his architects and interior designers."

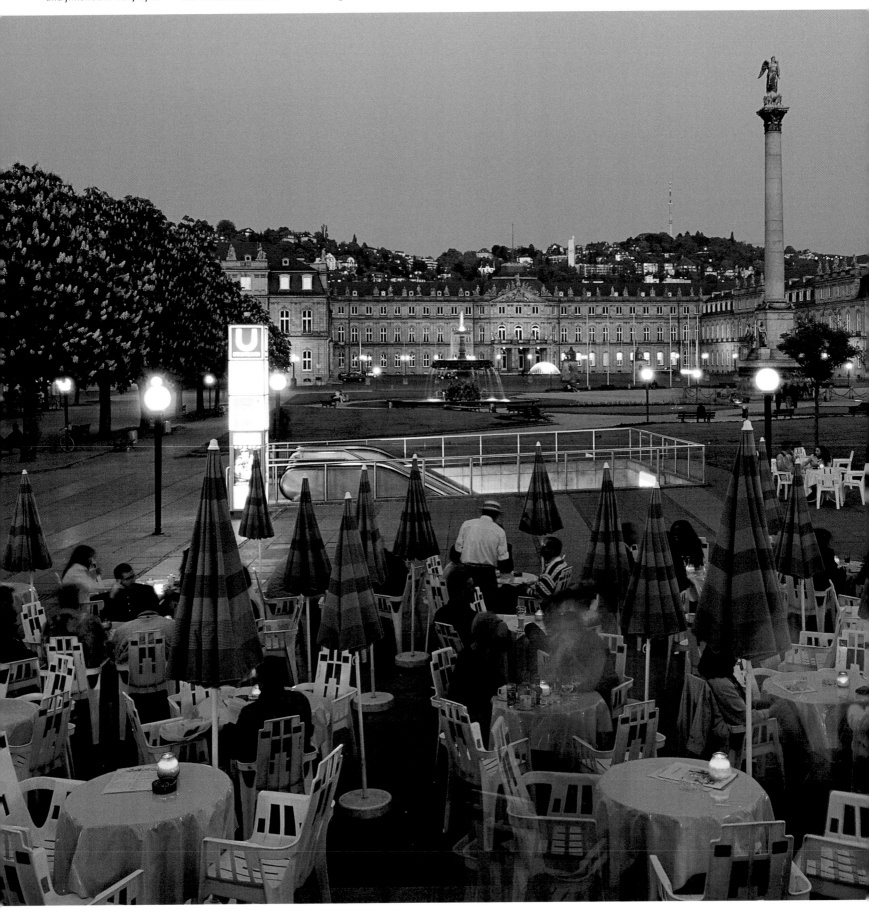

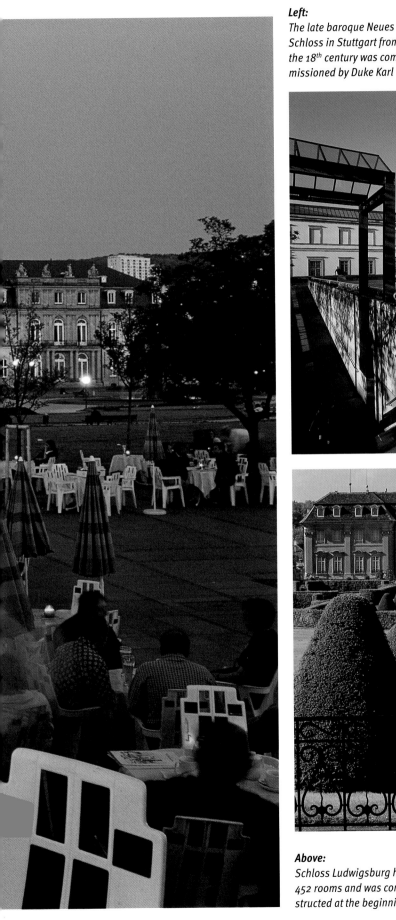

Left:
The late baroque Neues Schloss in Stuttgart from the 18th century was commissioned by Duke Karl Eugen. The jubilee pillar on the palace square was erected in celebration of King Wilhelm I's silver jubilee in 1841.

Below:
As early as just after the First World War Stuttgart was seen as a bastion of modern architecture, its name inextricably linked to those of Walter Gropius, Le Corbusier and Mies van der Rohe. The state capital of Baden-Württemberg still lives up to this reputation with the building of the Staatsgalerie or state gallery by James Stirling in 1984, for example.

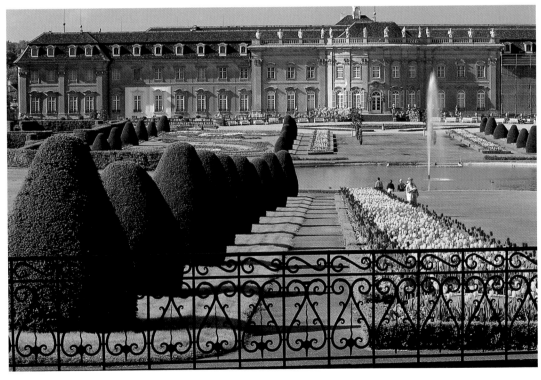

Above:
Schloss Ludwigsburg has 452 rooms and was constructed at the beginning of the 18th century in answer to Versailles. The baroque gardens, which lack none of the elegance and grandeur of the palace, are a big pull, drawing millions of tourists a year.

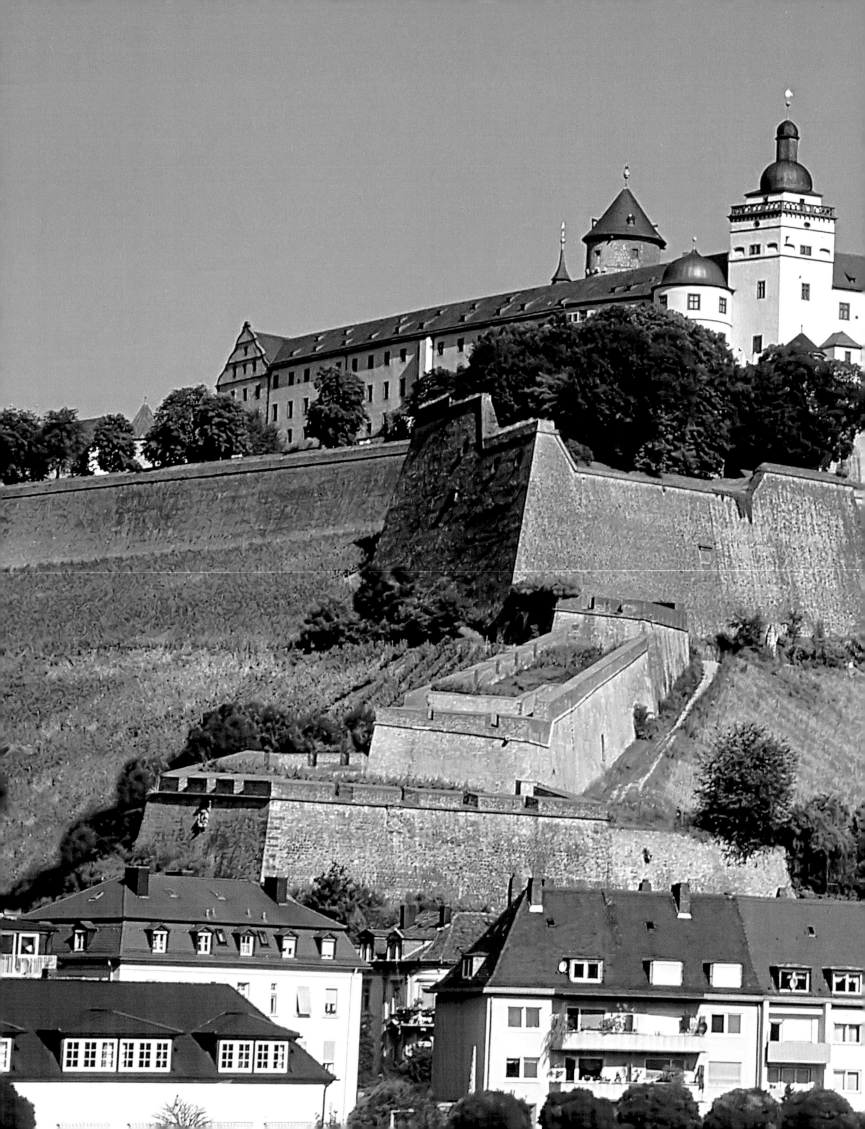

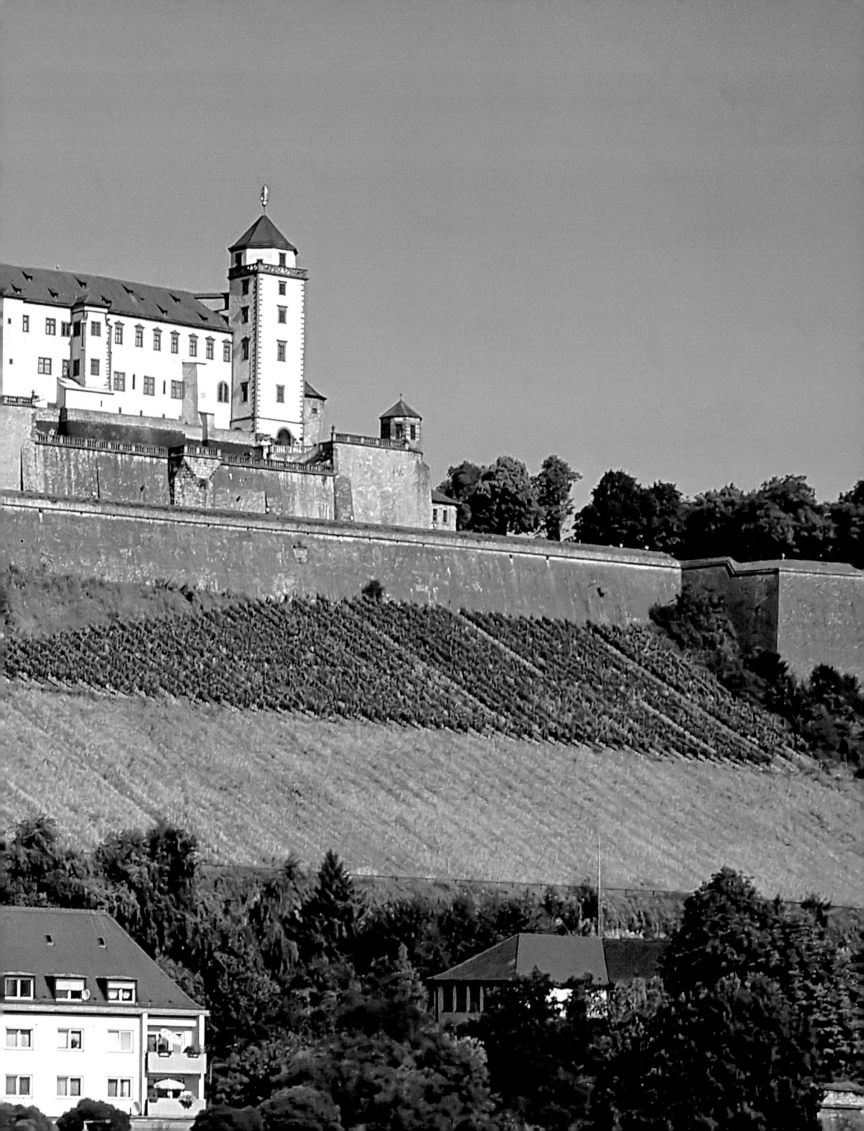

Page 112/113:
The mighty Festung Marienberg dominates the vineyards of Würzburg. A chapel dedicated to the *Virgin Mary was first erected here on the site of a Celtic fort; in 1201 the fortress was begun. This was to be the seat of the* *prince-bishops until 1719 when they moved down into the city and their new and splendid residential palace.*

Below:
Bamberg, the old imperial city and diocesan town in Franconia, is definitely in *the top ten of beautiful German cities. The historic centre with its famous cathedral and colourful* *town hall in the middle of the Regnitz River is a UNESCO World Heritage Site.*

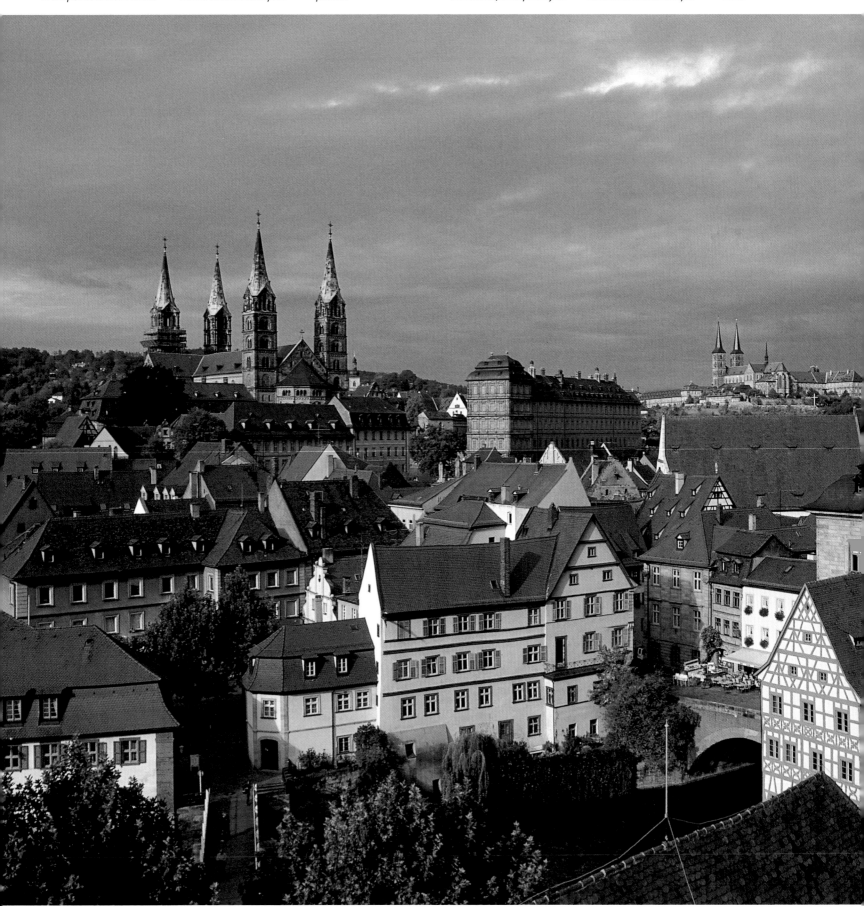

114

Page 116/117:
Rothenburg ob der Tauber still boasts its unique medieval centre, characterised by half-timbered houses and the mighty towers and walls which once defended the town. It boomed early, during the 14th century; later less prosperous periods meant that there was little or no money for modernisation. And thankfully so it has stayed!

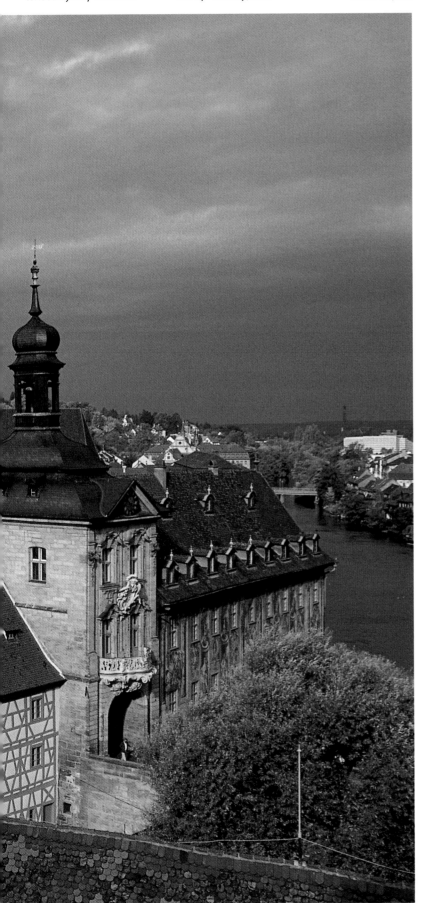

Below:
Regensburg on the Danube was a place both the Romans and later Germany's kings and princes felt was worth settling in. The Romans built a castle here, with their successors holding Imperial Diets in the city. The stone bridge is 12th-century and the cathedral, which is dedicated to St Peter, is Gothic.

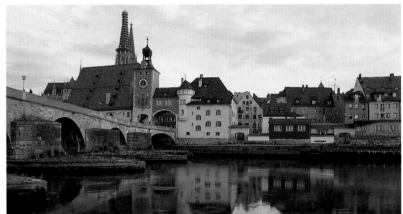

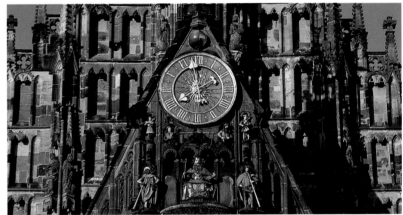

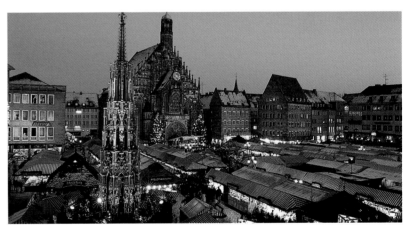

Above centre:
Nuremberg, capital of the Franconian region, was for centuries one of the political and intellectual centres of the empire. The photo depicts the intricate gable of the Frauenkirche. Each day at noon, seven electors trot round Emperor Karl IV while musicians play their instruments, a feature installed in 1509.

Above:
From a balcony on the Frauenkirche, each year at the start of Advent the Christ Child declares the most famous of Germany's Christmas fairs open. The hunt for Christmas presents is then on, interrupted only by the occasional glass of mulled wine or spicy Nuremberg sausage.

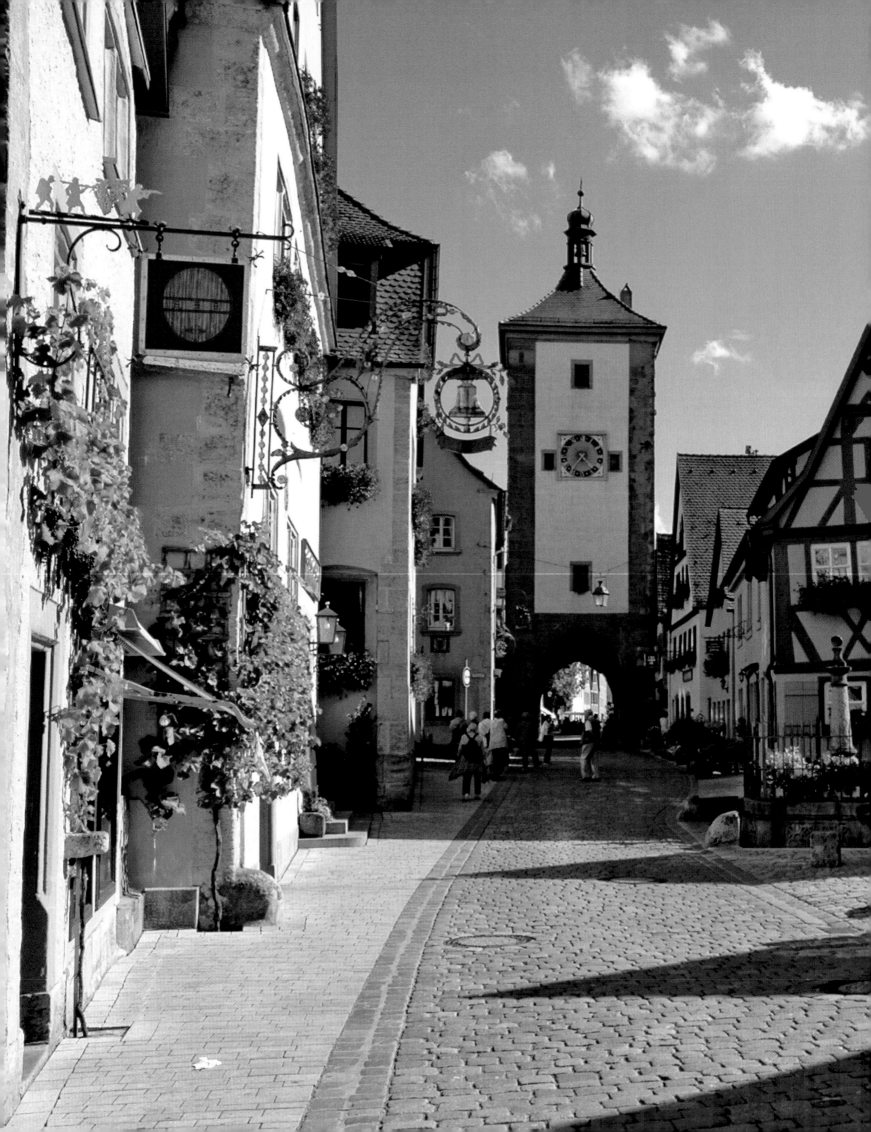

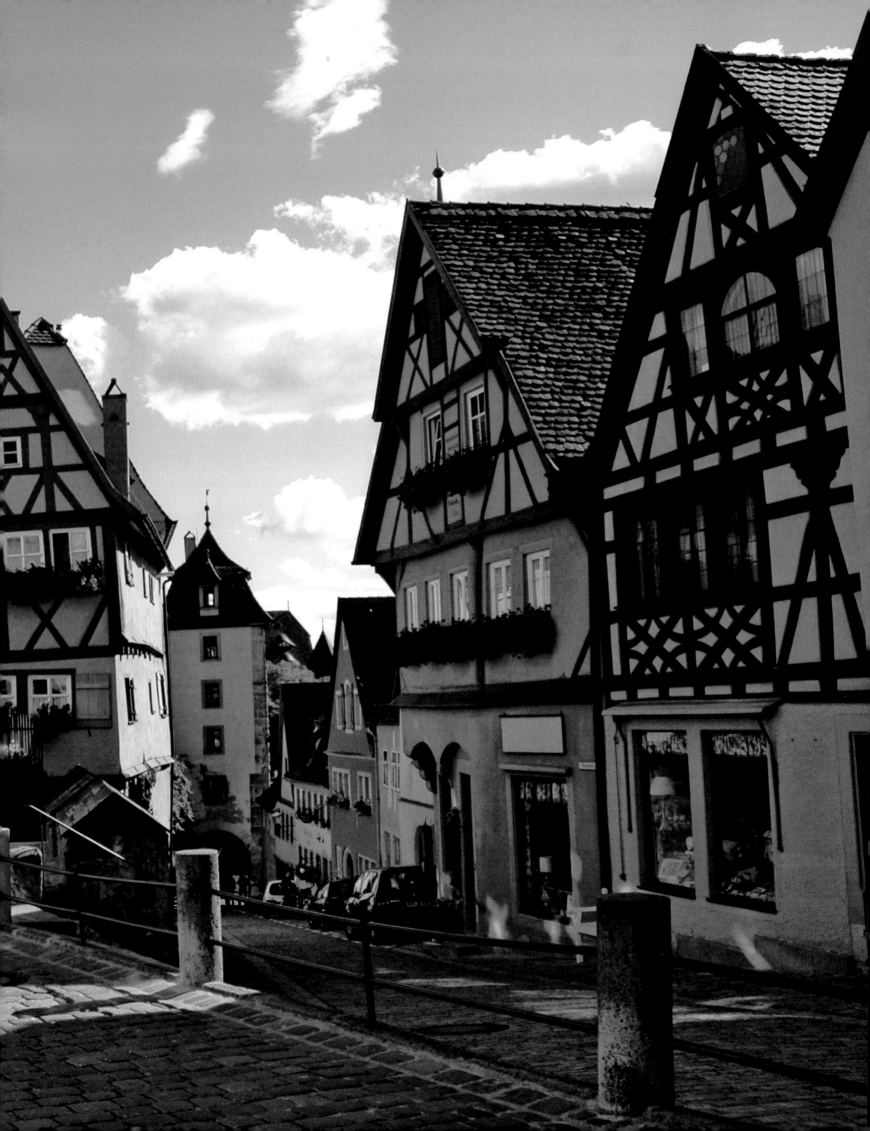

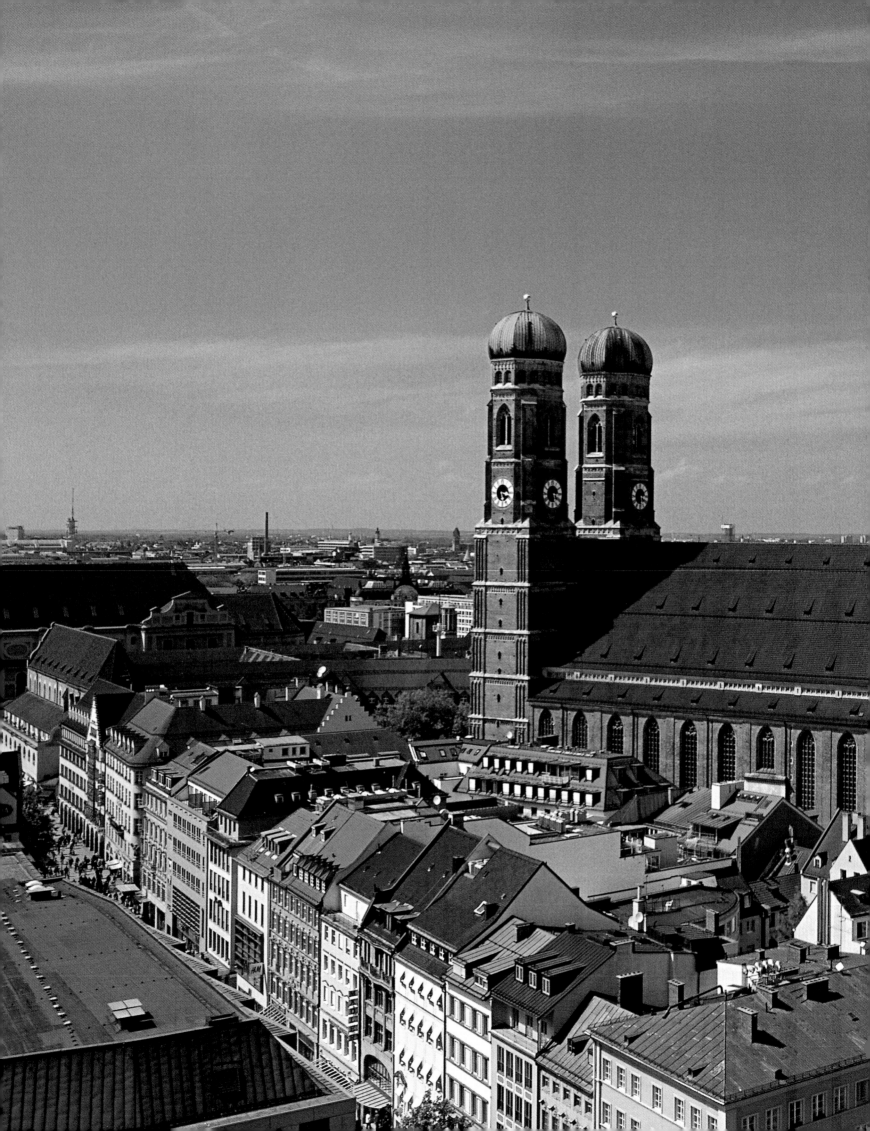

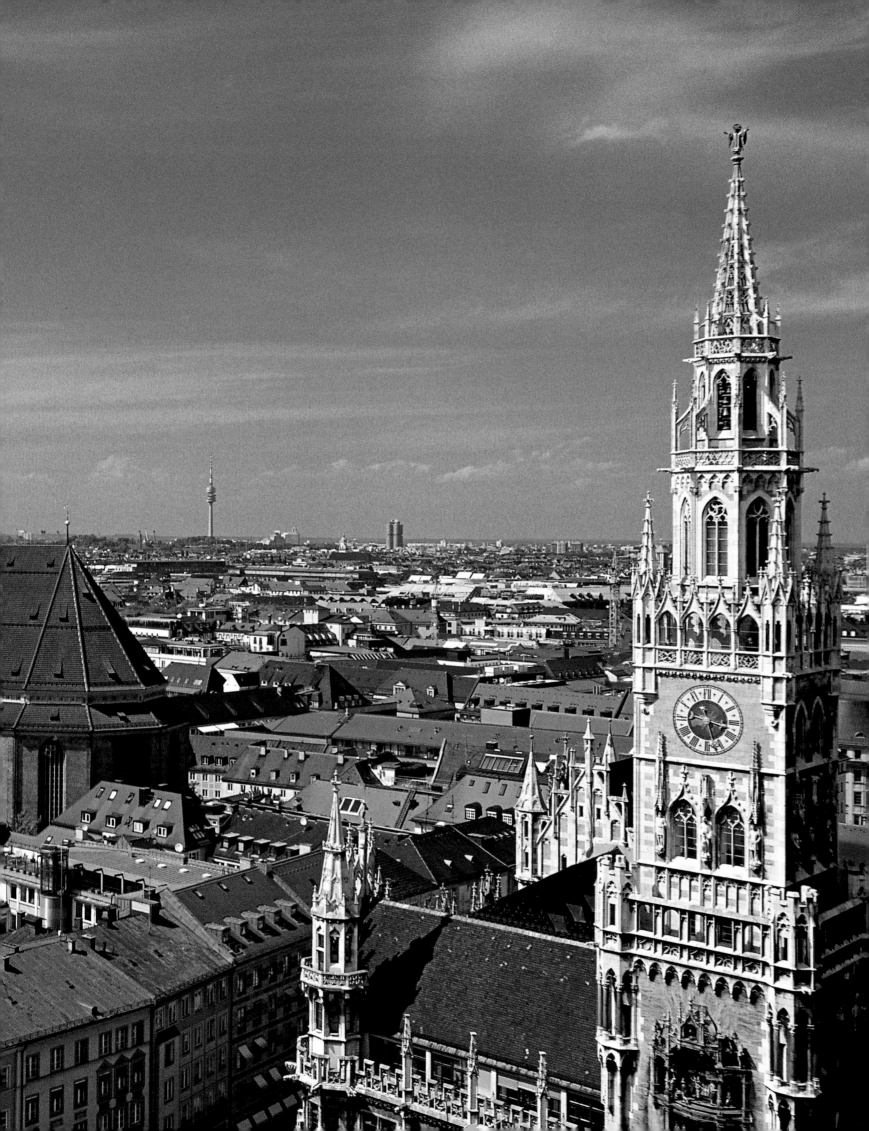

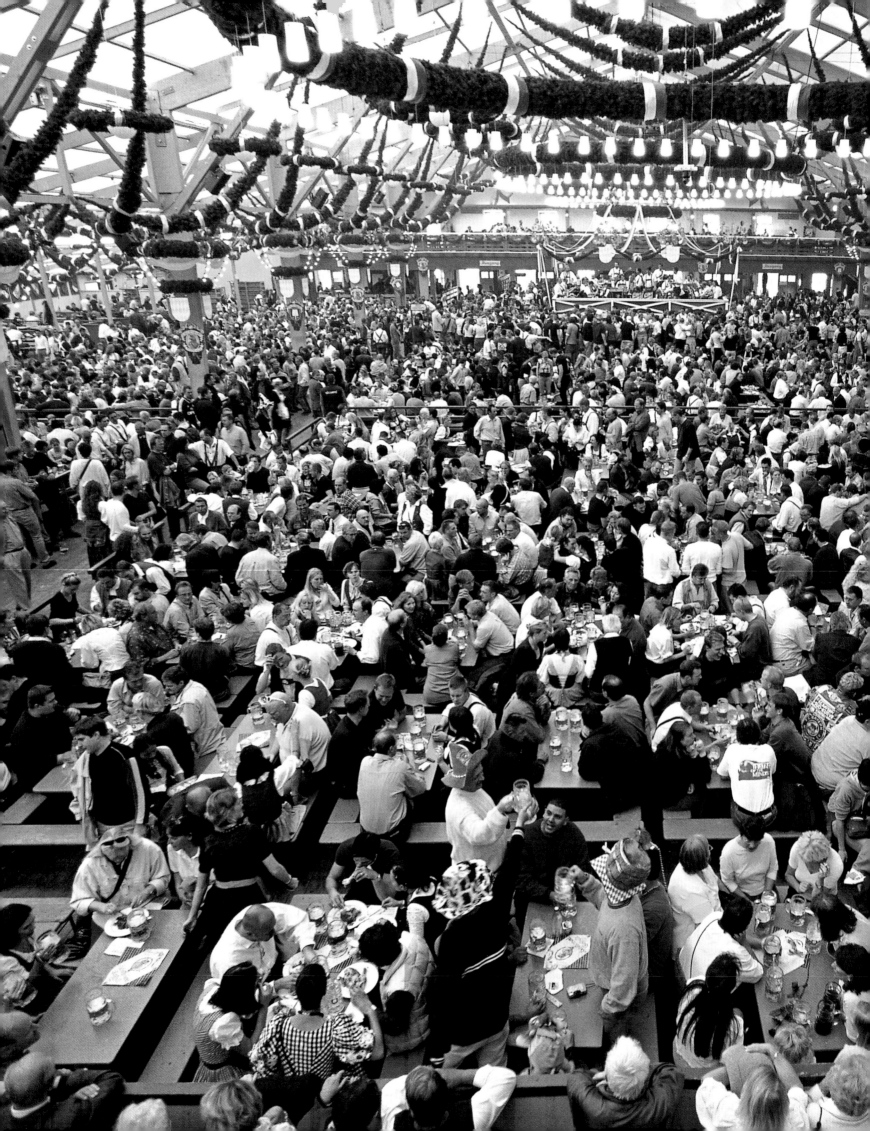

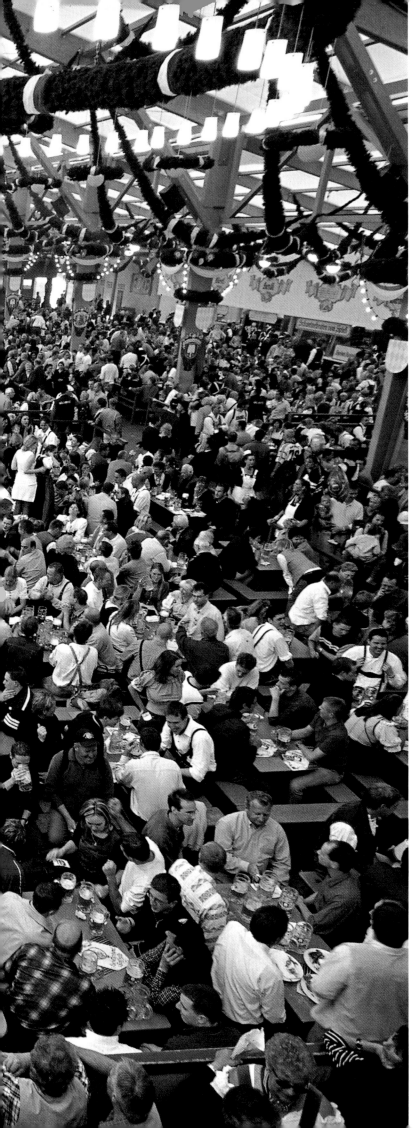

Page 118/119:

Munich. View from St Peter's, the oldest church in the city, of Marienplatz at the heart of town. Whereas the new town hall has disguised its real age (despite its Gothic appearance, it's only 19th- and 20th-century), the twin domes of the Frauenkirche, Munich's local landmark, are half a millennium old.

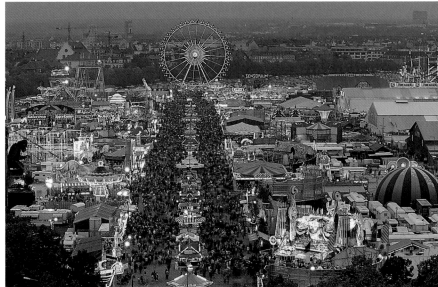

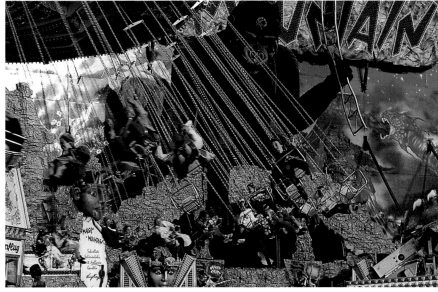

Munich's Oktoberfest is a festival of superlatives; it's the biggest in the world! Here you can try out the newest and flashiest rides in the fairground business and also taste some of the local cuisine. The top victual is, of course, beer, which in the local vernacular is also referred to as "staple foodstuff no. 1". It's served in the traditional litre jugs, with the obligatory oompah band puffing away in the background as you sip.

121

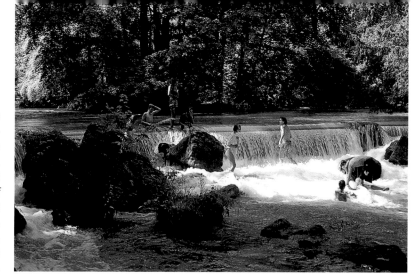

Below and right:
Munich's Englischer Garten covers an area of 417 hectares (over 1,000 acres) along the banks of the Isar River. This makes it one of the largest inner-city parks in the world. When the weather's fine, half of Munich can be found here taking a walk, lying in the sun or firmly ensconced in one of the beer gardens. The Monopteros (below) is one of the many follies dotted about the gardens.

Centre right:
The beer garden is part of Bavaria's cultural heritage – and nowhere more so than in Munich. Friends meet under shady trees to drink beer and eat Weiß-wurst sausages, to watch people watching them. And if you think this is all reserved for the height of summer, then think again! The first rays of sunshine, even if they are in January, herald the opening of the beer garden season.

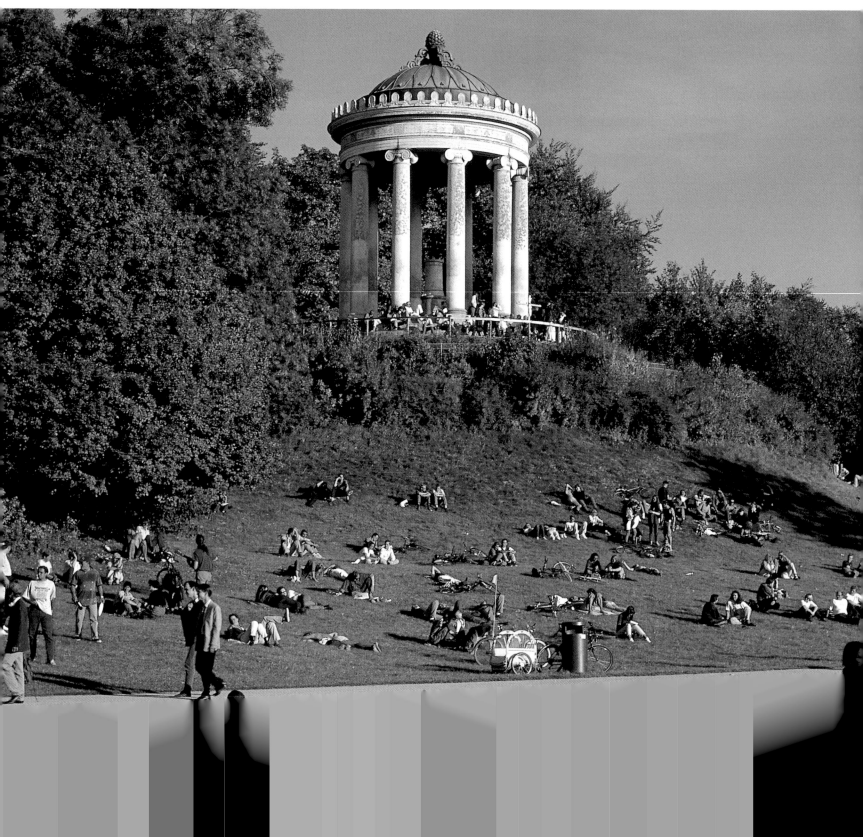

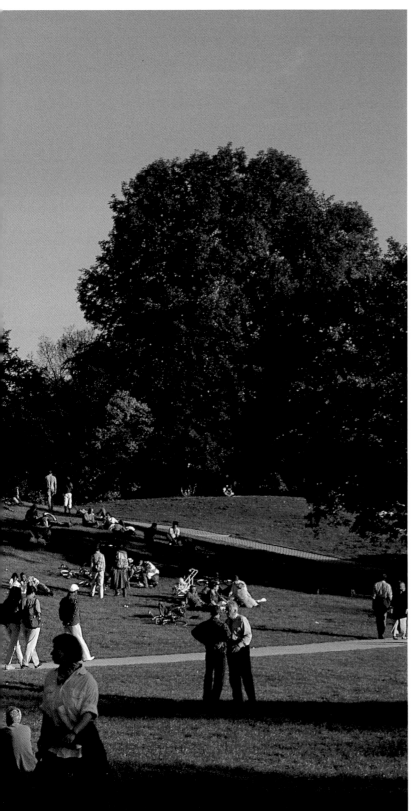

Below:
Karlsplatz, known locally as the Stachus, was once one of the busiest cross-roads in town. It's now been pedestrianised, its fountains providing cool relief on hot summer days.

Below centre:
Viktualienmarkt, Munich's food market, does its name full justice. Here you can buy the best, freshest produce, most of it straight from the farmer. There are still some of those cele-brated stallholders left, tough, weather-beaten souls who serve their customers with that special keen Munich wit. On the left of the picture is the old town hall, to the right the Heilig-Geist-Kirche.

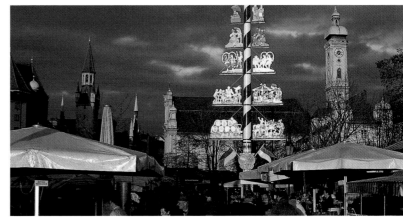

Above:
Out of the many famous beer temples in Munich, the cult Hofbräuhaus has just got to be number 1. Here you can drink, eat and sway along to the brewery hit "In Munich there's a Hofbräuhaus..."

Andechs Monastery bathed in morning sunshine on the shores of the Ammersee. Founded in 1460 by Duke Albrecht III of Bavaria, it later became an eminent place of pilgrimage. The Benedictines provide fortification for both the mind and the body, the latter in the form of strong Andechs beer which the monks brew from an ancient recipe.

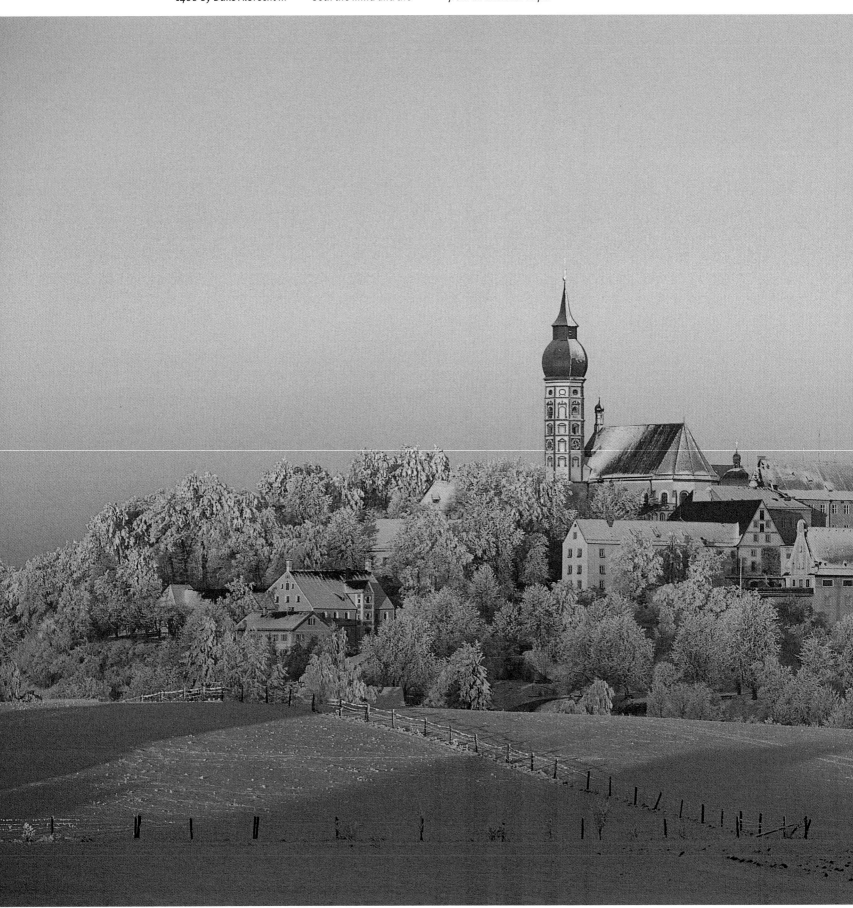

Right:
The deep, moving sense of religiousness shared by the people of Bavaria is evident in the many way- side shrines and crosses spread about the country- side, such as the one here in Aidenried in the Pfaffenwinkel area.

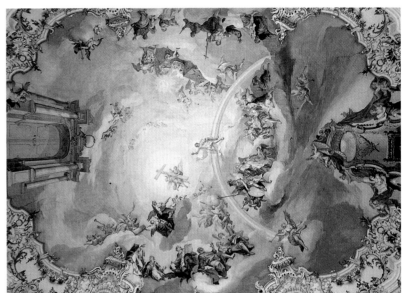

Above and above centre:
The Wieskirche between Schongau and Füssen in the Allgäu is a masterpiece of southern German Rococo. The interior, absolutely smothered in stucco orna- mentation and colourful frescos, is a feast for the eyes. When a military plane out training flew too close to the church, causing the walls to vibrate and the stucco to collapse, there was total dismay. The place of pilgrimage has since been restored to its former glory.

Page 126/127:
Winter on the Alpsee. King Ludwig II of Bavaria may have gazed dreamily upon stark icy landscapes such as these from his west balcony at Neuschwan- stein. In the foreground is Schloss Hohenschwangau, the summer residence the king's father Maximilian II had built for the family. Ludwig II spent his happi- est childhood years here.

125

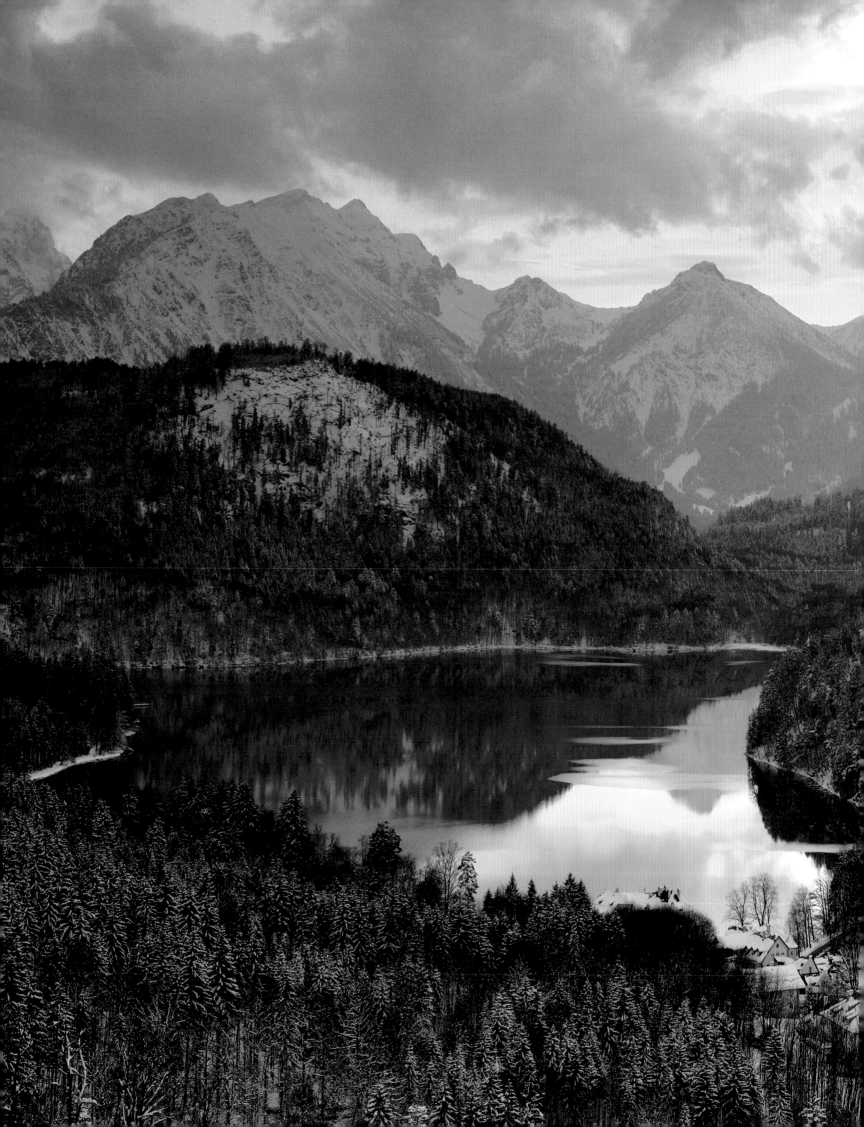

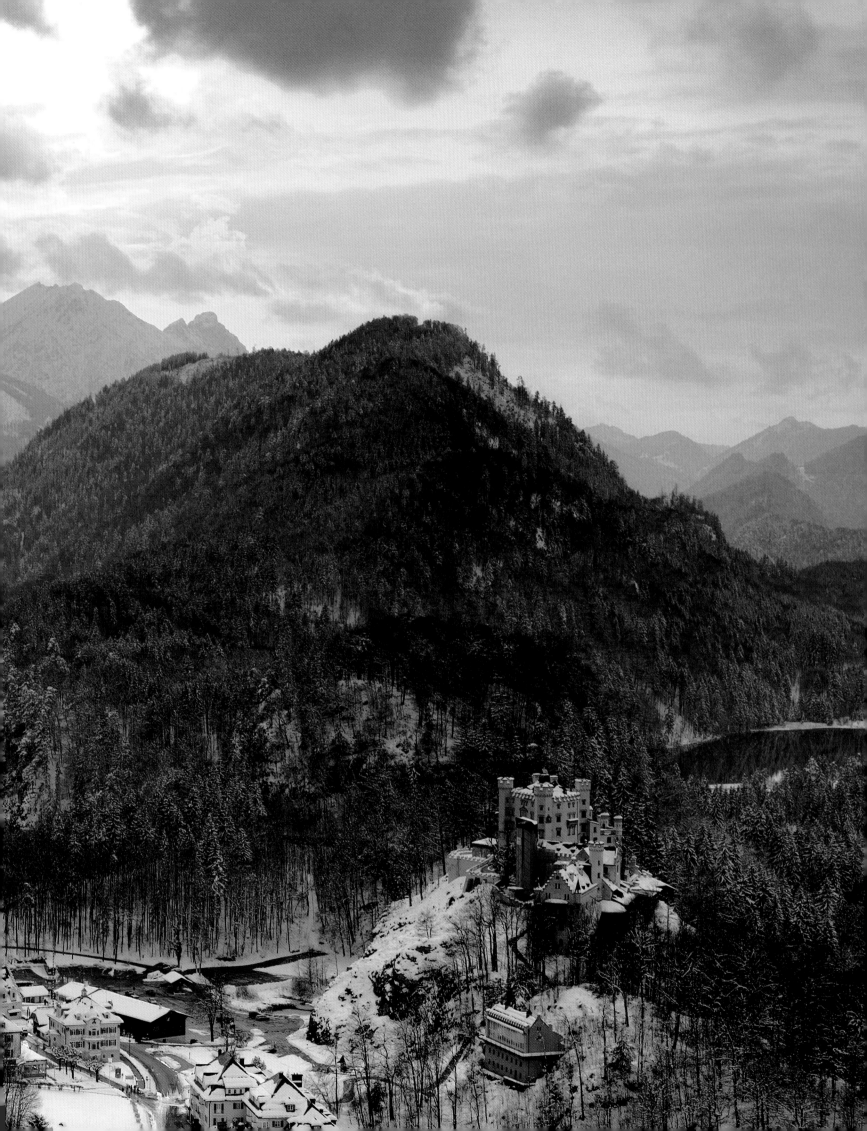

LUDWIG II OF BAVARIA AND HIS CASTLES

For someone known as The Dream King of 19th-century Germany, it is appropriate that his castles look like something out of a fairy tale. In our prosaic, modern world, Ludwig II and Neuschwanstein, Linderhof and Herrenchiemsee still hold all the magic of a bygone age, drawing millions of tourists each year from all over the globe to Upper Bavaria.

King Ludwig II of Bavaria, son of Crown Prince Maximilian of Bavaria and Prussian princess Marie Friedericke, was born in 1845. Following the early death of his father, Ludwig was made head of government at the tender age of 18, forced to function in an environment he abhorred. Despite his revulsion, he made an effort to be successful in his new role. His endeavours were recognised in 1883, three years before his mysterious death, by none other than the Prussian Imperial Chancellor Bismarck, who conceded that the king ruled "better than all his ministers". High praise indeed – which had a certain irony to it. Prussia's hegemonic politics and its two wars were something the sensitive Ludwig absolutely detested. He confided his misgivings to his dear friend Richard Wagner, dreading he would become "a puppet king without any power". Things in fact turned out worse than he feared; at the order of Germany's princes, Ludwig had to offer the imperial crown to his private adversary, the king of Prussia.

These crass realities would probably have been the end of Ludwig if he hadn't found escape in another, fairytale world, a world where he made all the rules and could be king as he saw fit. The Bavarian monarch was a great admirer of the French Sun King Louis XIV. Yet in his desire to honour the obligations of their shared name, he sadly failed to acknowledge that in the one-and-a-half centuries which separated him from the French regent, much had changed. The rest is history. In an attempt to make his wildest dreams come true – that of a poetic existence à la Lohengrin, Tristan and Tannhäuser – he soon found himself in dire financial straits. He grossly underestimated the capacities of the royal coffers, which for a Bavarian king of the bourgeois 19th century were far more modest that those of the absolutist French sovereign. Ludwig's castles swallowed up his money at an incredible rate. Accused of bringing the country to ruin, he was deemed an incurable madman and certified. On 13 June 1886, the ill-fated ruler and his psychiatrist were found drowned in the Starnberger See.

Ludwig's bequest to us are his castles. Ruined Hohenschwangau, for example, was initially scheduled for renovation only; it was to be turned into a humble baronial abode. Ludwig's original plans were soon abandoned, however, in favour of designs for a romantic four-storey edifice on a monumental scale. In his mind's eye was a Bavarian version of the palace at the gigantic Wartburg in Eisenach. The king even travelled incognito to Thuringia to see the castle for himself and gain inspiration. Yet time was not on his side. When he died, only part of what was later to be called Neuschwanstein was finished. The rest was completed posthumously in accordance with his wishes and ideas.

In comparison with this fantastic construction set against its bizarre Alpine backdrop, Schloss Linderhof seems extremely unassuming and private. And the park, too, with its contrived Venus Grotto, Moroccan House and Oriental Pavilion, symbolises more a personal preoccupation of the king with foreign myths and cultures rather than something public. Once the monarch had glided through the palace gates in his golden Rococo sledge he was alone, with only his staff to bother him. Linderhof was incidentally the only one of his building projects he saw completed.

His third castle, Schloss Herrenchiemsee on Chiemsee lake, was to be a "new Versailles". In 1878 the foundations were laid for a huge building whose main façade actually trumped that of the prototype. The king, who usually only came to his island palace at night, attached great importance to detail, insisting that the furnishings be copied from the French originals. While Paul Verlaine celebrated the regent as the "last true king of this century", others angrily called him a mad squanderer. Ludwig, in his own words, claimed to be neither, professing to "remain an eternal puzzle".

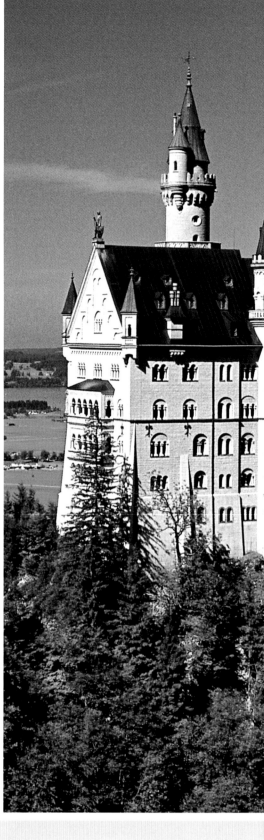

Left:
Richard Wagner in a letter (1866) about Ludwig II: "I persistently consider the young King Ludwig to be immensely competent. Yet how his qualities of leadership shall develop remains to be seen. An inconceivably futile education has succeeded in arousing in the young man a deep-seated aversion to earnest preoccupation with state interests which to date shows absolutely no sign of abating. He performs matters of state ... full of loathing. He is disgusted by his family, by the entire court indeed; he hates the army and

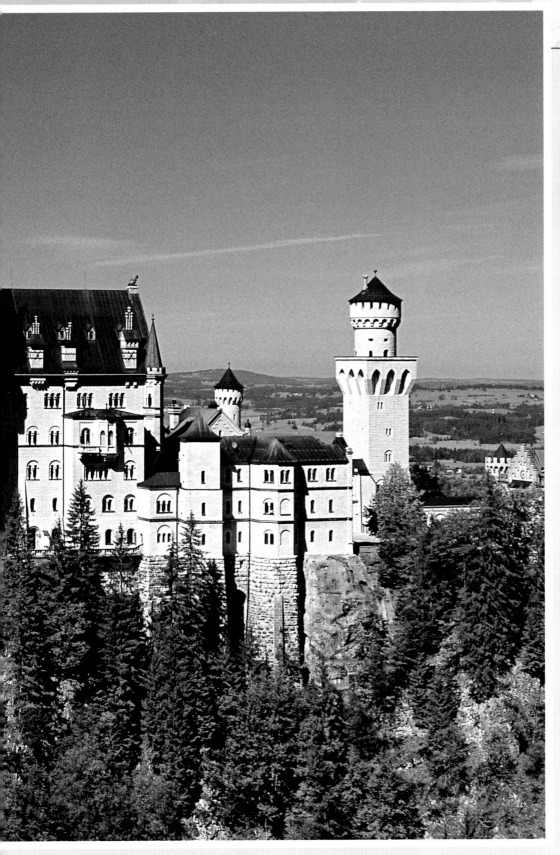

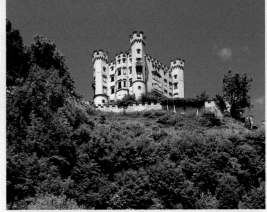

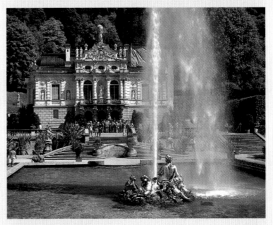

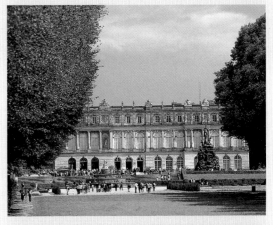

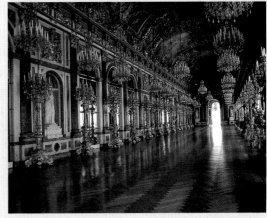

soldiery; he finds the aristocracy ridiculous and his subjects contemptible. Yet about the clergy he expresses himself clearly and without prejudice; on matters of religion he is serious and ardent."

Above:
Schloss Neuschwanstein rises up above the precipitous gorge of the Pöllatschlucht.

Right, from top to buttom:
For Ludwig II, Schloss Hohenschwangau up above the Alpsee was "paradise on earth". Schloss Linderhof, the smallest of Ludwig II's palaces, was the only one he actually lived in.

Schloss Herrenchiemsee was modelled on Versailles. The mirrored gallery at Herrenchiemsee is even bigger than the French original.

Below and below centre: In Bavaria, St Leonhard has long been the patron saint of animals. On 6 November, his name day, Leonhard processions are staged in many of the villages, such as here in Fischhausen on the Schliersee (below) and in Harmating near Bad Tölz (below centre). The parade culminates in the participants riding splendidly adorned horses and horse-drawn carts around the churches and chapels to be blessed by the priest.

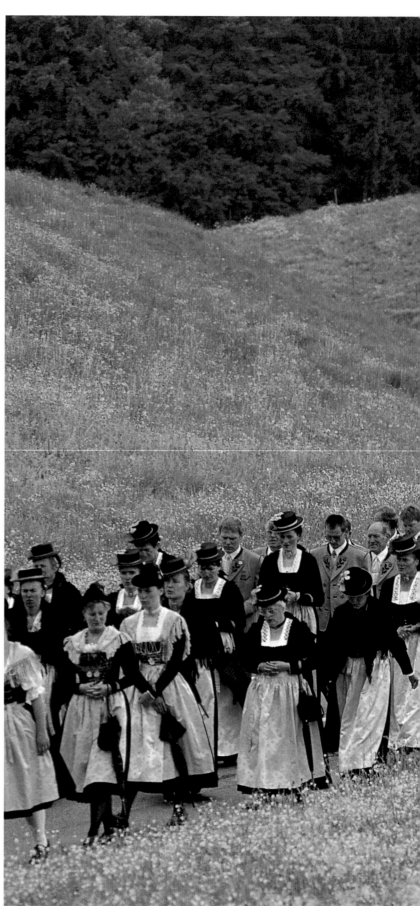

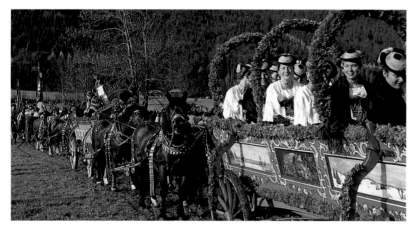

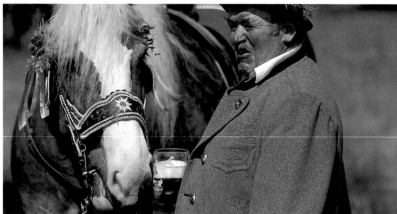

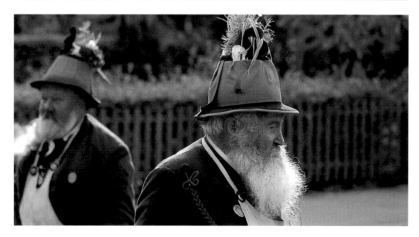

Above: The mountain hunting festival in Lenggries is a high point of the year for locals and visitors alike. This is when the hunters – in full traditional dress – choose their king. Once the ceremony is over, the rest of the night is spent drinking beer, eating hearty plates of food and dancing to the strains of Bavarian folk music.

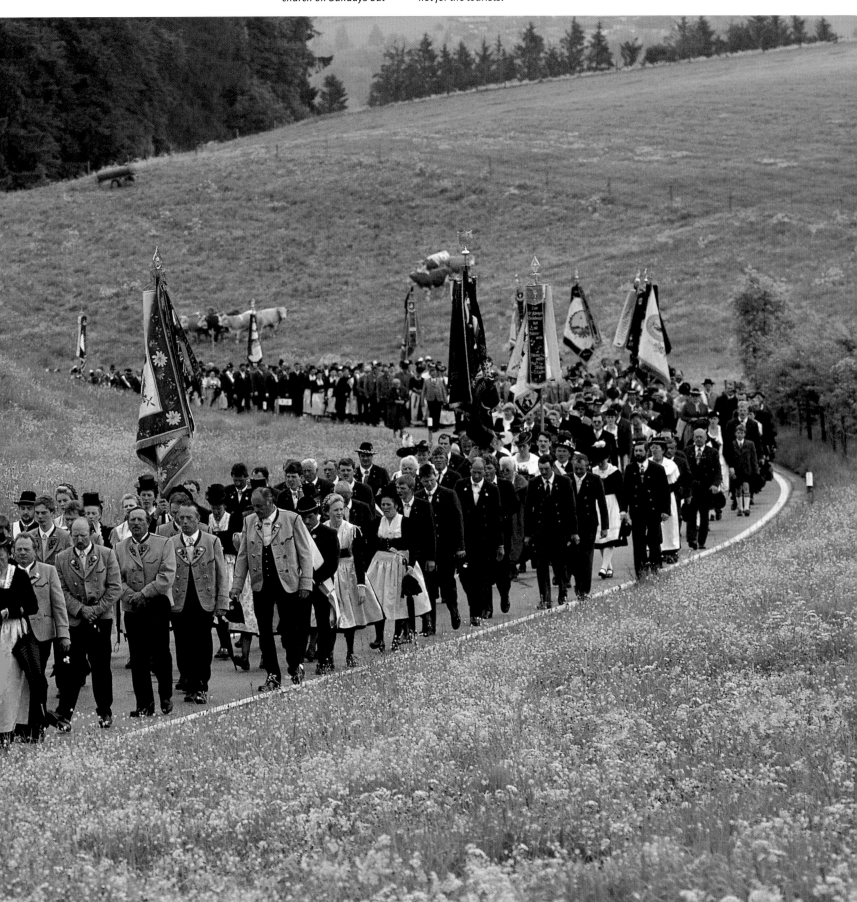

In Upper Bavaria many ancient customs have been preserved. People not only dress up for church on Sundays but also for pilgrimages, donning their local costumes as a matter of course and not for the tourists.

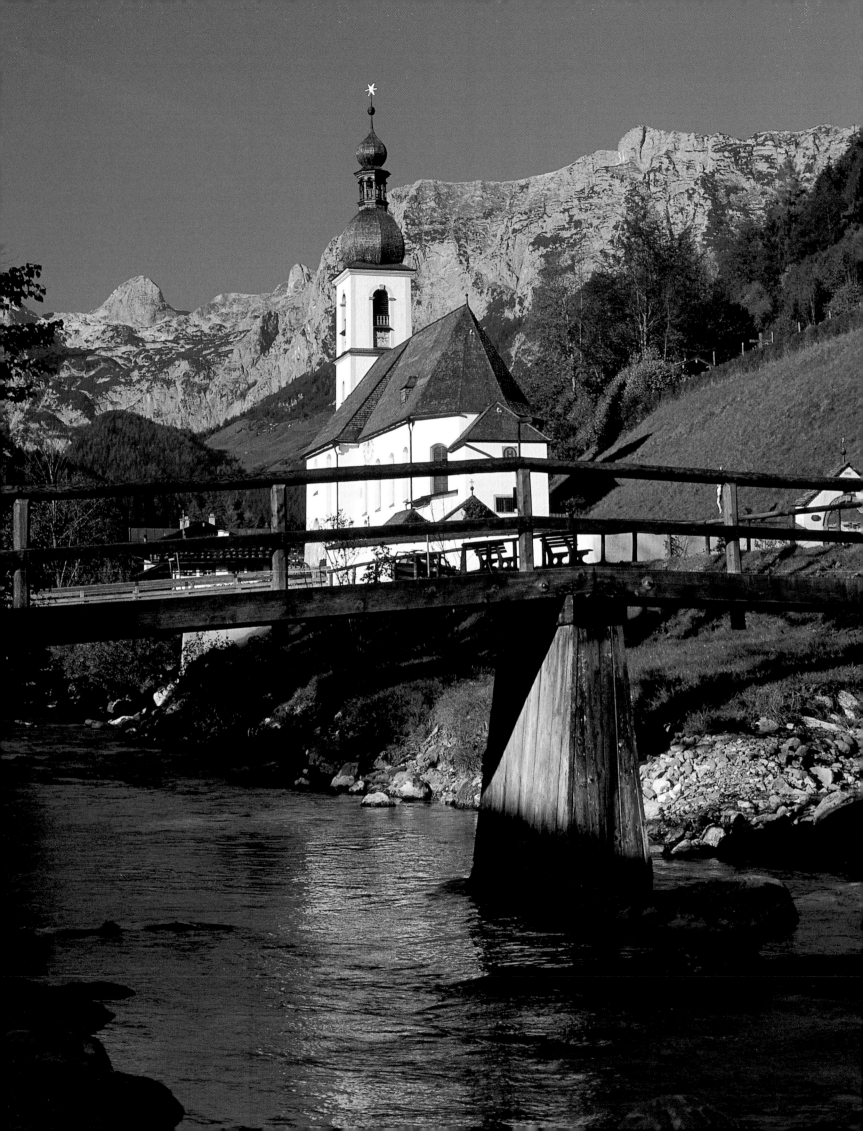

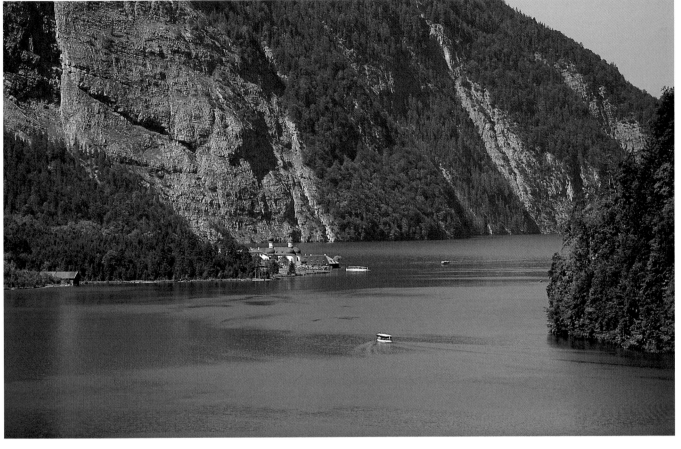

The Königssee is the pearl of the Berchtesgadener Land. The grey limestone rocks, some of them up to 8,860 ft (2,700 m) tall, are reflected in the dark green water. Along its shores is the old pilgrimage church of St Bartholomä, dedicated to St Bartholomew, after whom the lake used to be named.

Left page:
The parish church of St Fabian and St Sebastian in Ramsau in the Berchtesgadener Land is a renowned Alpine motif. Features include some very artistic carving on the gallery and also the old cemetery with graveyard crosses from the 17th and 18th centuries.

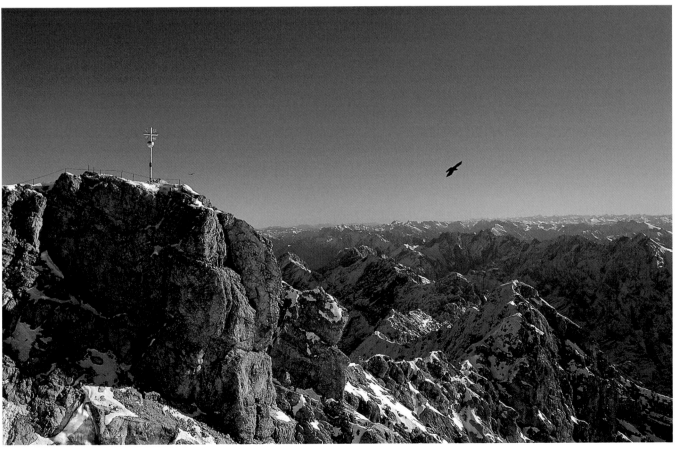

On a clear day, from the top of the Zugspitze, Germany's highest mountain, you have an Alpine panorama spread out beneath you.

INDEX

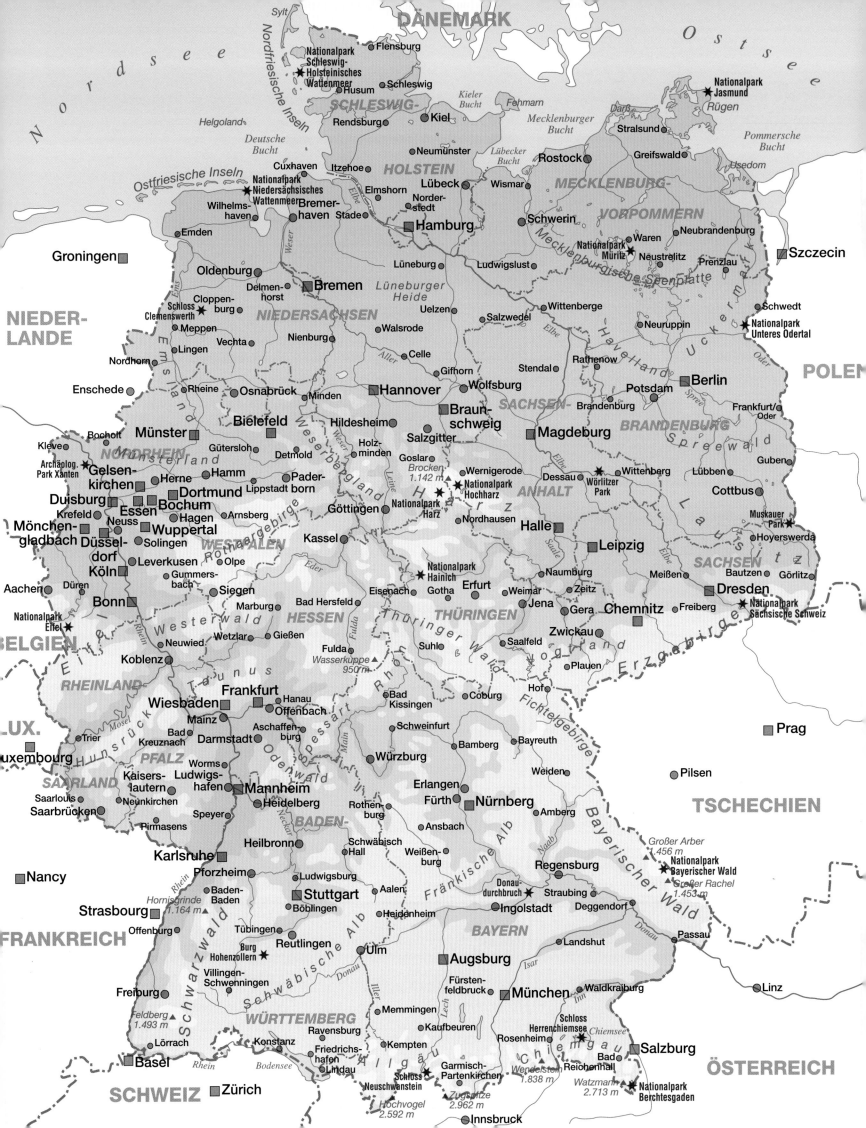

Typically Bavarian:
Hotel Post in Wallgau
near Mittenwald.

Design
www.hoyerdesign.de

Map
Fischer Kartografie, Aichach

Translation
Ruth Chitty, Stromberg
www.rapid-com.de

Printed in Germany
Reproductions by Artilitho snc, Lavis-Trento, Italy
www.artilitho.com
Printed by Offizin Andersen Nexö, Leipzig
© 2012 Verlagshaus Würzburg GmbH & Co. KG
© Photos: Horst and Daniel Zielske, Martin Siepmann
 and Karl-Heinz Raach
© Text: Ernst-Otto Luthardt

ISBN 978-3-8003-4059-0

Details of our programme can be found at
www.verlagshaus.com

Picture credits
Günter Franz:
p. 35 bottom.

Ralf Freyer:
p. 24/25.

Jürgen Henkelmann:
p. 18/19, p. 66, p. 73 top.

Tina and Horst Herzig:
p. 14/15, p. 28/29, p. 62 bottom, p. 76/77 (4 ill.).

Werner Richner:
p. 83 bottom right, p. 94 top left, p. 94 centre left, p. 95.

Martin Siepmann:
Cover, p. 5, p. 20/21, p. 90/91, p. 118/119, p. 120,
p. 121 bottom right, p. 122–125 (10 ill.),
p. 128/129 top centre, p. 128 top left, p. 128 bottom right,
p. 129 centre left, p. 129 top right, p. 130–136 (8 ill.).

Karl-Heinz Raach:
p. 10/11, p. 35 top, p. 96/97 (5 ill.), p. 100–103 (5 ill.),
p. 107 top left, p. 107 top right, p. 107 centre right,
p. 107 bottom right.

Publisher's archives:
p. 129 bottom right (2 ill.).

Ernst Wrba:
p. 16/17, p. 56 bottom, p. 70/71, p. 78 top, p. 78 bottom,
p. 82/83 top centre, p. 84/85.

Horst and Daniel Zielske:
p. 6/7, p. 12/13, p. 22/23, p. 26/27, p. 30 top, p. 31 (4 ill.),
p. 32/33 (5 ill.), p. 34, p. 37 centre right, p. 38/39 (6 ill.),
p. 42–55 (28 ill.), p. 56 top, p. 57 (3 ill.), p. 58–61 (6 ill.),
p. 62 top, p. 63 (4 ill.), p. 64/65 (6 ill.), p. 67 top,
p. 67 bottom, p. 68/69, p. 72 bottom, p. 72 top,
p. 73 right, p. 77 (3 ill.), p. 80/81 (3 ill.), p. 82 top left,
p. 82 bottom right, p. 83 top right, p. 86–87 (5 ill.),
p. 92/93, p. 90 bottom left, p. 98/99 (3 ill.), p. 104/105 (3 ill.),
p. 106 bottom, p. 106 top, p. 110/111 (3 ill.), p. 114/115 (4 ill.),
p.121 top right, back jacket.

Other:
p. 30 bottom: PictureArt/fotolia.com;
p. 36: Daniel Sainthorant/fotolia.com;
p. 37 top right, p. 37 bottom right:
Wolfgang Mette/fotolia.com;
p. 40/41: Gourmecana/fotolia.com;
p. 76/77: Matthew Dixon/iStockphoto.com;
p. 88/89: Rolf Weschke/iStockphoto.com;
p. 108/109: Manuela Weschke/iStockphoto.com;
p. 112/113: Werner Hilpert/fotolia.com;
p. 116/117: Steffi Langer/iStockphoto.com;
p. 126/127: Ingmar Wesemann/iStockphoto.com.